Creative Shutter Speed

Master Your Camera's Most Powerful Control

Derek Doeffinger

WILEY

Wiley Publishing, Inc.

Creative Shutter Speed: Master Your Camera's Most Powerful Control

Published by
Wiley Publishing, Inc.
10475 Crosspoint Boulevard
Indianapolis, IN 46256
www.wiley.com

ISBN: 978-0-470-45362-9
Manufactured in the United States of America

10 9 8 7 6 5 4 3 2 1

For general information on our other products and services or to obtain technical support, please contact our Customer Care Department within the U.S. at (800) 762-2974, outside the U.S. at (317) 572-3993 or fax (317) 572-4002.

Wiley also publishes its books in a variety of electronic formats. Some content that appears in print may not be available in electronic books.

Library of Congress Control Number: 2009928481

About the Author

Derek Doeffinger started writing, editing, conceiving, photographing, and marketing Kodak photo books when film SLRs were the rage back in the 1980s. When Kodak started down the digital photography path in the early 1990s, he joined their digital imaging division and participated in the launch of Kodak's first consumer digital camera. He's been participating in digital photography for over fifteen years now. In recent years, in addition to writing about digital photography, he has also written and photographed several regional photo books about upstate New York.

Credits

Acquisitions Editor
Courtney Allen

Project Editor
Carol Doeffinger

Technical Editor
Alan Hess

Copy Editor
Carol Doeffinger

Editorial Manager
Robyn Siesky

Business Manager
Amy Knies

Senior Marketing Manager
Sandy Smith

**Vice President and
Executive Group Publisher**
Richard Swadley

Vice President and Publisher
Barry Pruett

Book Designer
Erik Powers

Author's Acknowledgments

Thanks to the many people involved in this project for both their patience and expertise. My daughter Bari Doeffinger, a fine writer in her own right, who edited the rough draft. To Carol Doeffinger for her meticulous (and I do mean meticulous) editing of the final manuscript. To John Wiley's Courtney Allen for taking on this project and providing valuable guidance. To fellow author, photographer, and friend Jeff Wignall for his suggestions, insights, and support. To Gary Whelpley, good friend and inspirational photo buddy, for the use of his photos. To photographer friends Stewart Hecht, Mike Brown, and Herb Chong for use of their photos. And to book designer Erik Powers for patiently handling many suggestions while producing a design that so nicely features both words and photos.

*To Bari and Bunny for their patience
with an obsessive-compulsive,
chain picture-taking photographer.*

Contents

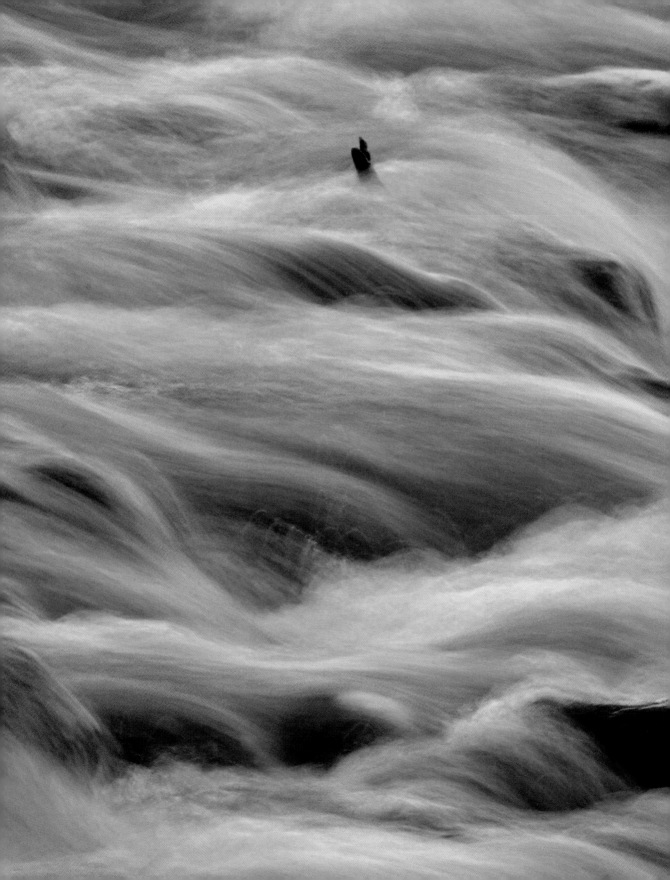

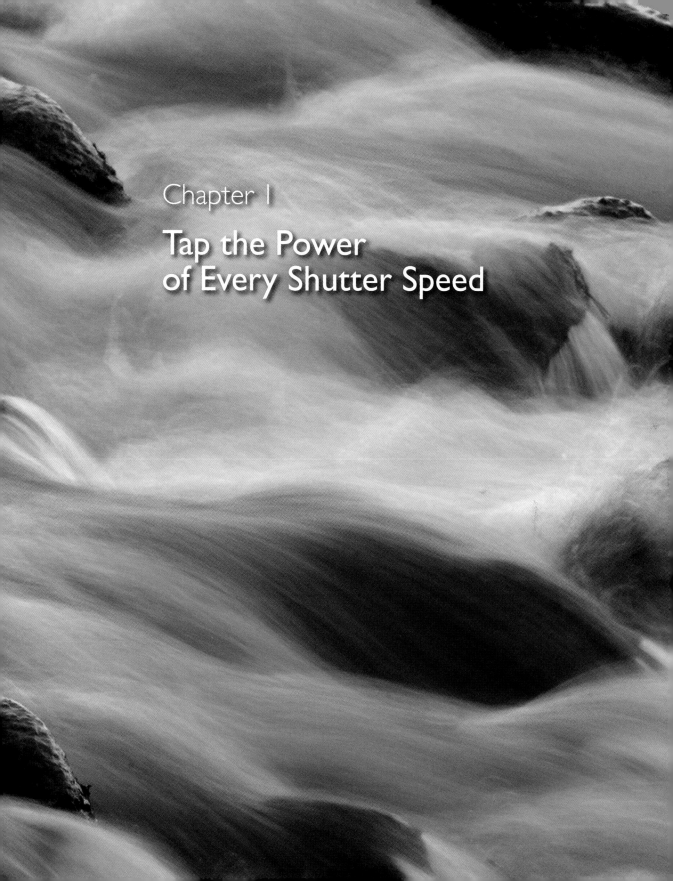

Chapter 1
Tap the Power of Every Shutter Speed

Have you ever counted how many shutter speeds your camera has? Like many digital SLRs, my camera has over fifty marked shutter speeds. Yours probably has a similar number. That's a lot of shutter speeds and it can be an overwhelming number when it comes time to choose the appropriate setting for a specific situation.

That tally raises an important question: What can you possibly do with over fifty different shutter speeds?

Well, that's what this introductory chapter is all about. These pages show you some of the fantastic pictures you can take once you learn how to use the full range of your camera's shutter speeds. As you look at the photographs and begin reading, you may want to pick up your camera and experiment with some of the shutter speed settings used in these introductory pages. That's not a bad idea. In fact, whenever you get inspired by a tip or a photo or one of your own ideas, bookmark your place and go out and shoot some pictures of your own.

I'll introduce you to some major players in the shutter speed lineup, but I'm not going to bore you by talking about every single shutter speed setting. After all, there's not much difference between the results delivered by neighboring shutter speeds such as 1/15 second and 1/13 second, or 1/500 second and 1/640 second. Instead, I'll give you an overview of a shutter speed series as its duration doubles, starting with the fastest shutter speed available—1/8000 second. So the sequence of shutter speeds I'll cover goes something like this: 1/8000 second, 1/4000 second, 1/2000 second, 1/1000 second—all the way up to 8 hours.

In the discussion of each shutter speed, you'll find the subjects it's best suited for, some of the challenges it presents, some techniques associated with that shutter speed, and occasionally a bit of shutter speed history or technology. Best of all, you'll see the types of pictures you can take with each shutter speed. Keep in mind this is just an introductory chapter that shows you the power and potential of shutter speed selection: the real nitty-gritty nuts and bolts about using shutter speeds comes in the later chapters.

Although thus far I've dodged the question of why your camera has so many shutter speeds, the answer is fairly simple. Your camera has so many different settings for the same reason your golf bag holds so many different clubs and your tool kit has so many sizes of drill bits.

The answer to my question is that variety—be it in golf clubs, drill bits, or shutter speeds—allows you to match the correct tool to your situation: a driver to make a long tee shot, a sand wedge to blast out of a trap, a putter for the green. And so it is with shutter speeds: with so many settings to select from, you can confidently reach beyond your comfort zone for fresh, more-challenging subjects. You can adapt to most lighting conditions and not feel intimidated by inclement weather or poorly-lit interiors. With so many shutter speeds to choose from, you can take excellent photos in almost any situation, anytime you like, anywhere you want.

Still not so sure of that? Well, read on and see for yourself.

Selecting the right shutter speed can transform a subject. Carol Doeffinger used a shutter speed of 1/125 second (f/5.6) to transform this reflection of a bridge in the Ohio River into a colorful abstract. Photo © 2008 Carol Doeffinger

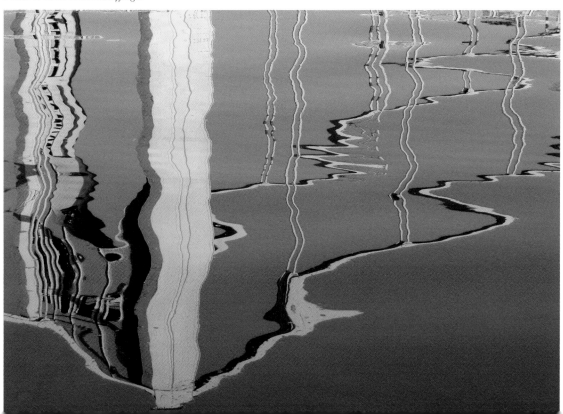

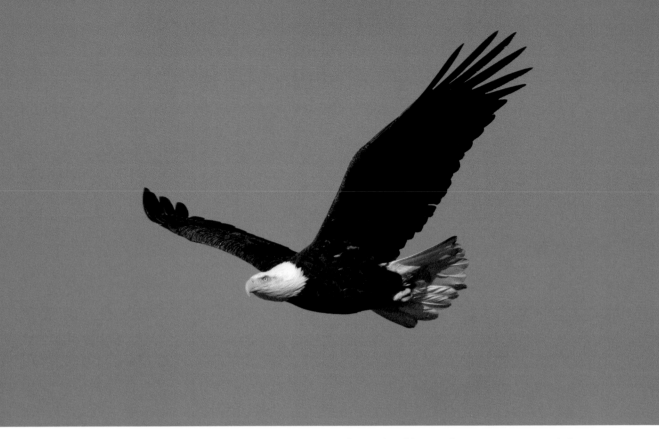

When you want to be absolutely certain to stop the movement of a fast flying subject like an eagle, set your camera to a high ISO (800 to 1200) and your shutter speed to 1/8000 second. Photo by Herb Chong. Exposure at 1/8000 second, f/5.6. Photo © 2007 Herb Chong

1/8000 Second— the shutter speed of NASA

As of this writing, the absolute fastest shutter speed available on a production model *single-lens-reflex camera* made anywhere in the world is 1/8000 second. It's blazingly fast and, not surprisingly, it's the best choice to use when you're photographing blazingly fast subjects.

It's a shutter speed so fast, in fact, that it strains your camera's ability to deliver it. To use 1/8000 second, you need to meet four conditions: a sunny day, an ISO of 1000 or higher, a large aperture lens (f/2.8 to f/4), and a board certification that indicates you're qualified to handle a camera that's faster than your brain. These are the challenges. Let's find out more about what 1/8000 second has to offer you.

What sort of jet-propelled subjects can you stop with 1/8000 second? Well, a trip to the Bonneville Salt Flats, Cape Canaveral, or the Blue Angels training grounds

can give you the answer to that question. And would there be any members of the animal world that 1/8000 second can't freeze in-flight or on-the-run? Well, neither stooping peregrine falcons nor charging cheetahs can escape its lightning-swift blink. Possibly, on a good day, the one living creature that can outrace 1/8000 second is the humble hummingbird, or to be more precise, just its rapidly beating wings.

Some human artifacts can also easily outrace this top shutter speed. As swift as it may be, not even 1/8000 second can freeze a speeding bullet—not even a slow one, with a doddering muzzle velocity of 1000 feet per second. During that 1/8000 of a second, the bullet actually moves over a full inch, thus rendering it blurred in a hypothetical photo. The only recourse to halt objects so fast that they slip the grasp of 1/8000 second is *electronic flash*. Advanced electronic flash can emit bursts as short-lived as 1/100,000 second, fast enough to make a speeding bullet dawdle even more than it does in the movie, *The Matrix*. The last two pages in this chapter talk a bit more about the stopping powers of electronic flash.

Have you ever taken a picture at 1/8000 second? Well, let's get to it. On the next sunny day that you're out with your camera, find some very fast action, set your ISO to 1200 and your shutter speed to 1/8000 second, and give it a whirl.

1/4000 Second— the shutter speed of NASCAR

This is the fastest shutter speed on many top-of-the-line consumer and prosumer dSLR cameras. (Prosumer cameras are for photographers who shoot like pros, but don't need all of the bells and whistles that professional cameras feature.) Although a step behind its 1/8000-second big brother, 1/4000 second is extraordinarily fast and more practical. It's more practical because you don't need a super sunny day or an extremely high ISO to achieve a good exposure.

Keep in mind that while you may need 1/8000 second to freeze the action of super-charged subjects, for nearly all other fast subjects 1/4000 second will do nicely. For NASCAR racers, Olympic sprinters, trampoline jumpers, speeding motorcyclists, and charging elephants, 1/4000 second can put them on your gallery wall as sharp as a tack.

To achieve a good exposure with such a fast shutter speed typically requires a bright day, a high ISO setting (400 to 800), and a lens with a fairly large aperture, such as f/4 or f/5.6. More important than the demands fast-action photography puts on the camera are the demands it puts on you.

Fast-action photography requires you to demonstrate both lightning-like reflexes and superb anticipation. Facilitate your quick reflexes with good planning by picking out a spot you know the subject will pass in front of. Then, instead of trying to track the subject with your camera, pre-focus the camera on that spot. With such fast-moving subjects, you may need to press the shutter button the instant the subject noses into the viewfinder. You should certainly set your camera for fast-sequence shooting, but don't expect the camera to think or react for you. You still need to

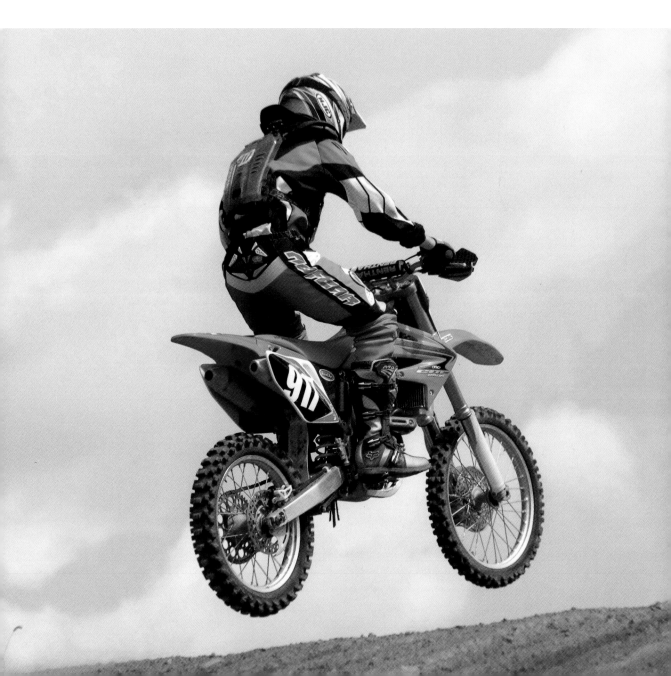

perfectly time that first picture, because the acceleration of a determined sprinter or a hungry cheetah can defeat even the rapid-shooting settings of your camera.

Many short-lived moments—slices of life—that you can't even perceive can be magically captured using this shutter speed. With your camera set to 1/4000 second, your finger poised on the shutter release and your eyes peeled on your speedy subject, some infinitesimally brief and hitherto invisible actions are sure to be revealed.

With a shutter speed of 1/4000 second, the fastest shutter speed on many cameras, you can freeze even speeding motorcycles. Exposure at 1/4000 second, f/6.3.

1/2000 Second— the optimal fast shutter speed

If I could have only two shutter speeds on my camera, 1/2000 second is one I'd insist on. Why? Well, because as the heading here says—it's the optimal fast shutter speed. The reason it's my choice for best fast shutter speed is because it's so versatile. It's an extremely fast shutter speed that can stop the majority of high-speed photo subjects that appeal to most of us—things like wave runners, motorcycles, and Triple Crown winners.

Unlike 1/4000 and 1/8000 second, which both require very bright light, you can use 1/2000 second on a cloudy day at a moderate ISO of 400 and still get a good exposure. Altogether then, shooting at 1/2000 second lets you stop the motion of most subjects under a wide variety of lighting conditions at moderate ISOs (200 to 800), to give you exceptional quality images that delight your eye. That sounds optimal to me.

But there's more. At 1/2000 second, you can handhold even a 600mm telephoto lens and get sharp results. A shutter speed of 1/2000 second counteracts the picture blur that can result from the slight movement of handholding a camera with a long telephoto lens attached, so you don't need to use—and shouldn't use—*image stabilization* when shooting fast-moving

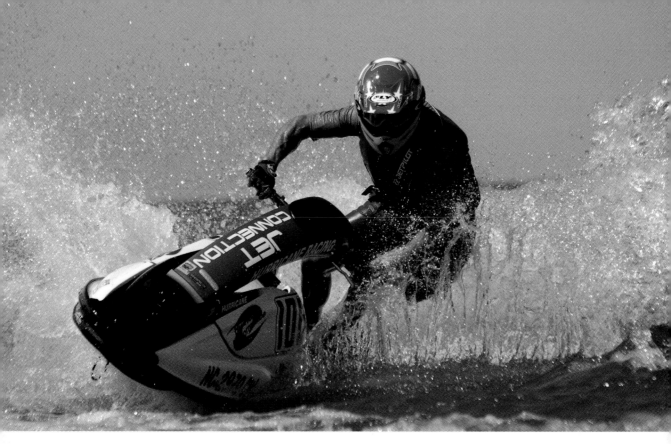

With a slightly slower shutter speed, such as 1/2000 second, you can use a smaller aperture for just a bit more depth of field. Here a sharp wake reinforces the effect of stopping the wave runner. Exposure at 1/2000 second, f/8.

subjects at this setting. Image stabilization is a fantastic technology, but in the fraction of a second it takes for the stabilization to lock in each time you focus, your subject could have slipped around the bend or have already made the winning goal.

And—just like when you open a bank account and get a free toaster—you get an added bonus when you choose 1/2000 second for your shutter speed. In this case, your bonus is having the option of using *selective focus* on a sunny day. Selective focus is the technique that relies on the shallow *depth of field* you obtain when you use a telephoto lens at a large aperture setting and focus on a nearby subject. Selective focus presents the foreground subject with emphasis because you see it sharply-focused against a very out-of-focus background. On a sunny day you achieve selective focus by using a low ISO, such as 100, a fairly large aperture, such as f/4, and a telephoto lens—all made possible by 1/2000 second.

1/1000 Second—
a former record holder

Although it's been quite a while since 1/1000 second could claim the title of the world's fastest shutter speed, it did indeed hold the title at a singular time in history. This shutter speed—once a milestone innovation—began appearing in cameras about the time Jesse Owens took center stage at the 1936 Summer Olympics in Berlin. That newfangled 1/1000 second shutter speed meant that Owens, his contemporary Sea Biscuit, and all the other speed demons of the sports world could be stopped in their tracks.

Be careful when using 1/1000 second shutter speed. It can stop fast subjects but not super fast subjects. Some of my action pictures show a very slight blur because 1/1000 second didn't quite freeze the action. Exposure at 1/1000 second, f/8.

Even today, 1/1000 second stands out among action-stopping shutter speeds. While it may be part of the old guard, 1/1000 second is no slouch when it comes to stopping fast action. It's ideal for everyday school sports like football, track, soccer, baseball, and basketball. It's the slowest setting you can use to reliably stop a high school hurdler in mid-stride. And 1/1000 second is still the slowest shutter speed that eliminates the annoying picture blur caused by handholding a camera that's equipped with a non-stabilized 300, 400, or 500mm telephoto lens.

Equally important is that on a bright day, you can use 1/1000 second with a fairly low ISO of 100 or 200 and achieve noise-free images that shout quality. Another good point for 1/1000 second is that it lets you use a medium aperture such as f/8 or f/11. Using one of these mid-range apertures works to your advantage in two ways: it maximizes image quality for most lenses by giving you the sweet spot of optical image sharpness, and it also provides your pictures with a bit more depth of field to convey sharpness in critical areas.

Yet don't put too much trust in 1/1000 second. Athletes and machines are faster than ever and when they're zipping directly across the frame, you're better off notching the shutter speed up to 1/2000 or even 1/4000 second to be sure you freeze even small details like the spokes of a racing cyclist or the eyelets on the shoes of that hurdler.

1/500 Second— a nostalgic favorite

My first single-lens-reflex camera, purchased in the late 1960s, featured a top shutter speed of 1/500 second. Back then it was the fastest shutter speed on low-end, single-lens-reflex (SLR) cameras. I had no choice but to use it whenever faced with fast action, which is why it's my nostalgic favorite.

Although half a century ago 1/500 second was a mainstay for fast-action photography, now the only fast action you should use it for is of the family variety. If you think of this one as your backyard or family-action stopper, it will serve you

Fast shutter speeds aren't only for action. They also let you use large apertures to create selective focus favored by both nature and portrait photographers. Exposure at 1/1000 second, f/5.6.

well. You can count on 1/500 second to document the prowess of budding family athletes. Whether the kids are chasing the dog or jumping into the pool, swinging a bat at a T-ball game, leaping from a swing, or catching butterflies—1/500 second can fill your family album with exceptional stop-action shots. You'll probably find that about the time your kids graduate from grammar school is also the time for you to graduate from using 1/500 second. Teens run faster and jump higher: to keep up with them, set your shutter speed to 1/1000 second.

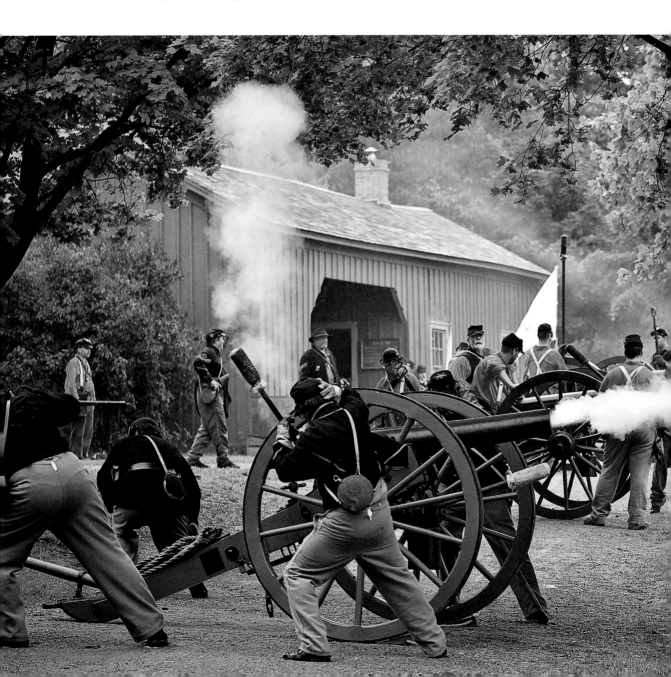

Where should you draw the limits when trying to stop fast action with 1/500 second? Let's take a look at what it can do. It can freeze joggers but not fast sprinters. It can stop weekend cross-country skiers but not downhill racers. It can halt swimmers in mid-stroke but not divers in mid-somersault as they plummet from a 3-meter board. It can render razor-sharp the pedals of your bicycling seven-year-old but not those of a cyclist sprinting to the finish line to complete the second leg of a triathlon.

But 1/500 second is Mr. Reliable when you use it with a telephoto zoom lens. As you'll soon find out, handholding a camera with a telephoto lens—even for photographs of still subjects like distant lighthouses—threatens your pictures with blur. That blur occurs because no matter how steady you are, you can't hold a camera perfectly still. But you can use a fast shutter speed like 1/500 second to counteract your slight movement. Whether you're using your telephoto to photograph squirrels comically dangling from your squirrel-proof bird feeder, a sailboat sliding in front of a setting sun, or the distant Statue of Liberty, set your shutter speed to 1/500 second and sharp pictures will follow.

Although 1/500 second may seem like a blast from the past, its past is based on the highest of pedigrees. It was first offered in the early 1930s on a Leica camera. Through the years, Leica's cameras and lenses have, like Apple's computer products, gathered a small but fanatical following of collectors. The long and storied history of Leica began in the 1920s and their innovations are still reflected in the digital age.

An experienced re-enactment photographer, Stewart Hecht favors a shutter speed of 1/500 second to reveal the powerful discharge of Civil War artillery. Exposure at 1/500 second, f/4. Photo © 2008 Stewart Hecht

1/250 Second—
the all-purpose shutter speed

If this shutter speed wanted to be your only shutter speed, its campaign slogan would be: "1/250 Second - Set it and forget it." Although it may not come replete with a screw driver, tweezers, corkscrew, toothpick, saw, scissors, and bottle opener, 1/250 second functions like the Swiss army knife of shutter speeds.

When you don't know what sort of photo opportunities lie ahead, 1/250 second is the shutter speed you want to be packing. It's a great shutter speed for photographers on the prowl. Whether you're strolling along the streets of Paris or following your dog as he explores the paths winding through the local park, with this setting your camera can cover a variety of everyday and once-in-a-lifetime situations. Whether you decide to play paparazzo with street jugglers and mimes, catch tourists hanging off cable cars, or coax your kids into pausing for a playground portrait before they careen down the slide, 1/250 second fills all those needs and more.

It's not the first, nor even the second choice for action shots, but a shutter speed of 1/250 second is not powerless to stop moderate action. What kind of action can it stop? Let's say a jogger, a kayaker, kids tossing bread bits to the ducks, or an old dog lumbering after a tossed stick. But don't expect it to keep up with kids throwing

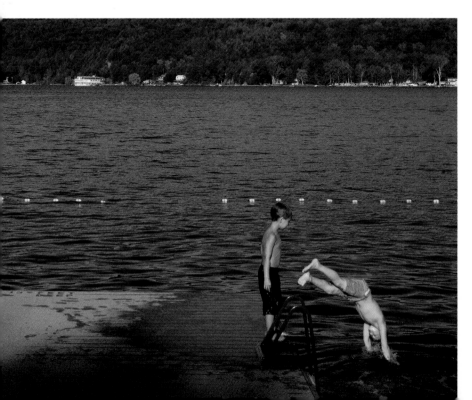

For casual photography, be it everyday action like a boy diving into a lake or a souvenir shot of a tourist landmark, a shutter speed of 1/250 second gives you both moderate depth of field and action-stopping ability.

Exposure at 1/250 second, f/8.

Exposure at 1/250 second, f/18.

fastballs or a recently-retired greyhound dashing after a Frisbee. Nor can 1/250 second freeze a speed skater streaking across the finish line or your teen flying off a snowboard ramp.

But it's the fastest shutter speed you'll likely use for the popular action technique of *panning*. Panning conveys motion by imparting selective blur to a picture. When panning, you take a picture while tracking the camera in synch with a moving subject like a bicyclist or wave runner—the camera movement blurs the background but shows the subject fairly sharp because you were tracking it. You can use 1/250 second when panning fast subjects like race cars, airplanes, speed boats—or me on my bicycle.

Another advantage of 1/250 second is its ability to deliver sharp pictures when you use a moderate *telephoto zoom lens* (say 70 to 200mm) to offset that camera shake I keep mentioning. It's a shutter speed often favored by your camera's *Program mode* because it allows a medium aperture choice, such as f/8 or f/11, thereby striking a balance between shutter speed and aperture. A shutter speed of 1/250 second is fast enough to stop moderate action and the medium aperture is small enough to provide sufficient depth of field to better assure the subject is sharp.

On many dSLR cameras, 1/250 second is the fastest shutter speed you can use with electronic flash. Use 1/250 second with flash outdoors on sunny days when photographing people. The light from the flash fills in harsh shadows under the eyes, nose, and lips to create more pleasing pictures. Compared to 1/60 and 1/125 second, 1/250 second in combination with your flash lets you use a larger aperture to throw the background out of focus and make your portrait subject stand out better.

Okay, here's your one-question quiz. What shutter speed should you set your camera to when you're not sure what photographic adventures await you?

1/125 Second— for the scenic shooter

The poor cousin of 1/250 second, 1/125 second is another all-purpose speed, one you can easily use on both sunny and cloudy days. The difference in how you use 1/250 and 1/125 is subtle but telling. At 1/125 second you've reached a threshold of sorts, the boundary where you are less concerned about stopping movement and more concerned about achieving greater depth of field to give your pictures overall sharpness.

The forte of 1/125 second may well be landscape photography on bright days. You see these pictures everywhere—those great postcard scenes you find at souvenir shops from the beaches at Waikiki to the Grand Canyon to Mount Katahdin in Maine. Calendars and travel books feature national parks and vistas of scenic byways. What do all those pictures have in common? Total photo sharpness. From foreground to background, everything is sharp. And how do you achieve such sharpness? Use a small aperture, such as f/16 or f/22, to create extensive depth of field. (Using a wide-angle lens, too, can help you achieve more depth of field). On a bright day, the companion aperture for 1/125 second will almost certainly be f/16 or f/22. But let the clouds roll in or the sun slip below the horizon and you may need a boost from a higher ISO setting to keep a good exposure at 1/125 second.

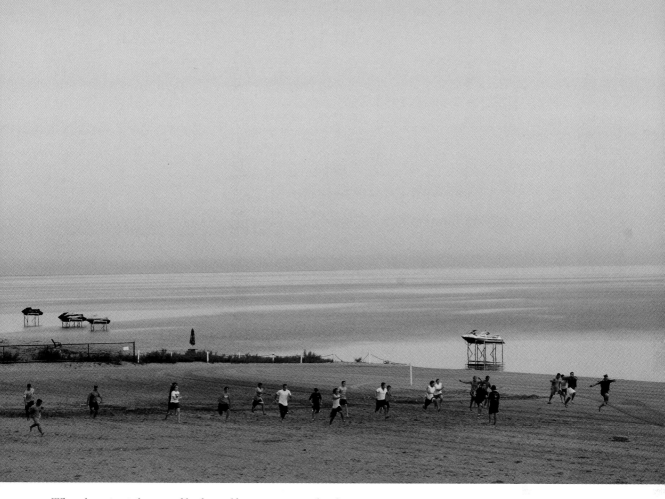

When the action is far away, like these athletes training on a beach,
even 1/125 second can freeze it. Exposure at 1/125 second, f/11.

Although 1/125 second may be a benchwarmer in stop-action photography, it's still a first stringer on the action photography team. That's because it excels as the primary shutter speed to use when panning fast subjects. With your camera set to 1/125 second, you can pan a horse galloping to the finish line or a bicyclist racing downhill, and the results will show each subject sharply against a blurred background. And 1/125 second is another good shutter speed to use with flash, especially *fill flash* outdoors on an overcast day.

The exceptional image quality from the higher ISOs (800 to 1200) available on newer dSLR cameras has rejuvenated 1/125 second. Those higher ISO settings often let you use 1/125 second in dim locations like art museums, giving you the ability to get sharp pictures without a tripod.

A shutter speed of 1/125 second excels for sunny day landscape photos because you can use a small aperture such as f/16 to give your pictures front-to-back sharpness Exposure at 1/125 second, f/16.

You've read all the good things about 1/125 second, now let's go over a few of the cautions. It's too slow to stop anything faster than mall walkers, so consider yourself forewarned: when the toddlers head out for playtime, 1/125 second probably won't stop them. If your camera is set to *Auto exposure mode* or *Program mode*, keep your eye on the shutter speed when shooting moderate to fast moving subjects. If the shutter speed falls to 1/125 second, boost it back up to 1/250 second or higher by increasing the ISO or setting a larger aperture (smaller f-stop number).

And finally, know that 1/125 second can't eliminate the picture blur that results from handholding a telephoto lens with a focal length longer than 135mm—unless that lens incorporates image stabilization technology. If it does, then 1/125 second is probably a safe speed to get sharp pictures. If it doesn't, then put your camera and its telephoto lens on a tripod to insure sharp results—or use a faster shutter speed.

But let's not end on a negative note. Because when you're on a hiking trail—like the one that connects the coastal villages of Italy's Cinque Terre—and you pause to admire (and just maybe photograph) the splendorous vista, you'll be sharing that magnificent and magical moment with none other than your beloved travel companion, 1/125 second.

1/60 Second— when the light dims it shines

When the skies darken or you head indoors to make a portrait using the soft light of that big north-facing window, you'll likely find 1/60 second waving its hands for your attention. That's because this is the premier shutter speed for taking pictures in moderately dim light—you know, those times when you take off your sunglasses but don't yet need to turn on the lights.

Think of 1/60 second as both your cloudy day shutter speed and your indoor existing-light shutter speed. It's slow enough to let in sufficient light to make a good exposure on a dim day, but fast enough to let you conveniently (if you're careful) handhold the camera in most situations. In other words, when sunny old England reverts to its gloomy skies, 1/60 second will let you capture the magnificence of mansions and the melancholy of moors alike.

Would it be a bit mundane to suggest that 1/60 second functions like a reliable neighborhood handyman? The guy who's always available to clean out gutters and repair that broken tread on the stairs? Probably. So let's not underestimate 1/60 second's skills. A more appropriate comparison would be to suggest that 1/60 second

shines as the understudy who can step into a starring role when conditions seem a bit too dim and dreary for the faster shutter speeds that usually star in your pictures.

But there is one place where 1/60 second sheds the understudy role to become the star, and that's action photography. But not stop-action photography, because even a toddler can outrun 1/60 second. Instead, 1/60 second stars in the lead role of panning. And boy can it grab your eye and rivet your attention. You might not think being a single stop slower than 1/125 second would make much difference, but here it does. Use a shutter speed of 1/60 second when panning subjects of fast and moderate speeds and you can add an extra brush of breathtaking blur to your panning shots.

When the snow flies, I especially like 1/60 second for its ability to show the individual, crisp flakes of a snowstorm, as if a giant cereal box in the sky was pouring out its contents. A slower shutter speed like 1/15 second turns the flying flakes into streaks. Exposure at 1/60 second, f/8.

This shutter speed also excels for taking indoor portraits by window light. People look great when illuminated by soft, indirect (no harsh sunshine) window light. Eyes open wide and twinkle, skin tones radiate a healthy glow, and hair shines gently.

But for a handheld camera, 1/60 second brings an inherent risk of camera-shake blur. If you're extra steady or using an image-stabilized lens, you can probably still feel comfortable about getting reasonably sharp pictures while handholding the camera. But if you're truly quality conscious or like to enlarge your pictures to 8x10 inches or larger, then consider using a tripod or other support when you shoot at 1/60 second, especially if you're using a telephoto lens. Your pictures taken with a tripod will vibrate with sharpness and color.

Ideal for portraits, soft, indirect window light often requires a slower shutter speed such as 1/60 second. If you are working without an image-stabilized lens, use a tripod or other support to obtain sharp pictures. Exposure at 1/60 second, f/6.7.

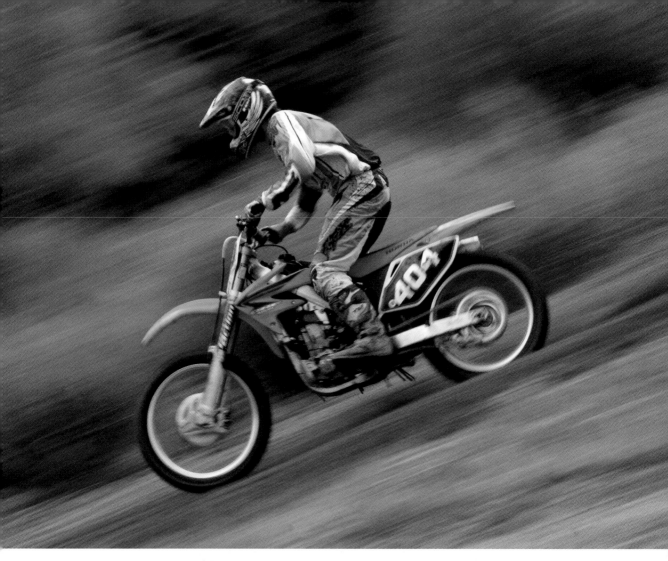

Whether I'm photographing a horse, a motorcycle, or a snowboarder, I love to pan the camera to capture moving subjects. Panning creates that wonderful speed-suggesting background blur. Exposure at 1/30 second, f/16.

1/30 Second—
the optimal slow shutter speed

Okay, remember when I said if I could only have two shutter speeds on my camera 1/2000 second would be one of them? Well, the other of my two speeds would be, I suppose, well, I guess it would have to be 1/30 second.

I say that with some hesitation, because 1/30 second is a tad slow for everyday photography. It's not as versatile as 1/60 second nor as fun to pal around with

as 1/125 second. And using it carries some risk—by now you know I'm talking potential picture blur caused from handholding the camera at a slow shutter speed. But even more than 1/60 second, 1/30 second is a shutter speed that greatly expands your picture-taking opportunities because it enables you to get *correct exposures* even in dim light.

Of course, you could use flash, but existing-light pictures are infinitely better. Natural light, because it conveys the ambience of a place, can be extremely attractive. Think of early morning light and how it pours through jewel-tinted windows of a cathedral. Or see how light falls softly through the open door of a barn, highlights an object inside, and then creates additional picture interest as it fades into darkness at the rear of the barn.

Unless you're one of those people who have developed their own personal biceps-building, image-stabilization improvement program (holding both arms straight out while clasping 16-ounce jars of Skippy peanut butter hasn't worked for me), using a 1/30 second shutter speed while handholding the camera can be quite risky. To successfully take existing-light pictures at 1/30 second, you need a support for your camera (such as a tripod, chair, or railing), or you need to take your pictures with an image-stabilized lens.

Perhaps the greater risk of blur comes from subtle, nearly imperceptible, movements of the subject and from any unwanted activity in the foreground or background of a scene. Posing by the window, your mother nods her head slightly; a bee brushes against a flower; the cat twitches its whiskers—though they are slight movements all—they're enough to create a distracting blur when you're shooting at 1/30 second. When this shutter setting is in use, a warning sign on the camera's LCD should flash: "Attention: If not used with proper care, 1/30 second may be hazardous to your picture health."

On the other side, a 1/30 second shutter speed can really boost your photo health when it's used for the action technique of panning. For those of us who pan neighbors mowing the lawn or dashing out in their jammies to retrieve the morning paper from the driveway, 1/30 second exaggerates the sense of motion and creates some excitement otherwise lacking from an event. If your neighbors are never outdoors, or voice an objection to your photo habits, be resourceful and take your camera further afield. Give 1/30 second a try for any subject moving slower than 30 miles per hour.

1/15 Second—
where subjects blur themselves

You probably think of yourself as a fairly normal person with a fewer-than-normal number of idiosyncrasies—some appealing and some not. (The jury is still out on that bird seed in your hair trick you use to attract the backyard chickadees). But the moment you set your camera to 1/15 second, the normal person you think you know so well morphs into that wild and crazy thrill seeker, *Photo Guy*.

Blame it all on 1/15 second. It's a shutter speed that pushes you to the brink of wild and crazy blurriness. At 1/15 second and slower shutter speeds, your exposures begin to trade predictability for possibility. Your pictures start to make irresistible "vroom, vroom" sounds and, from that moment on, you'll be creatively blurring away as you bring all your action techniques into play. The results may surprise you.

Surprise was the essence of that old Monty Hall game show, *Let's Make a Deal*. If you remember, contestants faced three closed doors and had to blindly pick the prize behind one of them. You play a similar game of chance when you take photos at 1/15 second: the prize picture you think you took may well turn out to be terrific, or just tolerable, or really terrible. It's the possibility for surprises that make 1/15 second a shutter speed to choose for artistic expression.

At 1/15 second with the camera supported and focused on one spot, a fast-moving subject smears across the picture like a swoosh of finger paint. Slow-moving subjects or those with only some parts moving, a fast-fingered fiddler, for example, may reveal intriguing areas of sharpness mixed with blur. This targeted sharpness can be a haunting effect at 1/15 second. (Try this, too, at even slower shutter speeds. It's very compelling.)

This is a good shutter speed to use for panning slow-moving subjects like joggers and toddlers, but a word of caution: your photograph may seem carelessly out of focus if you don't track the subject accurately with your camera.

As daylight fades, 1/15 second begins to brighten. Think of a full moon rising through deep blue twilight. Make a study of rowboats tied up at a dock and see how they appear under the glow from a still bright evening sky. Watch as the barn on the ridge burnishes a deeper red under the fiery clouds of sunset.

When snow covers the ground, I like to photograph still lifes indoors by natural light. Since most of the subjects are close to the camera, I use very small apertures (f/22 for this picture) that often require a slower shutter speed, such as 1/15 second. Exposure at 1/15 second, f/22.

But whatever you do, bring out the tripod when you want your pictures to be extra sharp.

Sure, image stabilization technology may tempt you to leave the tripod behind. Sometimes you'll get away with it, but don't make a habit of trading in your tripod for image stabilization at slow shutter speeds. In churches and city halls—if you're without a tripod, support your camera on a pew or chair or railing. You may dodge the angry gods of camera shake for a while but eventually they'll give your camera an unwanted hug.

Carnivals offer bright lights and lots of motion. Here I panned the overhead swings as they seemed to fly into the Ferris wheel. Exposure at 1/15 second, f/5.

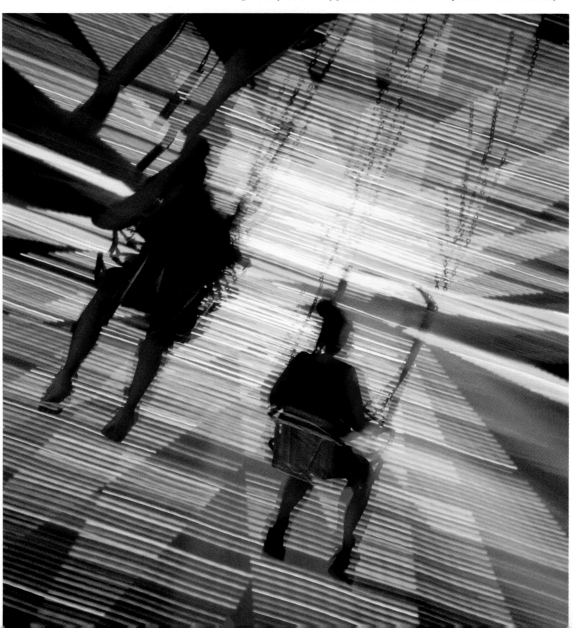

1/8 Second—the blessing of the blur

With your camera set to 1/8 second, you have two choices: find some moving subjects and stir up some serious impressionistic motion blur, or use a rock-steady tripod to make sharp renditions of immobile subjects.

If a 1/15 second shutter speed introduced you to the world of motion blur, 1/8 second immerses you in it. At first you might think that the expression "motion blur" refers to panning with the camera—and it does. But not exclusively: you can also immobilize the camera, then use a 1/8 second exposure to let the subject's movement blur itself while keeping the rest of the picture sharp. This, then, is the

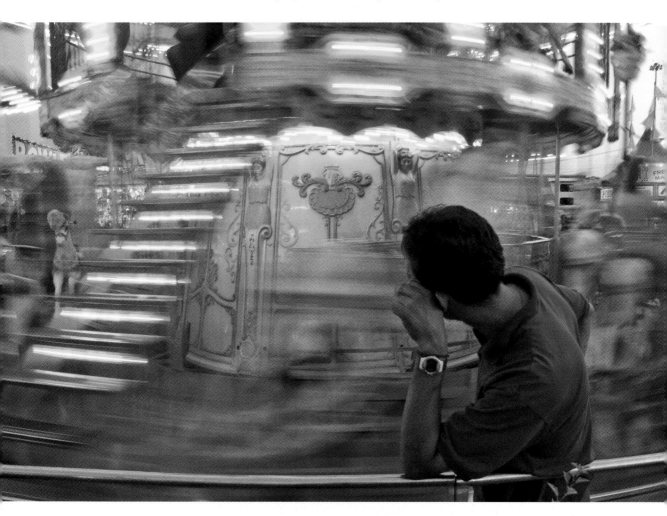

With the camera set to a shutter speed of 1/8 second, I used a picnic table as an impromptu tripod to keep the bored ride attendant sharp as the spinning merry-go-round blurred itself. Exposure at 1/8 second, f/8.

shutter speed that "softens" waterfalls and gives them that tasty cotton candy look. Against a sharply-focused background, dancers, jugglers, drummers, and pirouetting ice skaters sweep you up in a swirl of blur.

Panning at 1/8 second challenges your skill to smoothly track the camera in alignment with a subject: look through the viewfinder and lock onto the subject like you are an equatorial mount on an expensive telescope. If you succeed, your reward will be a rocketing rush of background blur that seems to push your sharp subject into warp speed.

Brrr. My friend Gary Whelpley took this picture of an ice fisherman at twilight while we were putting together a travel photo book on New York State's Finger Lakes. Exposure at 1/8 second, f/5.6. Photo © 2005 Gary Whelpley

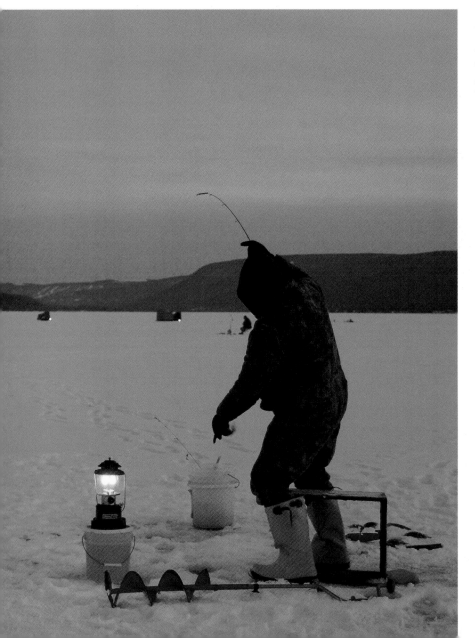

A firm camera support (hint, hint—get a tripod) is a necessity for shooting pictures that show subject blur against a sharp background.

There's more to life for this shutter speed setting, of course, than a constant daze of blur. Choose 1/8 second when you have dim light and you need small apertures like f/22 to expand the narrow depth of field inherent when taking indoor still lifes, close-ups of flowers, or portraits of insects. When you're shooting outdoors, watch out for even tiny puffs of air. They may cause a flower to shiver and give

Drummers, fiddlers, dancers, piano players, and many other performers blur attractively at slower shutter speeds. Exposure at 1/8 second, f/32.

you the dreaded blurs. Wait for absolute stillness, brace your subject with a stick, or shield it with an impromptu wind block such as your coat or your body before you take the picture.

This and other slow shutter speeds give even tripod shooters a challenge: to achieve sharpness, you need to master techniques that minimize camera vibrations. When trying to achieve sharp pictures of city skylines, rocky seashores, or twilight mountain ranges, you need to release the shutter without rocking the camera—not causing even the slightest nudge. This is especially crucial if you're using a telephoto lens. Whether you choose the self-timer, a remote release, or the delayed release mode, you need to reduce (best of all eliminate) the camera vibration that subtly destroys sharpness in a picture.

Like the drumming picture taken at 1/8 second, the slightly slower motion of dancing becomes a kinetic group callisthenic at 1/4 second. Exposure at 1/4 second, f/13.

1/4 Second— the poet laureate of motion pictures

The simple reality is that if you're using 1/4 second for your shutter speed, either the sun has set, storm clouds have swept in, or you've stumbled into a cave. Or, possibly, you've gone over to the dark side and attached a light-blocking *neutral density filter* so you can achieve the slow shutter speed necessary for extraordinary motion-blur effects. If 1/4 second intimidates you as much as it does me, remember this simple fact: it's about the same length of time it takes for your own shutter, the eyelid, to open and close.

The rewards of 1/4 second can be enormous. Many a waterfall photographer feels lucky to work in lighting conditions that allow the luxury of a 1/4-second exposure, because it softens the flow of falling water. If you master 1/4 second in your motion studies, then the title "Impresario of Impressionism" or "Master of the Abstract" could well belong to you. At 1/4 second, whether

you choose to pan or use another shutter speed technique, photographing motion becomes an act of faith.

Some technology infatuates still believe 1/4 second suffices for practical photography. They are the diehard and disillusioned handholders who make a last ditch effort at getting a sharp image by overtaxing their image stabilization system and assuming their most rigid statue-emulating poses. They'll have little luck unless Medusa reaches out and touches them an instant before they take the picture.

At 1/4 second, you're entering the world of time exposures. Technically all photos are time exposures, but those that use a significantly longer time than required for the normal daylight photo are considered true time exposures.

Using a tripod, you may still be doing some conventional photography at this level, such as photographing dim interiors or foggy coastal settings, but you've begun to face some creative and technical issues. Artificial lights can cause *white balance* and exposure accuracy problems, especially against dark surroundings.

If such issues don't faze you, come join the elite club of the few who venture into the dark. You'll discover darkness brings its own unique pleasures—especially for photographers in search of special effects. The extended darkness late in the year brings on a carnival of multicolored holiday lights. I drive around looking at displays and when I find a particularly impressive one, I sweep or swirl my camera across it to create joyous streaks of light.

As you explore the nether world of night photography and 1/4-second exposures, don't be surprised if you occasionally stumble because you are, after all, in the dark.

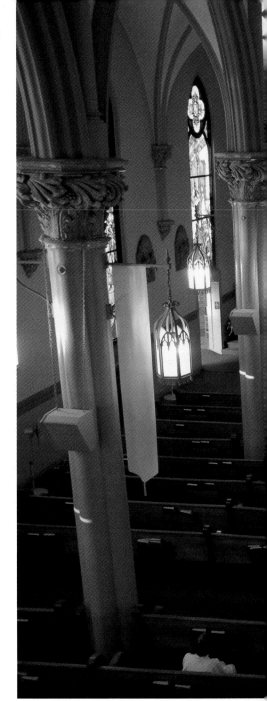

Light streaming through the windows let me use a 1/4-second shutter speed to capture the interior of this church high on Mt. Washington overlooking the Pittsburgh skyline. Yes, I used a tripod. Exposure at 1/4 second, f/5.6.

Although it may simply seem dark to you, to a camera collecting light for 1/2 second, late twilight paints the sky with intense oranges and blues that seem incredibly soothing. Exposure at 1/2 second, f/8.

Slow shutter speeds turn the many distinct braids of a waterfall into a smooth and enticing ribbon of white. To minimize camera vibration, I used the camera's selftimer and Exposure Delay mode; the delay mode minimizes vibration-induced blur by not opening the shutter until about two seconds after the mirror inside the camera flips up. Exposure at 1/2 second, f/25.

1/2 Second—
where writing with light becomes reality

What do you do with a half-second exposure? Maybe the best place to understand your photographic opportunities with 1/2 second is to begin by understanding (and appreciating) the origination of the word "photography." Photography is based on two Greek words, *photos* and *graphos*, which, when combined, mean writing with light. Technically, all photos are written with light reflected from a subject onto your camera's light-sensitive sensor.

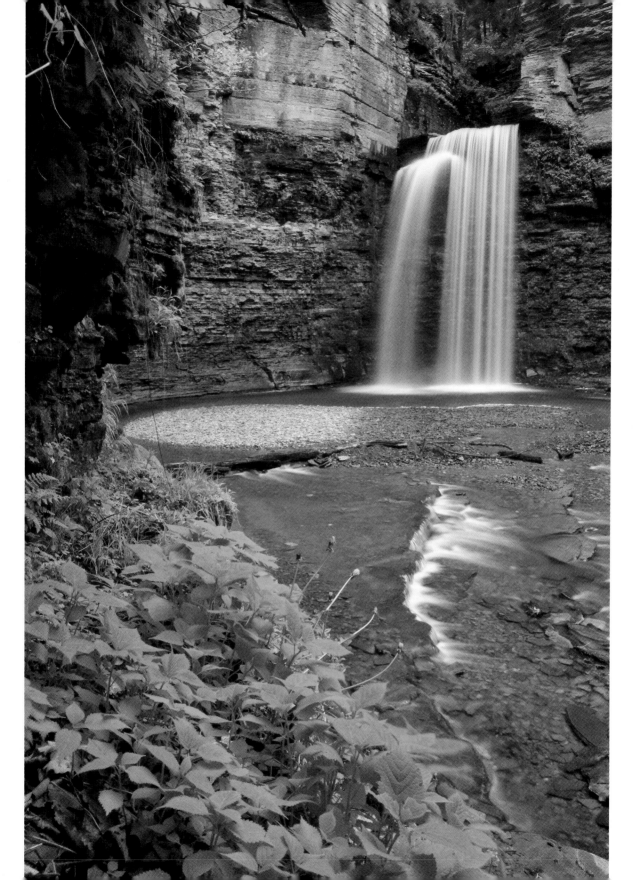

But if you take the meaning of "writing with light" more literally you might begin to see some picture possibilities. At slower shutter speeds writing with light becomes a reality as moving light sources pen their paths across the camera's sensor. Car taillights leave pairs of bright red trails, fireworks stitch brilliant threads across the sky, and stars and satellites etch their silver routes against the dark. In somewhat brighter conditions of daylight and lamplight exposures, walking people become ghostlike at 1/2 second, cyclists dissolve beyond recognition, and speeding cars vanish without a trace.

At 1/2 second, expect the unexpected. You're on the verge of breaching the time barrier of 1 second. Even now the photo weft may begin to warp as the goblins of motion and physics squirm out between the pixels and initiate their antics. If you are photographing still subjects in dim light, prepare to boost the ISO to 400 or 800; you may want to turn on the camera's built-in noise reduction to reduce the annoying colored sprinkles of *electronic noise* that may spatter across your photos. (This problem is most obvious in the darker uniform areas of a picture.) The amount of noise increases at longer exposures and higher ISOs, and becomes prevalent in pictures made with snapshot cameras.

At 1/2 second shutter speed, that sturdy tripod becomes a fixture. If daylight begins to fade into darkness while you're taking pictures, work quickly before it disappears. Carry a miniature flashlight in your bag in case the sky turns pitch black before you finish; you may also want to add one of the hands-free, hiking headlamps to your equipment bag. Your camera manual explains how to activate the illumination setting for the LCD panel on your camera. In the dark you really don't want to have to guess which shutter speeds you're setting.

1 Second—
breaking the time barrier

One Mississippi, two Mississippi… At a shutter speed of one second you step into human time. Who can really understand what instantaneous events might occur within 1/8000, 1/1000, or even 1/100 second? But one second puts us into familiar everyday human time. Whether we're counting off by seconds for a game of hide-and-seek or watching the final moments of a football playoff game, we're comfortable with time intervals measured in seconds.

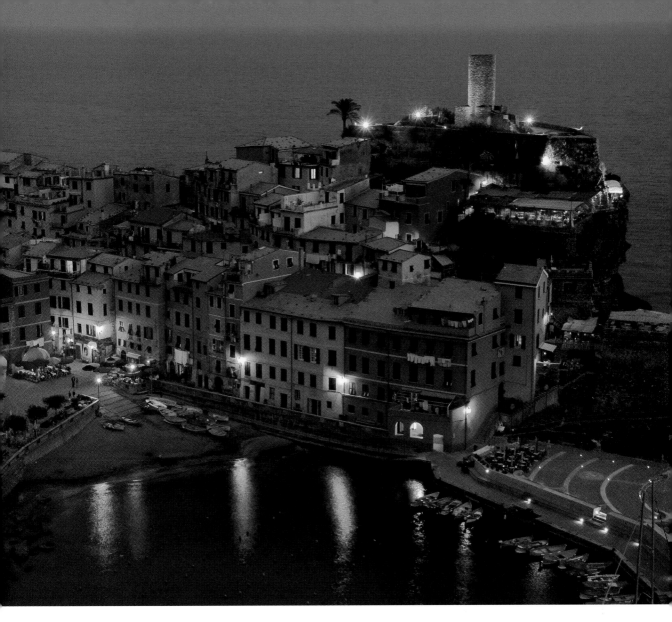

Vernazza, one of the small villages of Italy's Cinque Terra region, glows with lights as twilight deepens. Shooting in the RAW file format mode makes it easy for you to later decide whether you want the warm color balance of the village lights or the cool blues of twilight—or something in between. Exposure at 1 second, f/4.8.

For the camera, one second is both an eternity and a rarity. When was the last time you set your camera to one second? What was your subject and what other subjects might require a 1-second exposure?

The most attractive photos created in a second or two tend to be taken after dark. Fireworks look great. In a second or two or ten or twenty, multiple bursts of aerial explosions collectively form a bouquet of sparkling blooms. The bright lights of

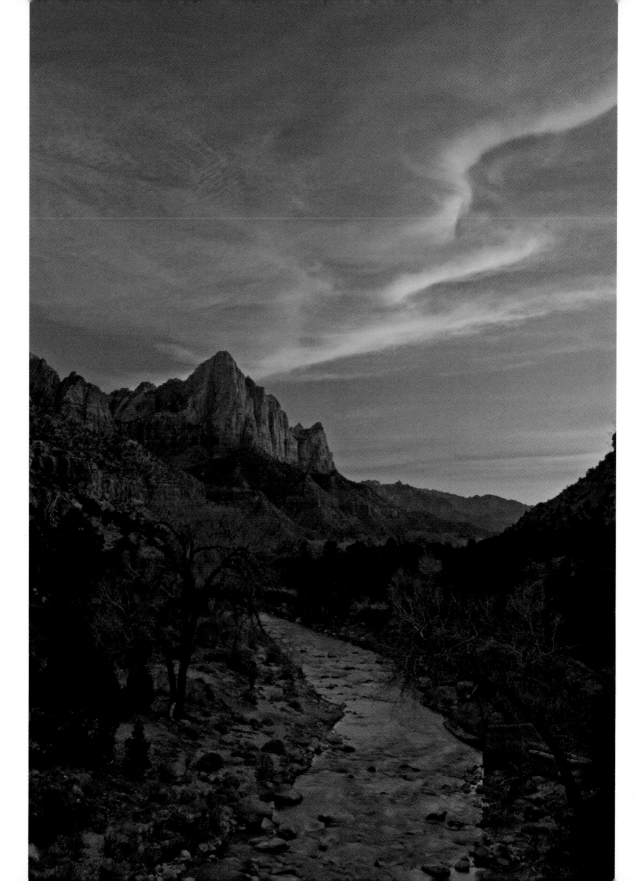

At the south end of Zion National Park, the Virgin River runs between the road and the canyon walls, affording you easily-reached spectacular sunset landscapes. This photo was taken in early March with an exposure of 1 second at f/11. Exposure at 1 second, f/11.

Ferris wheels, carousels, and other carnival rides whirl round and round; in just a second your camera can record the brilliant colored circles and ellipses they're carving through the dark sky. Armed with Fourth of July sparklers or small flashlights, children can paint pictures or write messages in the dark that only a camera can capture.

Dedicated landscape photographers (some seen only when the sun hovers a little below and a little above the horizon) frequently play with exposures of one second and longer. Not for them the harsh burning orb of midday: they venture out only for the sensuous, subtle light and lengthening shadows that caress the worlds of twilight and dawn. (Shamelessly poetic, but I've run out of sports jargon.)

And shortly before dusk, another group of photographers who fancy exposures of 1 second and longer can be found gathering along the rims of vast canyons and on the terraces of city overlooks. (Because some of these scenic places get crowded, you can very quickly find yourself in competition for one of the prime spots to set up a tripod.)

You'll also find photographers who favor long shutter speeds indoors, too. Interiors like poorly-lit cathedrals and centuries-old landmark buildings present some great opportunities for capturing images of highly-detailed statues and ornately-painted ceilings. However, the mixed contrast of brilliant artificial lighting and dark recesses or corridors can mean a struggle to balance exposure and white balance. Both problems can be minimized by shooting in the RAW file format or using HDRI (*high dynamic range imaging*).

The new multi-exposure techniques of HDRI give you vastly improved photos that reveal details in the deepest shadows and brightest highlights. You take three to ten shots of the same scene, varying exposure each time—long exposures to show details in the dark areas, medium exposures for the mid-tones, short exposures for the bright areas—and then use software to combine the differently-exposed images into one final photograph that shows a full range of tonal detail.

And some very creative motion photographers struggle to capture meaningful photos as they reach the threshold of their art. At 1 second, time exposures of moving vehicles in the dark cut long swaths of light across the image, making abstract patterns. The technique of panning can be used to swirl images towards oblivion, while zooming can still be effective even as it becomes more experimental and difficult to render a recognizable image.

1 Minute—
reenact exposures of the "ancients"

Admittedly, using the word "ancients" to describe photographers of the 1860s may be a stretch, but there's no questioning they were among the pioneers of photography, an occupational field that expanded rapidly when short exposure times like one minute and less became practical. This era found many photographers documenting the broader world to the delight of everyday folk who could not afford long and expensive travel by train or steamer. Photographers often spent weeks traveling to their exotic destinations, hours setting up for a single shot, and several minutes preparing each glass plate for a single exposure.

As the decades slipped by, the time required for ordinary tasks shortened considerably. The time for long distance travel shrank from days to hours, for cooking from hours to minutes, for round-the-world communications from weeks to a few seconds, and for photographic exposures from minutes to fractions of a second. By the turn of the 21st century, a single minute seemed a lengthy duration during which much could be accomplished.

In our world of multi-tasking and one-minute managers, a sixty-second wait is annoying. You release the shutter, and as you begin your one-minute exposure, you start to worry about the time wasting away. Doubts and to-do lists assail you. Why haven't you painted the bedroom or finished that online business course? After 45 seconds goes by, you pull out your Spanish-language pocket guide and recite a few vocabulary words.

So why would you, today, want to use a whole minute or more to expose a single picture? It's because some worthwhile things, like the ripening of a pineapple or the blossoming of a tulip, still take time. Wait a minute or longer with your camera pointed at the right subject, and you might "grow" some pretty amazing photos. You could set up your camera in the back of the open van and aim at distant lightning forking across the night sky. Or you could turn the crashing late-twilight surf into a dreamy wash of color as a lighthouse beacon flashes in the background. You may just want to invoke the magic of an extra-long shutter speed to make moving subjects

Like a bucket placed under a slow-dripping faucet, a long exposure can gradually collect light where it seems there is none. In fact, if the exposure is long enough, it's possible to produce brightness out of darkness. This 30-second exposure in Antelope Slot Canyon shows that effect. Exposure at 30 seconds, f/14.

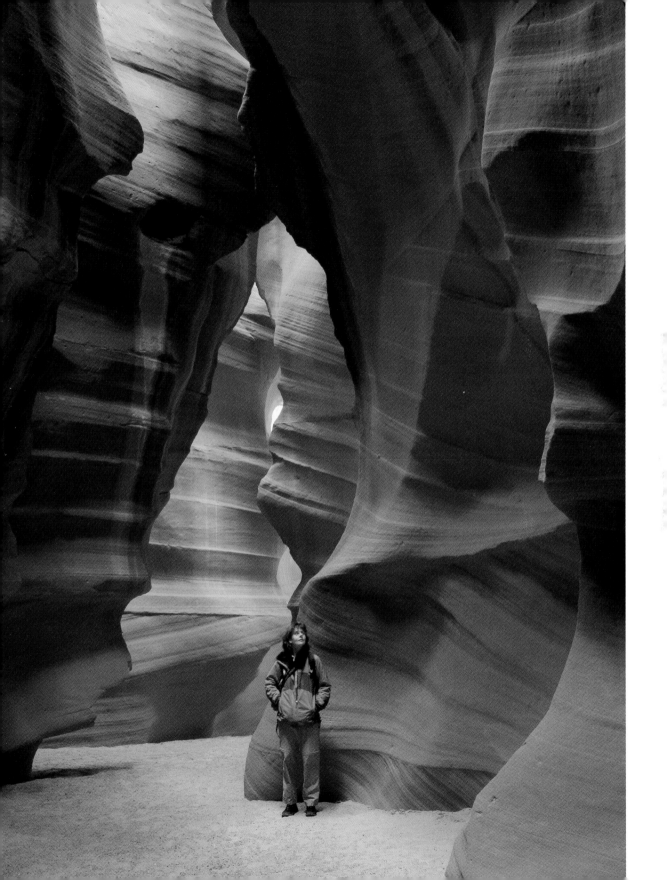

disappear from a scene. When such subjects are of average brightness and travel through the scene for a small fraction of the overall exposure, they simply are not recorded, as demonstrated in this photo of Grand Central Station.

You could be a desperate dying-light landscape photographer and hope for one more minute of the day's last gasp of light, the kind of light that coats the late evening with a precious shine that your camera intensifies.

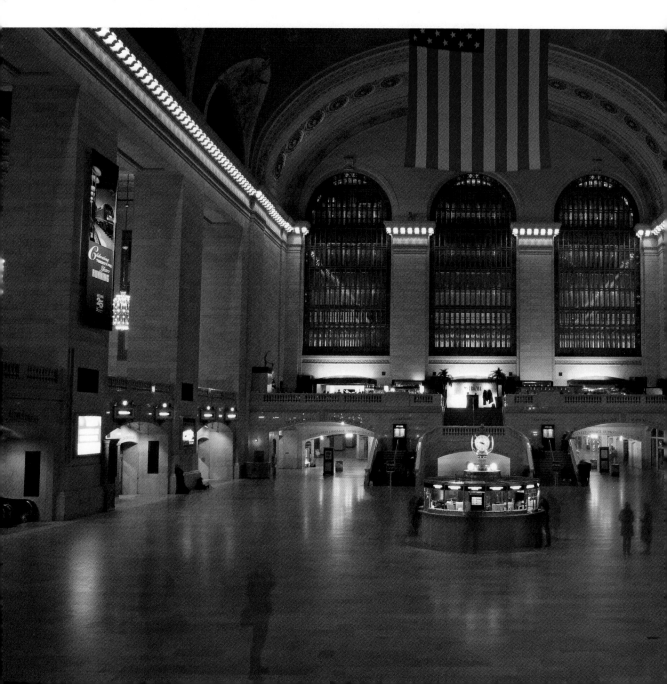

More likely you're an astrophotographer aiming your tripod-mounted camera at the nighttime sky. With your ISO set to 400 or 800, you can catch the International Space Station as it streaks by and create a picture that shows it as a brightly curving arc reaching across the entire sky. You can turn the faint glow of Northern Lights into brightly shimmering curtains of light, and—if you wait until after midnight around August 11 every year—you can put in your pocket the sparking trails of falling stars from the Pleaides meteor shower.

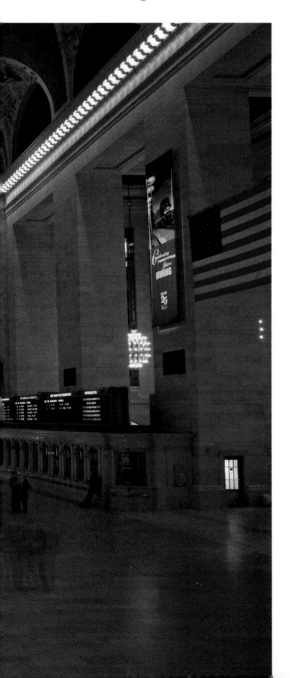

One thing you're probably not doing with a few extra minutes is making portraits like the "ancients." They were thrilled when new and improved methods came along that shortened exposure times from the length of a sitcom to that of a commercial. When exposure times became short enough to make photo portraits practical, costs dropped and itinerant and store-based studio photographers became the rage. Everyday folk, for whom painted portraits were far too costly, found they could well afford photographic likenesses.

Here's Grand Central Station at rush hour. If you've ever doubted the camera's ability to see things you don't, here's proof. Hundreds if not thousands of people scurried through the station to catch their trains home during Herb Chong's six-minute exposure on a Tuesday at rush hour. To block enough light to allow such a long exposure time, he used a 10x neutral density filter. Exposure at six minutes, f/11. Photo © 2008 Herb Chong

8 Hours—
put your camera on the "C" shift

You'll not find a shutter speed setting for eight hours on most cameras. Instead you trigger the "Bulb" setting to start the exposure and then release it when you're done.

Make an eight-hour picture and you can say you used the same exposure time used for the first photograph ever taken. That picture was taken in France in 1826 by Joseph Nicéphore Niépce. On a sunny day he aimed his camera out a second story window. The subject of this momentous occasion—the first thing to ever be photographed—was none other than the roof of a pigeon house.

Niépce made his marthon exposure on a light-sensitive material that's a type of asphalt called bitumen of Judea. Sadly, the early promise of Niépce's first picture never blossomed. You could acquire a tan faster than he could take a picture, and—although Niépce experimented for the rest of his life—he never found a more practical material to replace his asphalt-based coating.

For what would you use an exposure time of 8 hours? Well, to track the rotational movement of the earth, of course. In other words, you'd make star trails. Point your camera at the North Star and keep the shutter open for several hours. You'll get concentric circles. Point it away from the North Star; now the light trails left by stars will be straighter. While your camera sits motionless, the earth relentlessly rotates and that's the movement that makes the stars above seem to travel across the sky.

A digital camera will add a large amount of noise for this length of exposure. If you want to make exposures of several hours, you're better off using a film camera. On a dark clear night, use a firm tripod, an ISO of 200, a 24 to 35mm wide-angle lens, an aperture setting of f/4 or f/5.6, set the exposure to B ("Bulb"), and keep the shutter locked open for anywhere from an hour to several hours. The longer the exposure time the longer the star trails will be in your picture.

Other than different forms of astrophotography, what else might require an exposure of several hours? I suppose anything that's in near-total darkness. I'll let you give it a try—I'm going to sleep.

This is a combination shot. I shot Maine's York Harbor lighthouse with my digital camera using an exposure of 2 seconds at f/8. Because digital cameras add a lot of noise during long exposures, I photographed the star trails using ISO 100 slide film: my exposure was about six hours at f/4. I scanned the film and combined the two images in Photoshop.

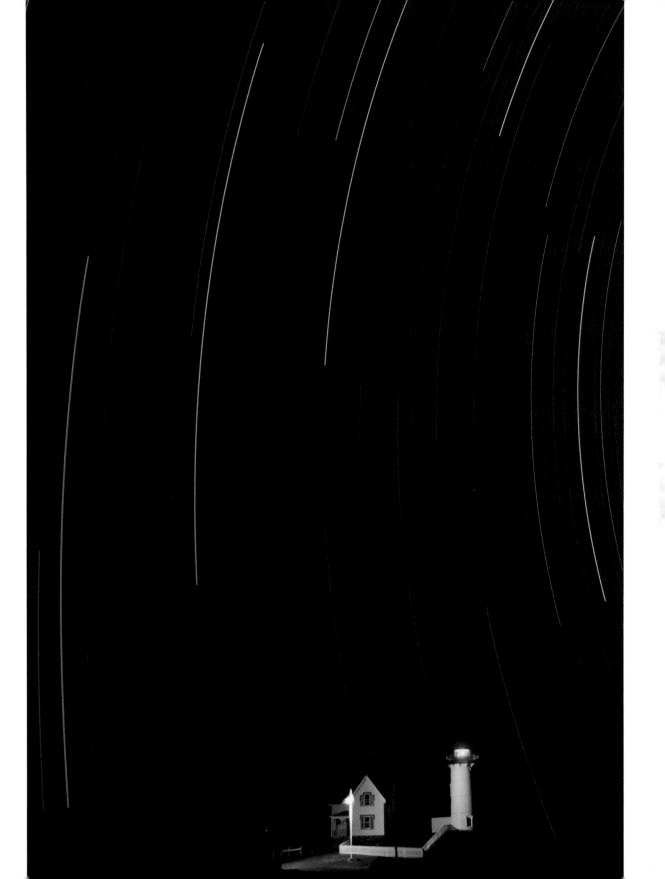

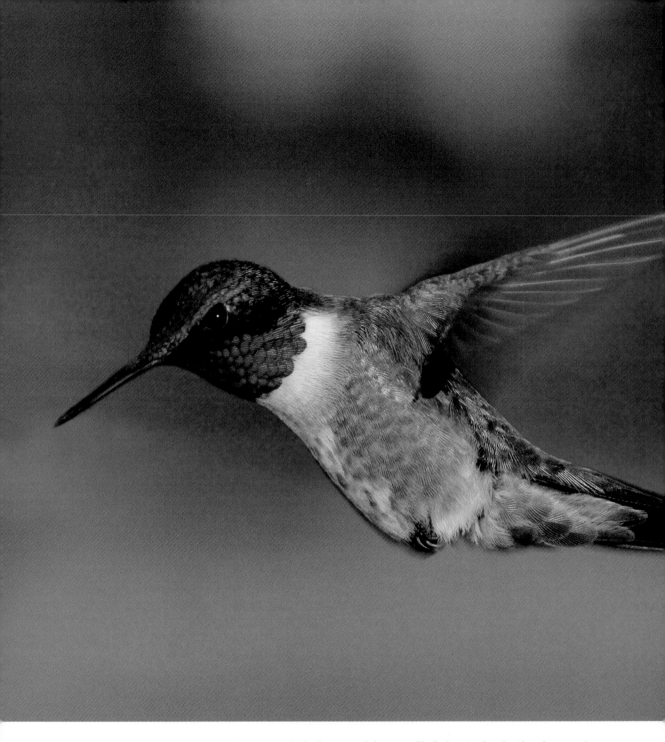

Mike Brown used three portable flash units placed within about two feet of a hummingbird feeder. With the units so close to the hummingbird, he achieved a short flash duration of approximately 1/15,000 second to freeze the rapid beat of the bird's wings. Exposure at 1/15,000 second, f/22. Photo © 1998 Michael Brown

Nano Time—the hidden world of ultra-speed electronic flash

Four million light-years, one trillion dollars, 1/1,000,000 second shutter speed—numbers like these are incomprehensible. For centuries humans have wondered about the world moving around them, about the mechanics of movement, and especially about the muscle actions of humans and animals.

But human vision could neither freeze nor analyze the motion of anything moving faster than a slow jog. It was not until the 1870s that even the relatively slow motion of a galloping horse was stopped by the pioneering motion photography of Eadweard Muybridge. If humans were curious about how fast-moving natural things would look if they could be instantly frozen, they were even more curious about the artificial speed they were inventing. Explosives, trains, airplanes, all kinds of machines could all be improved if their minute movements—and speeds—could be analyzed and understood.

The first to achieve fame in this area was Harold Edgerton of MIT. In the 1930s, Dr. Edgerton improved electronic stroboscopic equipment to the point where it could be used to take pictures with exposures as short as a few millionths of a second. One of his most famous photographs shows a bullet, frozen in mid-air, exiting an apple.

In the following decades electronic flash became the constant companion of professional photographers. Later, as miniaturization gripped inventors, tiny flash units were built into camera bodies intended for both professional and amateur consumers.

With electronic flash, sights beyond the ability of the human eye are ours for the taking. Photographed at flash durations as short as 1/100,000 second, darting dragonflies, hyper-speed hummingbirds, speeding bullets, impacting water droplets, and a whole host of other subjects reveal their secrets to the camera. If you want to stop movements beyond the reach of a 1/8000 second shutter speed, you can do so by mastering the intricacies of electronic flash.

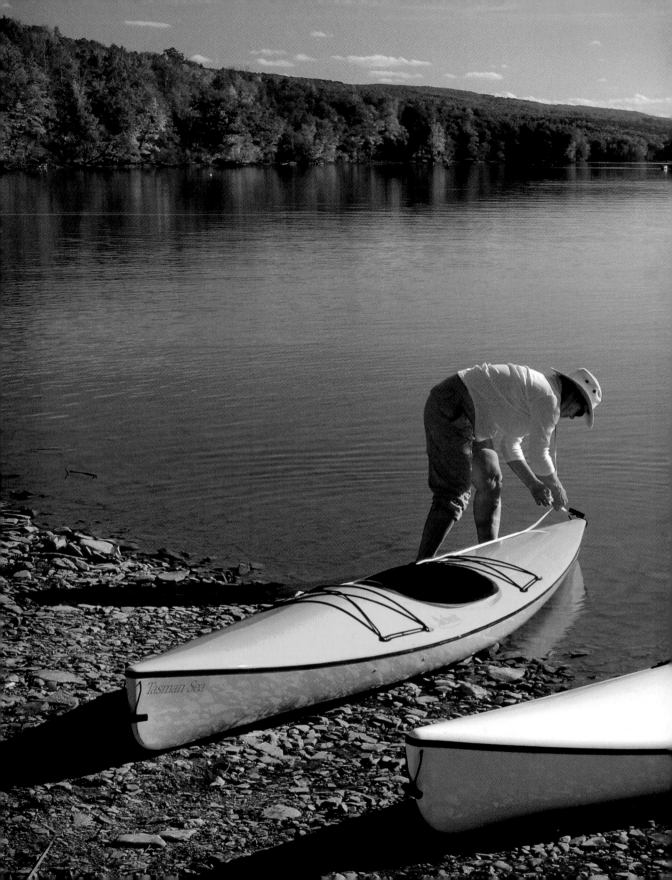

Chapter 2

Understanding Shutter Speed and Exposure

If "take control of your life" is the mantra for self-help gurus around the world, let's add a twist to it and say "take control of your shutter speed" should be the mantra for self-help, do-it-yourself photographers.

Let's face it, taking control of your life can be difficult and complex; taking control of your shutter speed isn't. This chapter will prove that. In about the time it takes you to call and get through to a live person at your health care provider, you can read this chapter and be well down the path of taking control of your shutter speed.

I'll introduce you to the important camera controls and settings that interact and influence exposure and shutter speed and ultimately affect the appearance of your photos. You probably are already familiar with many of the controls essential for basic picture taking, such as exposure and focus modes, aperture settings, the *exposure compensation control,* and ISO settings. As well, you likely understand the fundamentals of not only what a good exposure looks like but its value. In both areas, you'll learn in more detail how to coordinate these controls, settings, and concepts and use them to achieve the shutter speeds you need to make expressive, well-exposed pictures.

To gain control of your life you must deal with bosses, spouses, creditors, aging parents, your health and finances, and a variety of bureaucrats and customer service reps whose primary goal is to put you on hold until you finally give up (and hang up). By comparison, taking control of your shutter speed is rewarding and pleasurable—and you have only your camera to deal with.

So here's my challenge. Before you continue reading, place that call to your health care provider and let's see if you finish this chapter before a live person gets to you.

How the shutter works

Like the automatic door at the grocery store, your shutter is an electro-mechanical device that opens and closes when an electrical signal triggers it. That electrical signal is initiated when you press the shutter button.

How long it stays open depends on the shutter speed you or the camera selects. Shutter speeds are designated by seconds and fractions of seconds, such as 1/250 second, 1/125 second, 1/2 second, and 1 second. The marked increments of shutter speed settings have traditionally been a doubling (or halving) of each adjacent step, thus 1 second, 1/2 second, 1/4 second, 1/8 second, 1/15 second (rounded slightly), 1/30 second, and so forth. This doubling/halving series harks back to the mechanical heritage of the shutter. Now that electronics play such a big role in photography, you'll see many more steps in the total range of shutter speeds, such as 1/13 second, 1/25 second, 1/640 second, and so forth. In most dSLR cameras, you can set the incremental jumps of shutter speeds to change by 1/3 or 1/2 stop or even 1 stop. (A 1/3-stop increment would be from 1/250 second to 1/320, a 1/2-stop increment would result in the value changing from 1/250 second to 1/375 second, and a 1-stop change would be from 1/250 second to 1/500 second.) This lets you customize your choices of aperture and shutter speed settings.

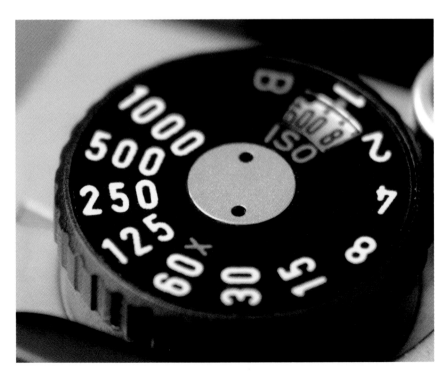

The old-fashioned shutter speed dial functioned as both a ready reminder of your many shutter speed options and as a one-step dial to setting the shutter speed.

At slower shutter speeds, the shutter fully opens like a door or window and completely uncovers the opening in front of the sensor. But at faster shutter speeds, such as 1/500 second, the shutter resorts to trickery, because its mechanical components cannot operate fast enough to fully open and close in such a short time. Instead of fully uncovering the sensor (as it does at slower shutter speeds), the shutter mechanism forms a narrow slit; as the shutter speed increases, the slit becomes narrower. The slit then travels across the sensor area, painting it with light—almost like using a roller when you paint a wall.

From portraits to still lifes to action, choosing the right
shutter speed can be critical to obtaining a good picture.
Exposure at 1/320 second, f/11.

The origin of shutter speed

Until the middle 1800s, "film" materials were not very sensitive to light. In contrast to the instantaneous exposures made on today's digital sensors, exposures in those early days were made on coated photographic plates and could last several minutes, sometimes an hour or more, even on a sunny day. With such long and imprecise exposure times, shutter mechanisms weren't even required. To regulate light coming into the camera, a photographer simply removed the lens cap, patiently gazed at his pocket watch until he judged an appropriate time had passed, then—in no great hurry—completed the process by restoring his lens cap. With experience and a bit of luck, enough light had been admitted for a satisfactory exposure.

Increasingly light-sensitive coatings and films were developed over the next few decades and photographers began to make shorter and shorter exposures shrinking from minutes, to several seconds, to fractions of a second. This shortening of exposure times had an enormous impact on popularizing photography and created more interest in experimenting with photo subjects far beyond studio portraits and static landscapes.

As photographers began to imagine what they could capture with these shorter exposure times, the evolution of a second camera property—smaller size—also helped to ensure many more creative and physical freedoms for photographers. Flexible film joined the parade of improvements, replacing unwieldy and easily-shattered glass plates. And soon after that introduction—with George Eastman of Kodak fame offering to do the complicated business of processing film and printing pictures—everybody wanted a camera.

With portable cameras and faster exposure times, photographers liberated their cameras from tripods and wandered the world taking pictures simply by handholding them. Armed with a camera, even a novice could at long last begin to capture the majesty of a king's coronation or the magic of an everyday life: picnics at the seashore, children rolling hoops, and horses cantering down country lanes joined the old, stiffly-posed studio portraits in family photo albums. By the 1900s, photojournalism was born as pictures of soldiers thrusting bayonets, politicians barnstorming from trains, fires ravaging orphanages, earthquakes shaking apart cities, and many other contemporary events made their way into newspapers and magazines. Reasonably fast exposure speeds were part of a great technological breakthrough that enabled many activities of the world to be photographically documented for display, analysis, and discussion.

So even 100 years ago, the best answer to the question "What is the primary value of shutter speed?" was not simply: "To admit light into a camera." By providing a specific amount of light for the sensor and helping to regulate when light is allowed to enter the camera, shutter speed is also an indispensable tool photographers use to creatively interpret their world.

About exposure

Unless you're one of those people who enjoys learning how things like small engines and large intestines work, you probably won't want to dig too far into the inner machinations and computations of your camera as it creates a picture. But you do want to dig far enough so that you understand the basics of exposure.

Exposure—which is the amount of light your camera uses to make a picture—is the very foundation of photography. Without a doubt, if your goal is to create an outstanding photo, you need to begin with a good exposure. I'll repeat—and raise the bar: to create an outstanding picture, you need to create an excellent exposure. Take a bad exposure and you might as well haul your photo to the curb for recycling.

And yet, essential as it is, even an excellent exposure cannot create an outstanding picture in and of itself. Think about it. You still need, for example, that human talent for decision-making, for composition and scene and subject choices.

Let's quickly review how your digital camera creates a picture. You aim the lens of your camera at a scene. Light reflected from the scene enters the lens, which, like your eye, forms the light into an image of the scene. And just as your eye transmits that image onto the retina, the camera lens transmits it onto the sensor to create a picture.

The sensor consists of millions of pixels—tiny individual light-capturing buckets. The amount of light captured by each pixel is converted into a corresponding amount of electrical voltage (virtually no voltage for black areas in the scene, nearly the maximum amount for white areas). A converter then changes the voltage coming from each pixel into a corresponding digital signal that becomes the basis of the digital image.

The most important thing to know about the sensor is that it requires a specific amount of light (the "correct" exposure) to make a good picture. It's not like winning the lottery where getting a lot is always better than getting a little. Correct exposure is more like paying your

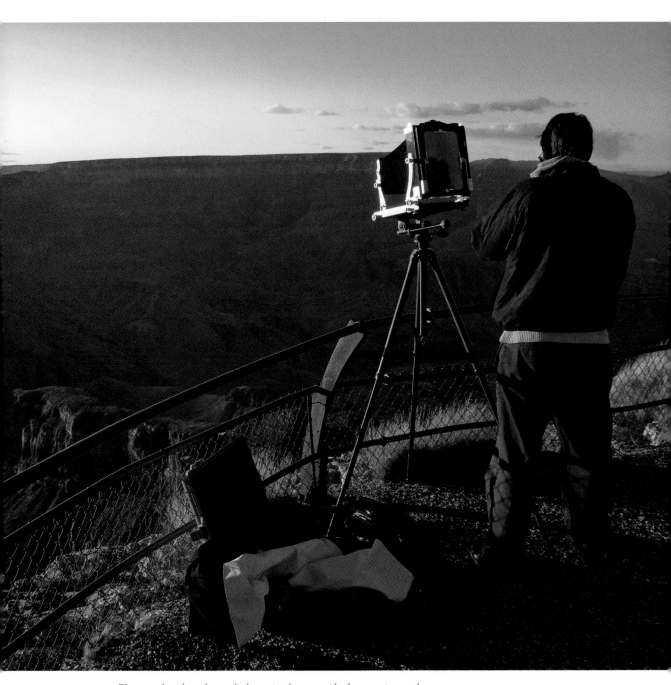

Photographers have long relied on tripods to provide the extra image sharpness that results when the camera is held immobile. Exposure at 1/90 second, f/9.

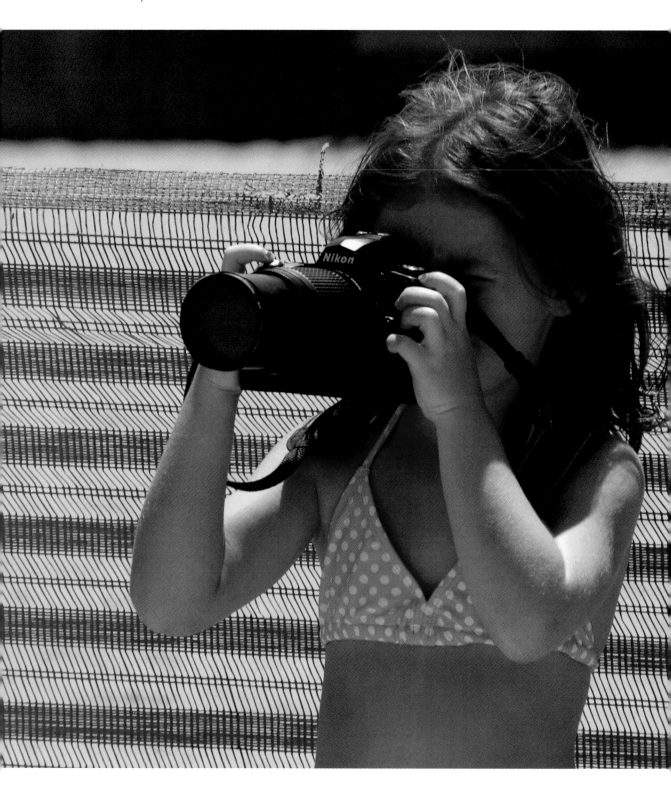

bills, where paying the exact amount on the bill is the best practice. So your goal is to give your camera's sensor only the amount of light it's owed.

If your camera lets too much light reach the sensor, the picture will be overexposed (too bright), so much so that light areas and highlights can be bleached out altogether. And conversely, if the camera delivers too little light to the sensor, the picture will be underexposed (too dark). Details can be lost this way, too, by disappearing into blackened areas and shadows that are far darker in the photographic image than they were in the original scene.

A good exposure nicely replicates the appearance of your subject, and the good news here is that getting a properly exposed, great-looking picture is pretty easy. Even though your camera can, in fact, do this automatically much of the time, you should know how to do it, too, because controls for exposure affect more than just the brightness of your picture.

Most photographers love the convenience of handholding the camera. Historically, photographers could not handhold the camera until light sensitive materials were developed that allowed fast shutter speeds and smaller cameras. Exposure at 1/200 second, f/9.

Camera controls for regulating exposure

The two controls regulating the amount of light reaching the sensor are the shutter and the aperture (lens opening). Both are adjustable, electro-mechanical devices. The lens aperture determines how much light passes through the lens. The shutter determines how long the light passing through the lens is allowed to strike the sensor.

The best place to understand how shutter speed and aperture settings regulate light to create a good exposure is your kitchen sink. Imagine that you've placed a coffee mug beneath the faucet and filled it with water. Notice that you held the faucet handle open for a specific amount of time to let the water flow and completely fill the mug. Similarly, the camera's shutter lets light flow for a specific amount of time to "fill" the camera sensor.

But in both examples–faucet and camera–the amount of flow is also regulated by a second important control. One of the internal workings of a faucet is a valve with a variable size opening; when you turn the handle, you change the size of that valve opening and that determines whether a thin stream of water trickles out or a thick stream gushes out. Inside your camera lens is a similar control. In this case, a diaphragm of variable size adjusts the lens opening (the aperture) to determine the diameter of the "stream" of light that passes through the lens and strikes the sensor. You can let a trickle of light pass through the lens by setting a very small aperture, f/16, for example, which is about the size of a popcorn kernel on a 50mm lens. Or let it gush through by setting a large aperture, like f/2.8, which is about the size of a penny.

Returning once more to the faucet analogy, the end result you want is to fill that mug only to its top. For the camera sensor, of course, the equivalent of a fully-filled mug of light is a correct exposure. This you can achieve by choosing an appropriate combination of shutter and aperture settings. Depending on what effect you want, you might pair a slow shutter speed and a small aperture setting (a trickle of light), or go for a fast shutter speed and a large aperture opening (a gush that fills the sensor almost instantly).

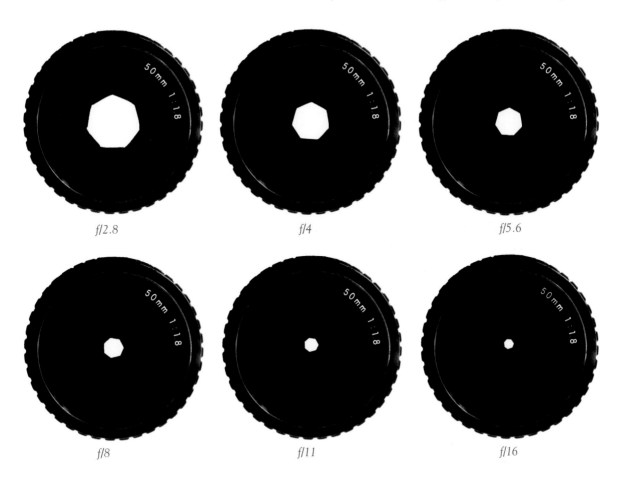

As the aperture (f-stop) number gets higher, the lens opening gets smaller. Here full f-stops are shown, with each successive smaller number letting in twice as much light as the number above it.

From good to great exposure

There's a simplistic but true statement about exposure—that it's good when it makes your picture look good. Fortunately, as you learn in the following pages, you can use your camera's *histogram* display to objectively analyze exposure. But for now, let's just try to understand what makes a good exposure and what makes a bad exposure.

Keep in mind that the problem with a truly bad exposure is that you cannot adjust it in Photoshop to make the picture good. A good exposure gives you the option of making all sorts of Photoshop adjustments and improvements that can make your picture sing.

Anatomy of a good exposure

This picture just looks good. Like the actual scene, the photo has nice dark shadows, bright colors, and some snap.

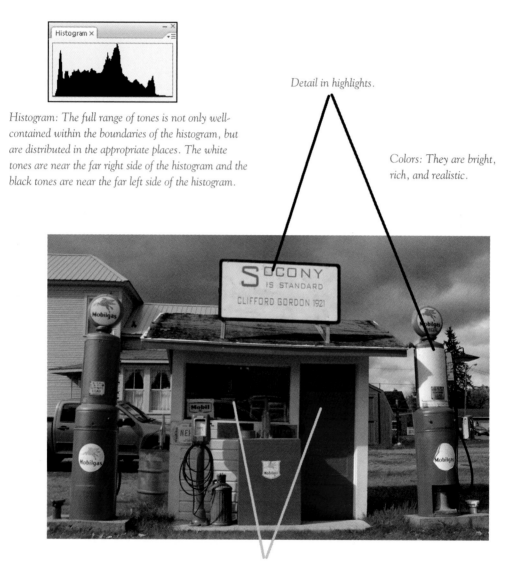

Histogram: The full range of tones is not only well-contained within the boundaries of the histogram, but are distributed in the appropriate places. The white tones are near the far right side of the histogram and the black tones are near the far left side of the histogram.

Detail in highlights.

Colors: They are bright, rich, and realistic.

Details in the shadows: Although the book printing process doesn't easily show dark features, you can still see some details inside the dark window.

Anatomy of a bad exposure

Something looks wrong. In this example, the photo is too dark and dull. It's lifeless.

Histogram: This picture is underexposed as indicated by the tone "mountain" jammed against the extreme left edge of the histogram.

Highlights are too dark.

Shadows are extremely dark and show no details within.

Do the math

Think about what happens when you photograph a rapidly moving subject, a gymnast doing somersaults, for instance. When the shutter opens for 1/500 second, it admits light for that length of time. If the gymnast is spinning in mid-air when the shutter opens for 1/500 second, the image of the spinning gymnast coming through the lens lasts only for 1/500 second. The sensor records the position she is in at the time you press the shutter button and also any distance she moves across while the shutter is open for that 1/500 second.

If the gymnast is spinning at 30 mph, she moves only 1 inch during the 1/500 second the shutter is open. That explains why a fast shutter speed can freeze motion. If the shutter remained open for 1/30 second, however, she would have moved about 1.5 feet through the air during that time and her recorded image would be somewhat blurred.

Keeping in mind that I can barely balance a checkbook, let's do some more math. Let's start with the fact that there are 5280 feet in a mile. At 30 mph, the distance covered in one hour is 158,400 feet. The distance covered in one minute would be 2640 feet (158,400 feet divided by 60 minutes). To find how far the subject moving at 30 mph travels in one second, divide 2640 feet by 60 seconds. That's 44 feet per second. To find how far the subject travels during a shutter speed exposure of 1/500 second, divide 44 feet by 500. That's 0.088 feet, or less than one-tenth of a foot, or a tad over one inch. So a subject moving at 30 mph travels only about an inch in 1/500 second.

If you really want to get into calculations of rendering an image sharp in a photo, the next step would be to determine how far the subject moves across the sensor. But let's leave that to the math whizzes, shall we? For now, I think you get the idea of how a fast shutter speed freezes a moving subject and why a slow shutter speed blurs a moving subject.

ISO setting—your secret weapon

Now you know two facts about how the sensor gathers light to make your picture: it needs a specific amount of light for a good exposure, and various combinations of the correct shutter and aperture settings let you deliver the required amount of light to the camera sensor.

However, you can actually change the amount of light the sensor needs by adjusting the ISO control. Choose a higher ISO number and the sensor needs less light to make a good exposure. Choose a lower number and it needs more light. Each doubling of the ISO speed halves the amount of light required by the sensor to make a good exposure (a picture of the proper brightness). Our faucet analogy should make this clear. If instead of placing a mug beneath the faucet, you place a shot glass

or a quart bottle, you would change how much water is required to fill the container. Increasing the ISO number is like setting a smaller container under the faucet. Decreasing it is like setting a larger container under the faucet.

By changing the ISO setting you vary the sensitivity of the sensor to require more or less light. Typical ISO settings you would use range from 100 to 3200. Although the ISO settings may stretch as high as 25,000 on some cameras, ISOs of 6000 and higher create so much digital noise that image quality becomes quite poor.

Can you see the advantage of this control? On a sunny day, you would likely use an ISO of 100 to 400 simply because there's so much light. But in a dark room or at twilight you can set your camera to a high ISO, such as ISO 1600, so the sensor needs only a little bit of light to make a picture. By using a high ISO in dim light, you can use a shutter speed fast enough to let you hold the camera by hand and still get a sharp picture. By manipulating the ISO setting you can greatly expand your choice of shutter speed and aperture. ISO speed is your secret weapon in gaining control over your exposure settings.

The downside is that higher ISO settings (those above 1200 in dSLRs, and above 400 in snapshot cameras) reduce the image quality by adding more image noise to a picture—digital noise appears as random, confetti-like colored pixels.

On most dSLRs, the ISO control is a button that you press and then change the setting by turning the control (or change) dial.

Determining the correct exposure

This little summary about achieving correct exposure is just that—a little summary. If you really want to learn all about the important task of achieving correct exposure, read *Exposure Photo Workshop*, an excellent book written by Jeff Wignall.

If you lack the time to read an entire book on exposure, there's still good news for you: achieving good exposure is easy. Your camera is a computer that's programmed to take well-exposed pictures and most of the time, under most conditions, it delivers. The bad news? There is none. But there is a caveat: sometimes, in order to get the best possible exposure, you need to intervene and guide your camera manually.

This very often occurs when you photograph subjects of extremely high or low reflectance (scenes that are nearly white, like snow and Caribbean beaches, or nearly black subjects, like coal and Halloween cats). You may also want to choose your own shutter speed and aperture settings when your subjects are very contrasty scenes with lots of very light and dark areas.

Programmed into your camera's metering/exposure system are shutter speed and aperture values and combinations for hundreds of possible photo scenes. When you start to take a picture, the camera instantly analyzes the scene before it and compares it to the scenes programmed into it and adjusts exposure accordingly. That works surprisingly well, especially if one of the programmed scenes is similar to what you are photographing. But the system is not perfect. When you photograph a scene that departs far from a typical or average scene, the exposure may be considerably off.

One solution for covering yourself in such tricky scenes is to use the RAW file format. It lets you adjust exposure in Photoshop (or whatever software you're using) to get a nearly perfect picture ninety-nine percent of the time while maintaining optimum image quality. It's almost a do-over without a downside.

But there is a slight downside for motion shooters—that's the large size of the RAW file format. They are very big. Often three to five times the size of JPEG files, RAW files can quickly slow down your camera as you're trying to shoot continuous action and eventually bloat your computer's storage capacity.

And, of course, you can immediately determine the exposure accuracy of the picture you just took by reviewing the histogram display on your camera. (See more about that in the section of this chapter, "Evaluating Technical Exposure with the Histogram," page 73). Although in the heat of the photographic moment you may not have time to pause and check the histogram, you can plan ahead. Before the action starts, take a few test pictures representative of what you'll be photographing, check out the histograms for the test shots, and then, if necessary, adjust exposure settings.

When set to the center-weighted mode, the meter gives extra emphasis to measuring the light reflected from a subject positioned in the center of the picture. Exposure at 1/800 second, f/9.

Matching metering modes to scenes

Whether it's a gas meter, electric meter, water meter, or speedometer, the main purpose of a metering device is to measure. For your camera meter, it's never happier and more fulfilled than when it's measuring light for an ideal exposure.

Once you (or the camera) know how much light is reflected from a scene and passing through the lens, you (or the camera's automatic exposure system) can adjust the aperture opening (f-stop) and shutter speed to give the sensor the exact amount of light it needs for a correct exposure.

Set your meter to the averaging mode when all areas of the scene are similar in brightness and equally important. Exposure at 1/250 second, f/11.

The makeup of the world and the scenes you photograph vary enormously, especially in how different parts of them reflect light. Your dSLR is designed to accommodate that variability and offers different metering modes within the camera. Let me briefly elaborate on the variations of scenes and light reflected from them. If I look out my front window in December, I see a brilliant field of snow and deep green pines illuminated by sunshine. If I'm in my kitchen, I see a dim room but with one exception—a can of tomato soup on the counter is being spotlighted by a sun beam. At the summer street fair, I see a mixture of tents shadowing the crafts inside and bright sunlight shining down on the marching band. And one week from now at twilight, the full moon will rise above the hill. All of these scenes offer widely varying amounts of bright light, highlights, dim light, and dark shadows. And all have detailed areas, each needing more or less light, that must be skillfully preserved to make a good picture.

Your camera's different metering modes are designed to take well-exposed pictures of the widely varying world you are photographing. It's for that reason that most cameras offer the following metering modes: center-weight, averaging, matrix, and spot.

Center-weight

This exposure system gives most emphasis to light coming from the center of the viewfinder or LCD display because many photographers very naturally put the main subject in the center of the picture and are primarily concerned that it looks good in a picture. Center-weight metering is particularly useful for people photography, including action shots, because these subjects so often end up in or near the center of the picture.

Averaging

The averaging mode gives equal emphasis to light coming from all areas of the picture, averages them into one measurement, and then sets the shutter speed and aperture accordingly. Averaging works well for outdoor scenes with fairly uniform lighting, and it's great for most scenics.

Matrix

The matrix system divides the scene into an unequal grid and gives different emphasis to different areas. After it compares the light coming from these areas to its programmed knowledge, it sets an exposure. Matrix metering works best when a scene offers a wide variation of light and dark areas, such as that summer fair with a lot of tents. It's my favorite mode for its versatility.

Use the matrix mode when a hodgepodge of bright and dark areas are scattered through the scene. Exposure at 1/60 second, f/22.

Use the spot meter mode when the subject is small and differs from in brightness from the rest of the scene. Exposure at 1/200 second, f/9.

Spot

It measures the light only from a small area—usually in the center of the scene—and ignores the rest of the scene. Use it when you photograph a small but important subject that is significantly brighter or darker than the rest of a scene, such as a distant white cat sitting in a barn door, spotlighted by a beam of sunlight.

Evaluating pictures as you take them

Checking on an image in your camera's LCD is like looking in the mirror before you leave home for the big social event of the year. Just as the mirror lets you confirm that you've wiped the toothpaste off your chin or that your curls are fluffed to perfection, the LCD lets you confirm that your photo is up to par.

There are a couple of big differences between a mirror and the camera LCD. There's that seven years of bad luck for breaking the one, of course. And that mirror is big. That makes it easy to see flaws. Even though LCD manufacturers may exclaim that your model has a "huge" 3-inch LCD, that LCD is not big. It's small, small enough to make it difficult to see toothpaste on a lip—or a slight blur from unsteady holding of a telephoto lens.

The real power of the LCD is like the magical mirror in *Snow White and the Seven Dwarfs*: it can tell you things. Instead of being deceptive, the things your LCD will tell you are true and helpful—if you use it correctly.

Evaluating visual image quality on the LCD

Use the photograph displayed on the camera LCD to look at picture qualities such as composition and image sharpness. Don't, however, use the LCD photo to evaluate exposure. Oh, you can glance at it and quickly see if the exposure is in the ballpark, but that's all. The light around you (be you outdoors on a sunny day or inside in the dim living room) affects your perception of the LCD image too much to make it reliable for exposure evaluation. Use only the histogram to evaluate exposure.

Do use the camera LCD to judge the *composition* of your picture. Just look at the image displayed and see if it's to your liking. You'll see the LCD display better when you stand in the shade, or shade the screen from harsh sunlight by blocking the sunlight with your body. Since many camera viewfinders don't quite display the full area being photographed, review the edges of the picture area on the LCD to make sure nothing unexpected (and unwanted) has been included.

Evaluating the picture for *sharpness* is a bit tougher. Use your reading glasses if you need them, or magnify the image several times using the appropriate image review functions. Look at critical areas. For people, check their eyes and hands. Are the eyes open and sharp? For landscapes, check tree branches, rocks, and other features that need absolute sharpness to convey image quality.

Just looking at the photo on the camera LCD is an unreliable way to judge exposure as ambient light can greatly affect the photo's appearance. In bright outdoors light, the image display may appear light and washed out—even if it's a good exposure. Use the histogram to analyze exposure.

In the light of an indoor setting, photos displayed on the camera LCD may appear brighter than they actually are. Use the histogram to evaluate exposure.

With the photo still magnified, continue to move around the image. But now look for flaws such as discarded Styrofoam cups in the foreground of a landscape or distractingly large wrinkles in a blouse, crooked eyeglasses, or a bit of broccoli in a toothy grin.

Evaluating technical exposure with the histogram

The histogram. You either love it or hate it. I love it. In fact, I love it as much as when the daily stock market graph shows my Tootsie Roll stock jumped 10%. Like any graph, it shows data with dispassion. It is what it is. Lacking the bright colors and raving emotions of the photo display, you are left to react objectively to a boring graph.

The histogram graphs the tonal values (all the light and dark areas) in the scene you photographed; by evaluating it, you can determine if your exposure is correct. You can look at the histogram on the camera (and you definitely should) and you can look at it again when in Photoshop (again, you definitely should).

The problem with the histogram is that you have to interpret it. The histogram doesn't make a judgment as to whether the image is underexposed or overexposed, it just graphs the image data in your picture and shows it on a scale running from deep black (value of 0) up to pure white (value of 255). It's up to you to figure out whether the picture you took represents a good exposure.

What does the histogram of a good exposure look like? Well, that depends. And it mainly depends on the subject you are photographing. Because a histogram represents the tonal (brightness) values of the scene photographed, its appearance is determined by the content of the scene. To help you understand what you see when you look at a histogram, I've provided a bunch of correctly exposed photos and their accompanying histograms. As you'll see, the histograms look different because the tones (bright, medium, and dark areas) in each picture are different.

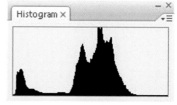

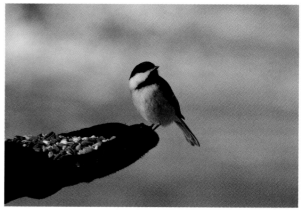

As this series of photos and accompanying histograms shows, the histogram that represents a good exposure depends on the subject.

Overview of a good histogram

This histogram represents a correctly exposed picture of a scene with a full range of tones. I know the scene was correctly exposed because the histogram easily contains all the tonal values and the values are in the correct locations within the histogram. Most importantly, the histogram shows that the dark tones and light tones have been exposed correctly. The bright whites of the boat decks show up on the far right side of the histogram (where they belong) but don't jam up against the right side. The black shadows in the background appear on the far left side of the histogram where dark tones belong, but again, aren't jammed against the edge.

All values fit within the histogram

Dark tones stop just short of the far left

Bright whites stop just short of the far right

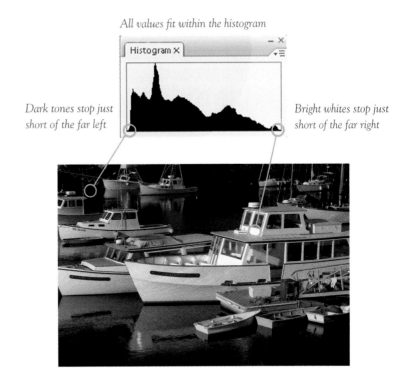

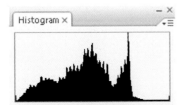

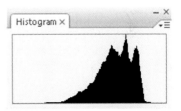

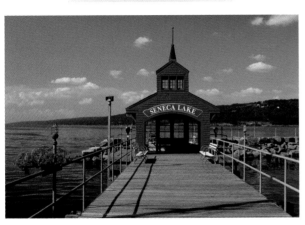

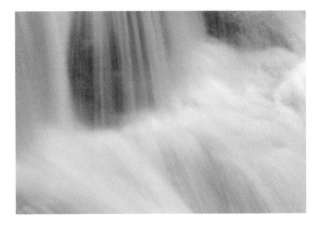

But they all share one thing in common: they each closely correlate to the brightness values of the subjects photographed. A histogram for white clouds peaks on the right side of the graph (without jamming against the far right) because the clouds are white. A histogram for a black cat falls to the far left where the dark values live, but again without jamming against the left border or wall of the histogram.

Jamming against either the right or left border is a definite sin in the world of exposure. It means you've exposed incorrectly and lost both subject details and the tonal values used to represent them.

A great exposure maximizes the tonal values—and therefore the subject detail— of any given scene.

To complement the histogram, most cameras offer an overexposure (too bright) warning. When you are reviewing the picture (not the histogram), the overexposure warning flashes (typically in red) on the areas that have been overexposed. Some cameras have an underexposure warning that flashes in the dark areas when the picture is underexposed. Both warnings are a quick visual reference that you should adjust your camera settings to let in less light (if overexposed) or more light (if underexposed) and take another picture. However, it doesn't give you any idea of how badly you've overexposed, whereas to the experienced eye, the histogram does.

Use and evaluate the camera's histogram to determine if the exposure of your photo is correct or not.

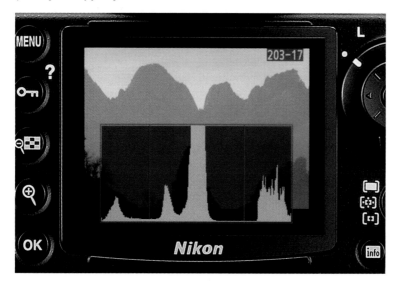

Balancing shutter speed and depth of field

If you're good with money, one of those people who can create a budget, adhere to it, and come to the end of the month with enough money to pay the bills, well, then, you won't have a problem balancing shutter speed and aperture selection.

The concept of correct exposure remains consistent throughout all combinations of shutter speed and aperture settings. Whatever the combination, whatever the shooting situation, you need to deliver a specific amount of light to the sensor to create a picture that looks good.

Like a pair of sibling teenagers, aperture and shutter speed controls vie for your attention. What combination of shutter speed and aperture settings will work for that seashore scenic, the ideal one with waves crashing on the black rocks in the foreground and a freshly whitewashed lighthouse in the background? You want enough depth of field to reveal both the rocks and lighthouse sharply, you want details in the rocks and on the lighthouse, and you're determined to freeze the frothy waves in mid air. Is 1/250 second at f/11 good enough to achieve all three goals? Or should you use a faster shutter speed?

Similarly, thirty bicyclists round the bend as a large group: What shutter speed and aperture combination do you need to freeze the group's motion, while showing at least the leaders of the race sharply? A shutter speed-aperture combination of 1/2000 second at f/8 would likely achieve that result.

Artistically, you may be forced to make tradeoffs in choosing your shutter speed-aperture combinations. Just like balancing your budget, you may need to decide whether you can afford that new big screen TV, or if you need to take care of that rattling noise in the car. Life is full of tradeoffs, right?

However, much of this book is devoted to helping you avoid making tradeoffs. By learning the important settings and accessories that affect the exposure settings you make, you can often achieve the shutter speed-aperture combinations that fit your creative needs.

The easiest way to expand depth of field is to set the camera to Aperture-Priority mode so you can directly select the aperture you want to use.

Equivalent exposure values

The discussion of combinations of shutter speed and aperture settings leads nicely into the technical concept of equivalent exposures.

The central principle is that a variety of aperture-shutter speed combinations can let in the same amount of light to give a correct exposure, or an equivalent exposure. If you use a shutter speed one stop faster (from 1/125 to 1/250, for instance), then you cut in half the length of time the light is admitted, and thus you cut in half the amount of light reaching the sensor. But since you (or your camera) wants a correct exposure, the f-stop for the aperture will be opened by one stop (from f/16 to f/11, for instance), so that twice as much light is let in. The end result is that you have delivered the same amount of light to the sensor.

So why would you want to change aperture and shutter speed settings? Well, I'm sure you already know the answer to that question. The reason is usually for creative

As this series shows, an equivalent amount of light can be delivered by many different combinations of shutter speed and aperture settings.

1/40 second, f/5.6

1/20 second, f/8

effect—and often for the sharpness provided by a faster shutter speed's ability to eliminate blur from camera shake.

Again, the goal for using equivalent exposure settings is to admit an identical amount of light to the camera to correctly expose the picture. If you change the shutter speed, you must also change the f-stop of the aperture in the opposite direction. And vice versa.

Table 2-1 Equivalent Exposure Settings

Shutter Speed	Lens Aperture
1/125	f/16
1/250	f/11
1/500	f/8
1/1000	f/5.6
1/2000	f/4
1/4000	f/2.8

Here's a series of equivalent exposure settings (Table 2-1). For a given lighting situation, such as a sunny day, they'd all let in the same amount of light for the sensor.

1/10 second, f/11

1/5 second, f/16

By learning how the many exposure controls interact, you can more easily manipulate them to obtain the shutter speed or aperture that you want for specific, creative goals. Here I wanted to use a large aperture so the rose would appear sharp and stand out against an out-of-focus background. Exposure at 1/1500 second, f/5.6.

Finding a way to get the shutter speed you want

As you strive to set a shutter speed that meets your vision, keep one thing in mind. The principle of correct exposure stands firm. (Well, not always. There's an exception to most rules, and below we'll see one way to bend that rule). Your camera meter measures the light reflected from the scene and indicates the amount required for correct exposure; then you adjust—or your camera adjusts—the shutter speed and aperture opening to deliver the correct amount of light to the sensor.

So what happens if the amount of light required for correct exposure prevents you from setting the shutter speed you want to use? You have several options. All but one work with the principle of exposure, so that means if you want to use a slower shutter speed, you must reduce the amount of light reaching the sensor. Of if you want a faster shutter speed, you must reduce the amount of light required by the sensor—or, more difficult—increase the amount of light reaching the sensor.

Start by setting the shutter speed you want to use (that means you should be using the Shutter-Priority mode). Now point your camera at the scene and take a meter reading to see if your camera chooses an aperture that gives correct exposure. If it doesn't—but is only two or three stops away from achieving correct exposure—you're probably okay. (Remember that many cameras will signal exposure problems with a flashing red

light.) You have several options to adjust settings to achieve a good exposure, and sometimes you may need to combine these options in order to maximize your ability to achieve that (desired) shutter speed.

Your first course of action is to adjust the ISO setting, to change the sensor's sensitivity to light. Raise the ISO speed if your meter indicates you are underexposing the scene, which would be common in dimly lit scenes or when using extremely fast shutter speeds. Lower it if you are overexposing the scene, which would be common when you are trying to use a very slow shutter speed on a sunny day.

Another option is to choose another lens, one with a smaller aperture if you are trying to set a slower shutter speed, or one with a larger aperture if you are trying to set a faster shutter speed.

Or if the light is too bright, you can reduce it by using a polarizing filter (1 2/3 stops) or by using a neutral density filter.

If the light is too dim, you can increase it. If you're shooting outdoors, you can wait for clouds to pass or supplement it with flash. If you're taking pictures indoors, you can use flash if you're willing to sacrifice the naturalistic appearance you might want.

But what if you've tried all the options and still can't get the correct exposure for the shutter speed you want? Well, you've got one more trick up your sleeve, and it's a good one, but perhaps used as a last resort. If—after trying several of the above options—you're still a stop or two away from achieving correct exposure, set your camera to use the RAW file format. Take the picture at your preferred shutter speed and then adjust for exposure problems in Adobe Camera Raw.

If you've exhausted all these alternatives and still can't achieve a good exposure with the shutter speed you want, then you might just have to adjust your creative strategy. In other words, plain and simple: you just can't use your preferred shutter setting, not this time. To get a good exposure, you're stuck: you'll have to choose a different shutter speed. Sigh.

Sometimes, the photographic gods of perfect exposure just aren't with us. But then again, maybe they are. Although you can't use the shutter speed you want, fate—if you'll only accept it—may be offering you an unexpected treasure. This is the kind of serendipity that's been my experience more often than not.

White balance

The white balance setting does two things for your photos. It adjusts an image to compensate for scene lighting that might be unusually or unnaturally tinted, so that subject colors appear normal and natural in a wide variety of lighting. And it also attempts to keep white objects looking white, even if the scene illumination changes and casts color onto them. Imagine a bride resplendent in wedding dress standing under fluorescent lights. You take a picture and her dress appears a sickly green color because the white balance setting was incorrect or ineffective.

More importantly, she probably looked lovely to you because you didn't even perceive the greenish light coming from the fluorescent lights. That's because your visual system automatically and easily adjusts colors to appear normal in a wide variety of lighting. If everything appears normal to you, shouldn't your camera see it the same way? Unfortunately, it doesn't. Your camera captures any slight tint

Many photographers love the warm golden rays accompanying sunrise and sunset and rather than neutralizing it with white balance settings instead seek to preserve it. Exposure at 1/125 second, f/11.

from existing or added light, and it renders colors pleasing only if the white balance setting is correct.

Reflect a moment on what it is that you actually see. Your eyes see light reflected from objects. The source of light might be the sun, a tungsten lamp, a flickering candle, a campfire, a floodlight, fluorescent lights, or another kind of light source. Each of these lights has its own color cast or tint which is imparted to any subject reflecting that light.

Still not convinced? Let's start by considering the colors of sunlight. What color is the sun at sunrise and sunset? Of course, setting and rising suns are a deep orange, sometimes almost red. And at midday? Well, at noon the sun appears almost colorless, or what we would call "white," as white light is composed of equal parts of the color spectrum. Subjects illuminated by midday sun appear quite normal in

The orange rising sun illuminated these white ceramic greyhounds placed on a table opposite my open front door. The "Sunlight" white balance setting of the picture below most closely renders the scene as it actually appeared. You can see how different white balance settings affects the photo's appearance.

White balance setting: Sunlight

photographs. The closer the sun is to the horizon, however, the more yellow and then orange light becomes as the sun's rays travel through more atmosphere. It's that longer journey at sunrise and sunset that filters out the bluish light, leaving behind red, orange, and yellow tones.

Not surprisingly, when subjects are bathed by the rich orange lighting coming from a setting sun, they pick up some of that orange coloration. This is quite obvious if you've photographed a snowdrift, white sand dune, lighthouse or a pale face illuminated by the setting sun.

Artificial lights add their own colors casts. Tungsten household bulbs give pictures a distinct orangish cast; fluorescent lights can add a touch of green or greenish blue—and give faces an almost sickly color.

Weather, too, affects the quality of lighting. Cloudy days are a bit bluish, and shady areas illuminated by a cloudless blue sky are even bluer. Some color casts, particularly from a setting sun, can be pleasant. Some others aren't, and you may want to reduce or eliminate the undesirable ones. To ward off the excessive and

White balance setting: Custom

White balance setting: Cloudy

depressive blue from cloudy days and deep shade, you may want to achieve a more neutral color balance that reveals more of the bright colors that viewers expect.

To allow you to both counteract color casts and achieve neutral colors, your camera provides a White Balance control. It typically offers eight settings: midday sunlight, cloudy, shade, tungsten, fluorescent, flash, automatic, and custom. Each situational name—flash, tungsten, cloudy and so forth—is designed to give neutral or best color results for the lighting situation it's named after. The problem is you need to remember to change the setting when the light changes. Therefore, many photographers—the self-confessed absent-minded ones, anyway—simply set the camera to the automatic white balance setting and let it work its wonders under all types of light.

However, the automatic setting usually isn't quite as efficient as a situational setting. And for best results in critical conditions, you'll want to use the "custom" white balance setting. Following your camera manual's instructions, set the camera to the custom setting. Point the camera at a white card in the same light as your subject, position it so it fills the picture area, and take a reading. The camera adjusts its

White balance setting: Auto

internal color settings to render the image of the card white, and when you take your picture the colors in the scene will be neutral—as if they were being lit by the midday sun.

The most flexible method of all is to simply use the RAW file format. When you open the RAW file, it lets you adjust the color balance either by clicking on a white or gray object in the scene, or by adjusting a color temperature slider. I use the RAW file format when I'm concerned about achieving accurate colors.

The plain fact is that you may not always want a neutral white balance. Sometimes, you may call upon the white balance to warm up pictures. Many photographers, especially people photographers, regularly use the "cloudy" white balance setting even on sunny days because it adds a touch of extra yellow—giving people a slight tan that seems healthy. And color casts can also wash a picture with emotion. The warm orange of a campfire reflected by laughing campers toasting marshmallows and the cold blue of a cloudless winter sky caught in the shadows of a snow drift—these and other color shifts can reinforce the mood of a picture. Indeed, even the dreary tint of a cloudy day can make one long desperately for sunshine.

Exposure rules of thumb

I have to admit something. I don't entirely trust the meter on my camera as my exposures sometimes seem inconsistent. Admittedly, I could have inconsistent shutter speeds or a less then reliable aperture diaphragm that doesn't open and close smoothly. But, right or wrong, I blame the meter.

To that end, I sometimes switch to the Manual mode and set both the f-stop and shutter speed based on exposure guidelines for the lighting in the scene and the ISO I'm using. This technique is reliable when the subjects or areas you are photographing all reside in similar lighting. This practice is less reliable, however, when one part of the picture is in a sunlit area and another in the shade.

Nonetheless, it's good to memorize these guidelines as a way to quickly double check that your exposure settings are approximately correct.

The guidelines all revolve around the "Sunny 16" rule. The 16 in this case stands for f/16. The rule then is that on a sunny day your exposure should be 1/ISO at f/16. The shutter speed should be the same as the ISO setting. So if you set the ISO to 200, then to get a correct exposure on a sunny day set the shutter speed to 1/200 second (1/ISO) and the aperture to f/16. Or you could use an equivalent exposure because it would let in the same amount of light. Equivalent exposures would include, 1/400 second, f/11; 1/800 second, f/8; 1/1600 second, f/5.6, and so on.

This exposure is remarkably accurate for typical scenes. If there's lots of snow or light-colored sand, use f/22 as your starting point.

Now the tricky part is when clouds start to cover the sky. For each denser type of cloud cover, you would have to open up one stop. For instance, with a light overcast in which the sun seems to be covered by a veil, you would open up one stop: 1/ISO, f/11. For a moderate overcast in which you can't see the sun's disk at all, open up two stops: 1/ISO, f/8. For a heavy overcast, open up 3 stops. In full shade, say the west side of the house in early morning, open 4 stops.

Because evaluating cloud cover is somewhat subjective, these guidelines are less reliable than when you have the constant and reliable illumination of the full sun. But they're still good enough to use for comparison with your actual meter reading.

If the meter reading varies by one or more stops from the rule of thumb, you may want to bracket your exposures.

When the sun is shining you can use the Sunny 16 rule to double-check your exposure settings. Exposure at 1/125 second, f/16.

Adjusting exposure for light type

If you're a golfer, you know that once you get onto the green, you need to be able to read any slope that could send your putt off course. Likewise, when you are about to take a picture, you need to read the scene to see if there are any unusual lighting conditions that could throw your exposure off course.

Light meters work best with ordinary subjects and scenes in average lighting, such as a sunny day at the soccer field or the backyard pool, or an overcast day at the park. Such scenes consist of uniform lighting, meaning there's not a big mix of light and dark patches. As the mixture of light and dark areas in a scene grows or becomes more complex, exposure problems can arise. The main problem is when extra-dark areas appear and the subject is quite bright or vice versa—when the subject is quite dark but surrounded by extra-bright areas. Those very dark areas may result simply from dark subjects or from shadows created by the lighting. Although built-in computer programs compensate for a variety of situations, they aren't perfect.

Perhaps the easiest way to make sure you get a good picture in tricky lighting conditions is to take pictures using the RAW file format. It gives you a range of almost 4 stops (from+2 to –2) of exposure adjustment range in Photoshop to address exposure problems.

But an even better practice is to adjust your exposure to accommodate for the lighting in a scene. That way you can produce a well-exposed picture nearly all the time and not have to rely on the RAW file format to bail you out. The following section deals with entirely predictable exposure adjustment situations based on lighting direction.

Adjusting exposure for tricky lighting conditions

Most tricky lighting conditions result from scenes with a mixture of unusually bright or dark areas. Some situations are entirely predictable, for instance, certain directions of light or certain types of subjects like snow. If you recognize these conditions, you can usually achieve a good exposure by using standard exposure compensation. Let's first look at lighting direction and then extra bright or dark subjects in a scene.

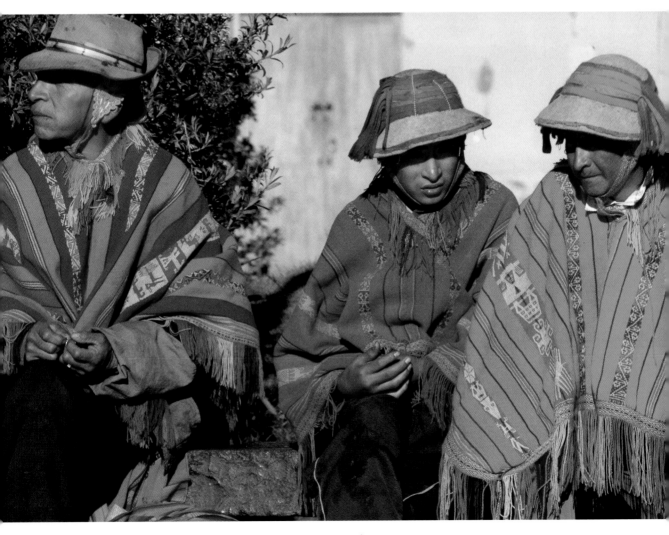

Because front lighting minimizes dark shadows, you usually don't need to adjust exposure to get optimum results. Exposure at 1/500 second, f/11.

Front lighting

The sun is behind you. The subject in front of you is fully lit and shows few large shadows. Lucky you. With front light, you've got a dead-on straight putt so there's usually no need to adjust the exposure—just shoot away and enjoy the results.

Sidelighting

When the sun shines on your subject from the left or right side, it usually creates some deep shadows. Shadows on the unlit side of a subject are dark and may hide pleasant or even critical details. To better show those details, you should let a bit more light into the camera to lighten the shadows. Typically, you would set the exposure compensation control to +1/2 stop. Check the picture's histogram to verify that the exposure adjustment you made has lightened the shadows enough to preserve important details.

The shadows of sidelighting can hide important details, particularly in people pictures. If you increase exposure by 1/2 stop, you'll lighten the shadow areas and reveal more details within them. Exposure at 1/250 second, f/11.

When you point the camera in the direction of the sun, you get extra dark shadows and more light that may fool the camera's meter. For best results, bracket exposure, taking extra pictures giving 1/2 and 1 stop more exposure. Exposure at 1/80 second, f/13.

Backlighting

Here the sun is shining into your face, and more importantly, into your camera. In addition to exposure errors, direct sunlight can cause flare, which can be like car headlights shining blindingly at you. Because the sun is behind the subject, the part of the subject facing you is in complete shadow—you may need to increase exposure up to a full stop. This lighting condition is tricky, so bracketing may be called for.

Extra-bright subjects

Increase exposure compensation 1/2 to 1 stop to let in more light and brighten the picture. Letting in more light for extra-bright subjects may seem counterintuitive but, as you'll see, it's the right move. These are actually subjects of extraordinary light reflectance that fill one-third or more of the picture area. They would include fields of snow, white buildings, large white clouds—really almost anything that is light gray or white.

A normal exposure rendered the snow too dark. Exposure at 1/125second, f/16.

The metering system tries to make these subjects "average" in brightness, like the meter reading for a grassy field or blue lake, so it will try to make them appear darker than they actually are. You compensate for this by forcing the camera to let in more light than it wants to.

I increased exposure by 1 stop to make the snow brighter. Exposure at 1/125 second, f/11.

Extra-dark subjects

For very dark subjects, decrease exposure by 1/2 to 1 stop to let in less light and darken the picture. These are subjects that reflect little light: black, deep gray, and other darkly-colored subjects such as buildings, storm clouds, lava fields, and black rocks.

The camera meter tries to make dark subjects average in brightness, which means it makes them lighter than they really are. Here I set the exposure compensation control to –1 stop to darken the black vase and black cloth.

normal exposure: 1/25 second at f/8

Again, the camera meter tries to make them average, which means it will try to show them lighter. Exposure compensation forces the camera to let in less light than it normally would.

1 stop less exposure:
1/50 second at f/8

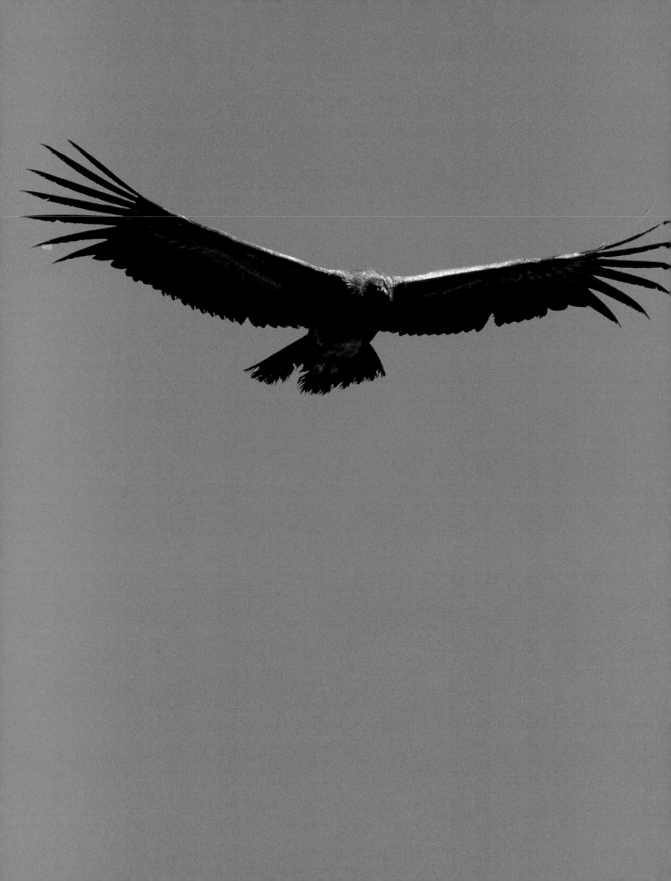

Chapter 3
How I Took These Pictures

For years I've been intrigued by how to reveal movement in still photography. How do you create, for example, the ideal picture of a white-water kayaker, a photo that would need to show her arms in motion and the action of her paddle churning round like the blades of a windmill. And how can a single, still photo be made to show the powerful pedaling—and some of the sweat and desperation—of a come-from-behind bicyclist as he races to overtake the leader only twenty feet from the finish line?

In addition to revealing physical movements of the world around us, motion photographers are also challenged to draw out some of the delight, surprise, humor, and deeper emotions we all associate with movement. Because humans are intensely emotional creatures and movement is the most intensely perceived of all the external events of our lives, there can be no denying our emotional ties to movement. Whether it's the heart jumping at the sight of a loved one's windblown hair, or the brain calculating the trajectory of cars flying through a busy intersection we must cross, movement does indeed move us.

The world of sports is a popular and rich source of movement and emotion for photographers: sports events positively drip with action-friendly adrenalin, an all-natural fuel additive that gives contestants a boost of both speed and determination.

Fortunately, photographers themselves don't need to be on the offensive line or on the back of a bucking bronco to feel swept up in the action. You feel excitement building at a sporting event even as you set up along the sidelines, focus from the bleachers, or scout out the best place from which to pan jumping horses or fast-paced cross country runners. Later, as you concentrate on the action and start to take pictures, you find that witnessing these contests of will and impressive feats of strength can dredge up powerful reactions from deep in your mind. Tucked away there are primitive brain circuits that still remember a time when athleticism was a survival tactic; then,

Sometimes the shutter speed you choose leads to a blurry impressionistic photo that bears little resemblance to what we normally think a photo should look like. I photographed this shimmying performer with a handheld camera set to a shutter speed of 1/6 second.

competition was equated with hunt or be hunted, fight or flee, and even mate or migrate.

Whether a sport you photograph is an individual effort to try to jump the highest, a hand-to-hand combat with fencing foils or fists, or a free-for-all muddle of mud wrestlers, you'll find plenty of opportunities at sporting events to try out your full spectrum of shutter speed settings.

Motion photography, of course, offers you more than just the traditional subjects, clichéd shots, and sometimes extreme emotions of organized sports. Allow yourself to draw emotions from scenes seemingly devoid of them. To some, the soft blur of a curtain blowing around a vase of sunflowers may simply be a windblown piece of cloth; to others, the display of this invisible force of nature can be haunting, perhaps calling back a childhood moment of a warm summer breeze playing through the house.

The camera can reveal motion in ways the eye never sees. Our human perception is that the motion of life is an ongoing and continuous saga—not an instant frozen in time. Your eyes can't perceive fast actions like the split-second of contact when a driver smashes into a golf ball. Thus you may have just seen your dog leap from a dock to get a stick you threw into the lake. But now—only a moment later—you can remember the action but probably not any of the details of what was happening. Without a photo you cannot recall the particulars of the dog's straining muscles, his tongue lolling from the side of his mouth and his ears flopping up. With the photo, telling details enrich the memory of a loyal friend.

County Fairs—Mania on the Midway

Step through the gates of a state, county, or village fair and you slip into a fantasyland of photographic opportunity. Bustling with a wide variety of activities from dawn to dusk (and later), fairs and festivals are wonderful places rich with activities that challenge your motion interpretation skills.

Exposure at 1/6 second, f/14.

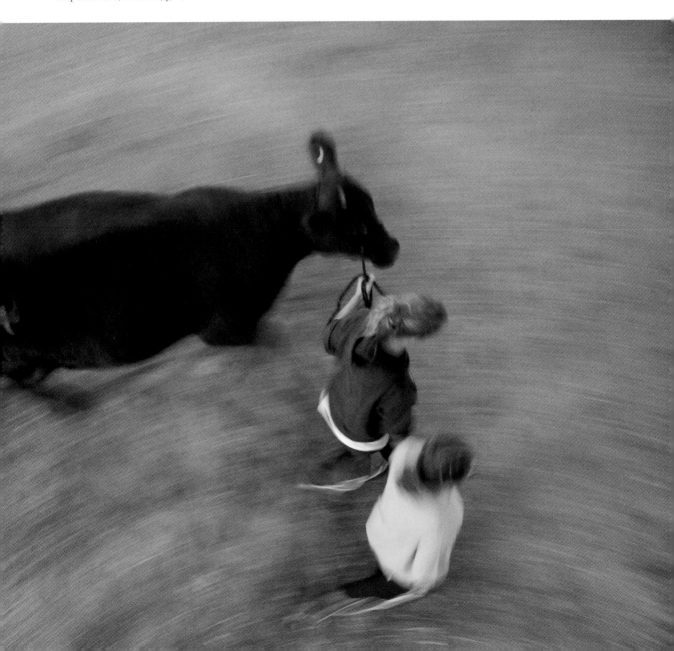

To obtain photos for this book I traveled to several sites, including the Crawford County Fair in Pennsylvania, the Wayne County Fair in New York, the New York State Fair in Syracuse, and the Firemen's Festival in East Rochester. Along the way, I encountered hurdle-leaping llamas, proud owners detailing their pigs with hose and scrub brush, strolling musicians strumming guitars, chainsaw artists carving eagles and bears, BMXers launching themselves from ramps and flipping upside

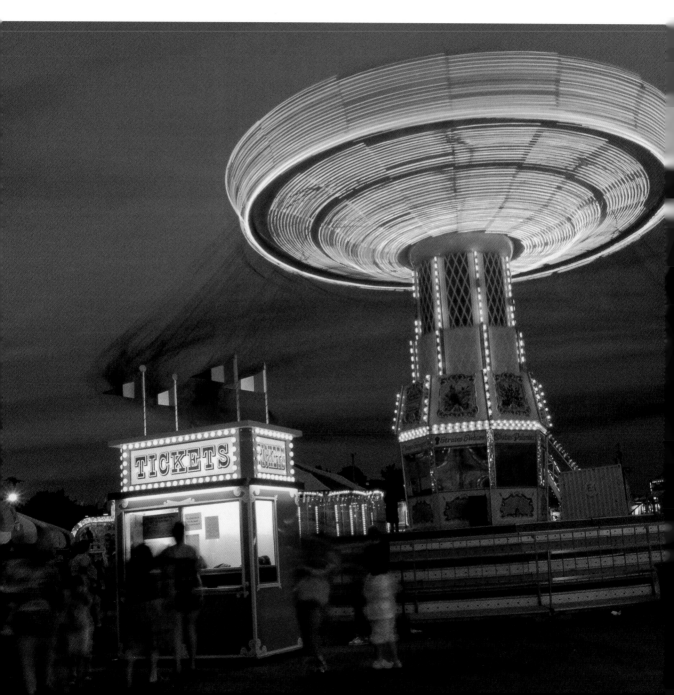

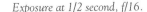

down on their stunt bikes. And that was just during the day. In the evenings, lights of Ferris wheels and a dozen other thrill rides spun incessantly through the twilight, their colors igniting against the darkening skies.

Here I will lead you through the thought process of some of the shots I took during my visits to the fairs.

4-H Clubs are a mainstay of fairs. At the Crawford County Fair, kids were taking their animals to and from the weigh-in scales and a long line of cows, goats, and sheep had formed. After their animals were weighed, the kids escorted them back to the livestock barn. Along their route was a stand of portable bleacher seats; I climbed up to the top for an "aerial" view of the arena. Because of the dim interior, even shooting at ISO 800 I was forced to use slow shutter speeds, within a range of 1/4 to 1/15 second. Since I couldn't get a sharp image (and didn't really want one) I panned the contestants escorting their animals.

A much larger event, the New York State Fair offers a whirlwind of activity that's almost overwhelming. Walking the grounds you'll come across a daily parade, a variety of famous entertainers on stage, grandstand activities like tractor pulls and sulky races, a large midway with carnival rides and games of chance, and an impressive array of agricultural displays. I spent two days there, shooting from mid-morning until after dark.

My favorite time of day was the start of twilight when the faces in the crowd began to fade into the dark along with other visual details. The screams and shouts of riders soaring through the dusk and the scents of cotton candy and corn dogs took over from visual feedback. But most magical of all were the colorful lights outlining the booths and the rides and glowing against the deepening blue skies of twilight. On the roundup, Ferris wheel, and aerial swing, the lights arced through the night with the ride, and I knew those colors would form amazing streaks with a long shutter speed.

So I chose a position to include a ticket booth in the foreground and the aerial swing in the background with fading streaks of sunset clouds embellishing the mood. With a shutter speed of 1/2 second, the lights and aerial riders in swings streak across the sky. In the foreground—heading to and from the ticket booth—excited fair-goers blurred into ghostly shapes.

Exposure at 1/2 second, f/16.

Curtains Lifted by a Summer Breeze

I spied the picture possibilities as soon as I walked into the bedroom: curtains at the open window, fluttering in a light summer breeze. As quickly as I managed to set up the tripod and camera, I wasn't fast enough. I learned that summer breezes are fickle and can't be counted on to waft curtains when you want them to.

I waited and waited for a breeze that never came. Rather than waste more time waiting for a wayward wind, I simulated a breeze by lifting and dropping the curtains. I placed the camera about eight feet from the curtains and set it on the two-second self-timer mode. Then I pressed the shutter release and did a quick three-step shuffle over to the curtains, pulled them up and spread them out like the train of a wedding dress. I then tried to drop them just before the self timer opened the shutter.

Judging by this picture you'd think I was successful. Well I was—but that's only because I played the numbers game. Many an outtake shows my hand still holding the curtains, or shows the curtains back at rest because I'd released them before the shutter opened. Suffice it to say that between my poor timing and the great variability of the appearance of the flopping curtains at different shutter speeds, I spent nearly an hour leaping from camera to curtains and curtains to camera. A remote shutter release would have greatly simplified my task.

Using shutter speeds ranging from 1/15 second to 1 second, I eventually found that shutter speeds around 1/4 second pleasingly blurred the moving curtains.

As in most aspects of life, contrast nearly always intensifies an experience. The contrast to motion is immobility. The contrast to white is color. So to contrast with the flopping curtains I chose an immobile but colorful subject—a flower vase. If you decide to try a picture like this, I suggest choosing a heavy, well-balanced flower vase. You'll want to avoid the possibility of having to clean up spilled water and shards of broken pottery or heirloom crystal.

Exposure at 1/2 second, f/16.

Swimmers— Half-Triathlon

This is a straightforward action shot I took for a book I was doing on the Finger Lakes in central New York. The swimmers are leaping into the south end of Cayuga Lake from a beach in Alan Treman State Park just north of Ithaca.

To catch the pandemonium, I decided to photograph the start of the race as the throng of triathletes thrashed into the water. I thought this transition from land into the water would reveal the most action, especially with lots of splashing as they first charged into the water, and then again as they reached the deeper water to begin swimming.

To get this picture I moved off to the side of the swimmers and waded into the water up to my knees. Then I stooped down a bit so I'd be more at the level of the swimmers, a move that helps pull viewers into my photograph. My intention was to make viewers feel like they're part of the action— out in the water, close to the pack of swimmers leaping right past their eyes.

Although for sports photography I often prefer blur shots over stop-action exposures, in this case I felt that freezing both the splashes of water and the burst of vigorous movements of athletes just starting the race would best tell the story.

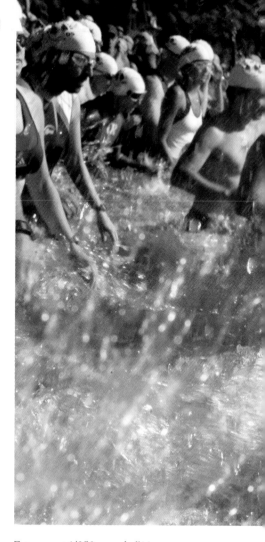

Exposure at 1/250 second, f/11.

I used a shutter speed of 1/250 second and an aperture of f/11. With the athletes springing into action at different speeds, the setting of 1/250 second shows some of them sharp and others subtly blurred. Maybe it would have been better to use 1/125 second so the blurred areas would have been more obvious, or perhaps 1/2000 second to make everything super sharp. The smaller picture, a crop from the original photo, shows an interesting pattern of water droplets obscuring the swimmer. Maybe next time I photograph similar swimmers, I'll try to replicate that. Studying your pictures often proves to be the best teaching tool.

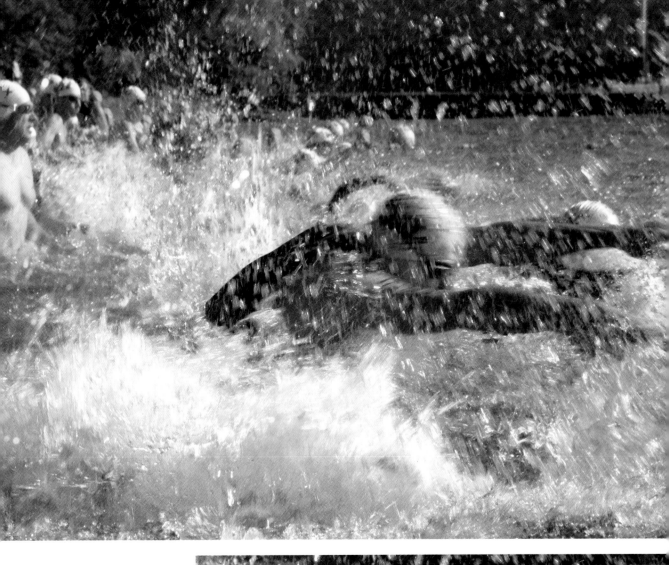

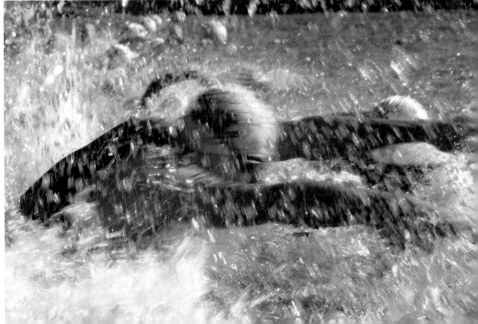

This is an example of reviewer's remorse (the reviewer being me). If I had a chance to take the above photo again, I'd probably zoom in for a tight shot similar to this cropped version.

Stunt Rider at the State Fair

The stunt rider in this picture was part of the entertainment at the New York State Fair. Two sets of ramps confined the action, and having watched the end of an earlier show, I expected that some of the best BMX tricks would occur just above the end of each ramp. Given the modest size of the crowd and informal nature of the sport, it was no problem for me to move into a prime position and get the angle I wanted.

You can use a moderate to slightly slow shutter speed in the range of 1/15 to 1/60 second to reveal the world both still and moving. You do this by intentionally blurring only part of a scene, leaving the rest of the picture area sharp. The part of the picture you choose to blur should be important or significant, because you are using the blur to draw attention.

Does it work? Turn your eyes away from this picture and then quickly look again.

The BMX show lasted nearly half an hour, giving me almost enough time to try my full repertoire of motion techniques. But what I really wanted was what I got for this discussion: a picture that showed everything sharp except the rider. To show the ramp and the spectators in the grandstand sharp and juxtaposed in contrast to the rider, I had to carefully choose my position.

Exposure at 1/60 second, f/29.

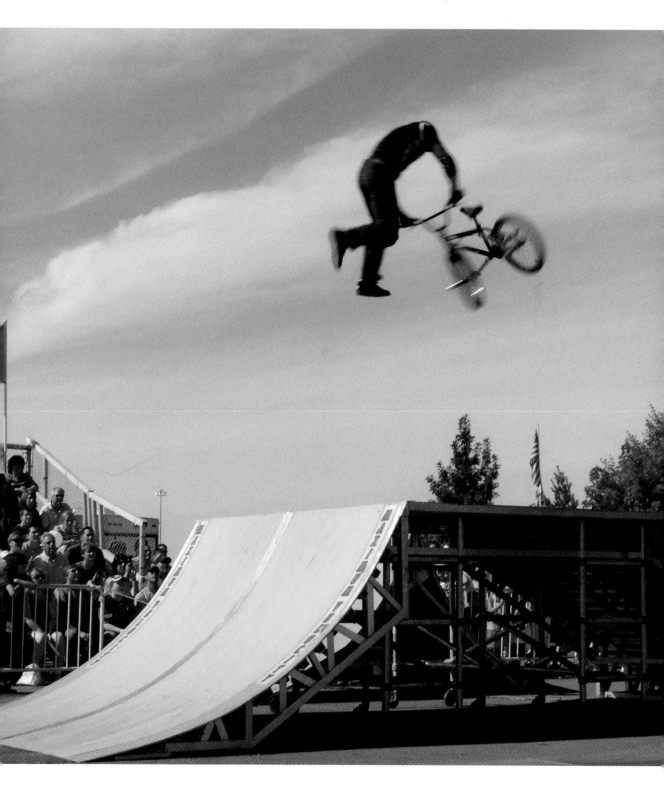

Perfect Timing for the Perfect Pose

A summer evening and I was once again driving around the Finger Lakes in central New York. The West Lake Road runs along the western side of Keuka Lake for most of its 25-mile distance. Cottages here are bunched together and always filled with vacationers.

As I drove along, out of the corner of my eye I saw a boy drop out of the sky. I slammed on the brakes and backed up about fifty yards to see what was going on. That's when I saw several dripping wet boys emerge from the lake and run into the open front door of an unfinished cottage. Dashing upstairs to the second floor, they quickly gathered on a balcony that overhung the water below.

Holding onto the balcony railing, one by one they climbed over it, leaned out as they gathered their courage, and then leaped into the sky. I wanted to join them— but instead asked the supervising adult if I could take a few pictures.

For some reason I had a prosumer snapshot camera in hand, which meant I could only get one shot of each boy's leap. The timing had to be perfect. And for this picture it was.

In this picture, he has turned in mid air; he's facing the setting sun and its warmth washes over him. Best of all he assumed a wonderfully graceful posture, with one hand clasped over his nose to block water from entering and the other raised to the sky as if in salute. The shutter speed was 1/500 second.

This is one of my all-time favorite pictures. Perhaps the real perfection of timing was that by pure coincidence I happened along while all this was going on. The more you're out taking pictures, the more such coincidences happen.

Exposure at 1/500 second, f/5.

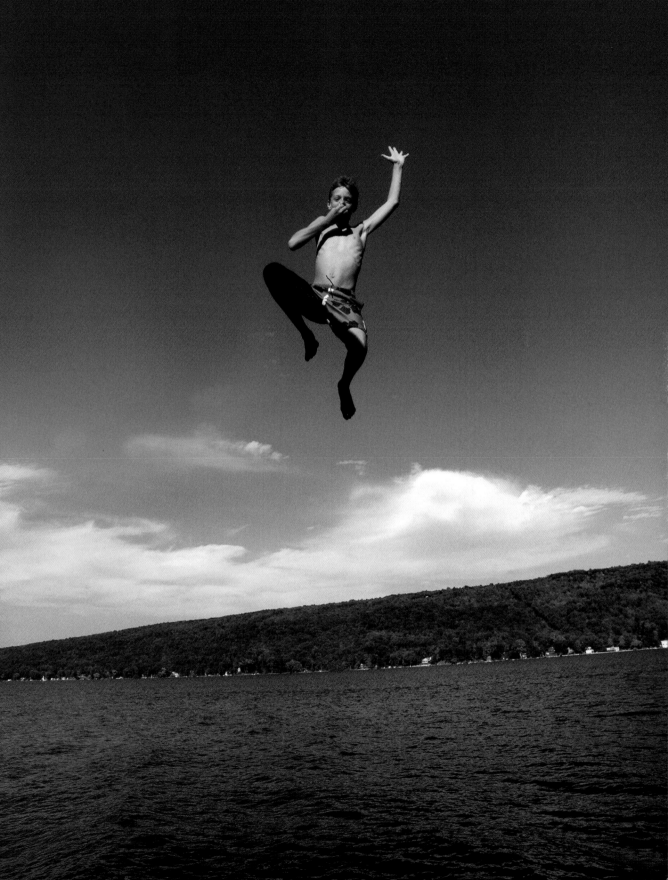

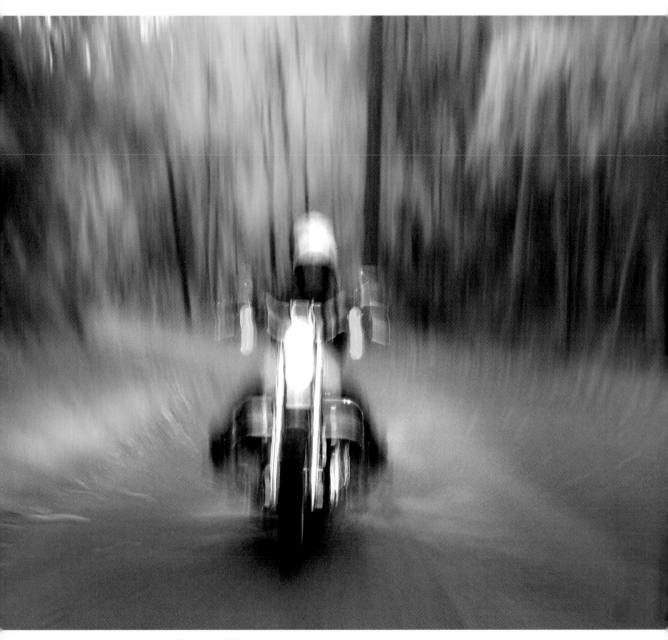

Exposure at 1/4 second, f/22.

The Planned Picture

Unlike the spontaneous picture of the boy leaping into the water, this one of the motorcyclist was entirely planned. Twice I had seen a yellow Harley tooling along back roads near the south end of Cayuga Lake. After I saw it the first time, a plan had formed in my mind for a picture. A few weeks later the same Harley passed me again, but going the opposite direction; by the time I'd wheeled my little station wagon around, the Harley had vanished.

It seemed as if I would have to find somebody else with a yellow Harley to participate in my little photo fantasy.

Then fate intervened. (Or is that coincidence working again?) I was visiting my twenty-five-old daughter in Ithaca, New York. She suggested we go to this little ice cream place. We did—and there in the parking lot was the same yellow Harley. As I walked up to the order window, I kept my eye open for a guy in motorcycle clothes. And there, finally, helmet in hand, was my road king: dressed in black leathers, eating an ice cream cone and running her hand through her long blond hair. Just like in the commercials, my elusive rider was a woman.

My daughter probably wondered what I was up to as, with no word of explanation, I left my place in the ice cream line and walked over to the leather-clad woman. And propositioned her. It turned out she was a professor, and, of course, my proposition was innocent enough: I asked if I could photograph her riding her Harley along a back road lined with autumn trees.

Now that I had my motorcycle model I needed to enlist a friend with a van. A week later everything was in place: we opened up the van's back door and, as my friend drove, I photographed the yellow Harley following along behind us.

There was one hitch. Those country dirt roads were incredibly bumpy. So—instead of my photos showing a smooth, continuous blur of the road and trees with the motorcyclist revealed fairly sharp—most pictures seemed like they were taken with the camera attached to a jackhammer. But several of the shots I liked, and this is one of them.

Boredom—The Great Creation Motivator

What the heck? That's probably what you're wondering when you look at this picture taken on a long, ho-hum, post-vacation drive back home. But, hey, trying out some new shooting techniques to pass the time has to be more fun than playing the license plate game or holding your breath every time you pass a graveyard (I guess knowing those games reveals my age group).

Instead of taking the wheel, I chose to sit in the passenger seat and figure out ways to take pictures while going 65 mph. Now that's real fun.

If you're going to shoot photos from a moving car, choose back roads and secondary roads that pass through small villages and zip by farms. On the 65 mph interstate, you're more limited to subjects like Walmart tractor trailers and then you find yourself daydreaming that you'll somehow take a shot that Walmart will want to pay ten grand for.

Exposure at 1/60 second, f/5.

But on the small roads, you pass town halls, a variety of churches with an assortment of steeples, water towers, intersections, barns, bales of hay, horses, and a generally wide mix of visual possibilities.

While returning home from a road trip I tired of admiring the autumn leaves and pulled out my camera. I turned off the auto focus and set the focus to infinity, the exposure mode to Shutter Priority and began experimenting with shutter speeds from 1/8 second to 1/60 second. Since you're introducing disorienting blur into the picture, you might as well reinforce the disorientation by tilting the camera at varying degrees.

I'm not sure you'll agree, but I had my greatest success with churches like this one. We were going about 30 mph, the shutter speed was 1/60 second and the tilt was on purpose. Now, it would've been even better if there was a graveyard included (I think I'll try that today since there's an ideal combination of church and cemetery nearby).

So what do you think? Your cup of tea, or not?

Luck, Not Skill

This shot is of the Portland Head Lighthouse, just south of Portland, Maine. The whole scene—from almost any angle, from nearly any time of day—is postcard perfect. After getting my cliché postcard-style shots, I decided to try and get a photo that I could use in this book, one that invokes motion as well as the essence of a lighthouse standing precariously on the shore of a treacherous New England coast.

To me that meant composing a picture showing water in motion, perhaps a giant Atlantic wave crashing against the rocks, with the lighthouse in the background. But the sea was quite calm, so I didn't get my hopes up. I thought I might have to settle for a wavelet washing and sloshing its white foam through the dark rocks in the foreground.

Thus it was that the calm sea lured me to the very edge of the rocks. I'd left my tripod higher up on the path but—as I intended to show motion—I knew that I'd need to use a support-required shutter speed of 1/20 second or slower. Working my way over large rocks, I finally found a good location and stooped down to use a low rock outcropping as a platform to steady my camera.

Needing an even lower vantage point, eventually I stretched out on a large flat rock. Now I had a nice set of jagged rocks in the foreground, the lighthouse in the distance—and the gentle sea lapping at the soles of my shoes. I took a series

of pictures showing white wavelets breaking over the dark rocks. As I pondered my next move, I subconsciously heard the pebbles and smaller rocks clattering against each other. But before I could process the meaning of their noise, a good-sized wave smacked against the rock, soaking me and the camera.

I immediately dried off the camera, and several times wiped and breathed on the polarizing filter over the lens to clean it. Despite repeated cleanings, as this picture shows, I wasn't quite successful. A salt residue had quickly formed on the filter and fogged the subsequent pictures I took.

Although I used a shutter speed of about 1/15 second to reveal some blur in the water, what makes this picture for me is the soft, somewhat random blur from the earlier wave that splashed me and fogged the filter.

My inability to clean the filter proved to be my good fortune. Do you like the effect? It's not the first time the fates have intervened to improve my pictures.

Exposure at 1/13 second, f/32.

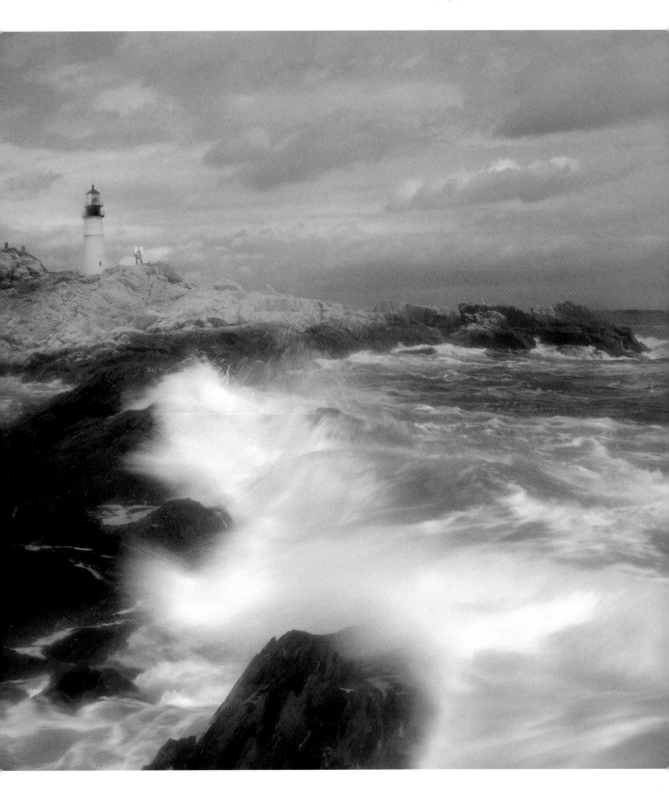

Everyday Life—in Peru

Climbing the steep steps, I paused and gasped for air. I was in Cusco, Peru, perched at 11,000 feet on a steep Andes mountainside. You might say the city was breathtaking. I was visiting my daughter who had just finished a couple of months of Spanish language school in Cusco; now we had plans to travel together in Peru and Bolivia. I'm in decent shape, but no match for thin air and steep streets.

Still, my first trip to South America delivered an amazing world. In Cusco, dogs and blue doorways popped up everywhere—as did strolling vendors besieging and

beseeching me to buy postcards, fresh flowers, scarves, blankets, and trinkets. But most intriguing of all were the swarms of bicycle-powered contraptions clattering along the cobblestone streets.

I awoke early on my second day and trolled the streets trying to catch some of these pedal-powered wagons as they flew by. Some pulled a small carriage—specifically designed for passengers. Others hauled a flat bed—clearly intended for cargo. A few seemed to handle both cargo and passengers.

It could be no easy task even for a native driver accustomed to the altitude to pull a passenger or two up the steep slopes. Perhaps the bicycle-equipped entrepreneurs only took them downhill and left the uphill strain for the motorcycle versions.

I began panning them using shutter speeds ranging from 1/4 to 1/60 second. Soon along came a young man pedaling and laughing with his passenger. His setup was reversed—rear engine power—he pushed a two-wheeled wagon in front of his bike. His passenger, a young boy, also laughed and often reached out to the driver.

I suspect the driver was delivering his child to school. As they laughed and chatted, I noticed each reach up a hand to exchange something. They were playing cards.

I snapped off a couple of shots and this is my favorite. What I like most about it is remembering their laughter as they swept by.

Exposure at 1/6 second, f/9.

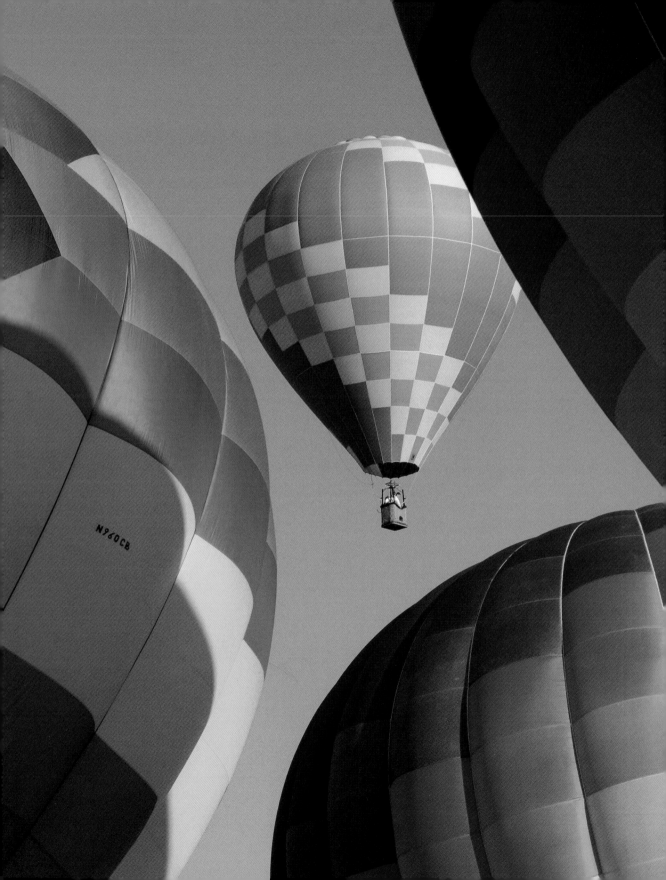

Balloons Away

Although I've been photographing hot air balloons for many years, only when it came time to take a few shots for this book did I realize that somehow a slow-moving balloon can be harder to photograph than a motocross bike that shoots out of the woods, roars round a curve and—in a split second—disappears from view.

Although hot air balloons seem poky, they are big. Bigger than elephants. At a festival with twenty or more house-sized balloons inflated and inflating all around you, it's like you're wandering amongst a herd of lumbering elephants.

And then these elephants become airborne.

Hot air balloons launch only if the winds are under 10 mph, so stopping their action is no problem. Keeping up with it can be. (You quickly learn that something the size of a balloon can cover a lot more ground than you can.) And unlike motorized sports that run laps on a course where you can reliably predict where the action will occur, the movement of balloons seems random.

Add in a dozen or more balloons in different stages of launch and you face a constantly shifting visual arrangement. A balloon lifts into the air and for a split second it hangs in the background, framed by two foreground balloons still on the ground. But—because every balloon is in motion relative to all the others—this particular composition lasts for just an instant. Even if the background balloon remains stationary, slight breezes may tilt the balloons in the foreground left and right, randomly opening and closing the gap through which the background balloon so beautifully hangs.

Exposure at 1/250 second, f/10.

Review Without Prejudice

As I was reviewing pictures for this and other chapters, I came across the one shown here. If you're going through this book from front to back, you may have already seen a few more photos of wave runners and jet skiers recorded using the more conventional techniques of stop action and panning.

In fact, you may even wonder why I picked a photo that seems a bit too blurred. If that's what you're thinking I have to admit I agree with you. Or did.

What struck me as I was trying to pick out pictures that represent specific shutter speeds was how much I wanted to choose pictures that epitomized the techniques of stopping and panning action—photos that showed razor sharp detail of a rocket subject frozen in mid air or strong blur for a panned shot. After looking at the same few thousand photos over and over again, I started becoming bored with seeing the same type of picture again and again (these are all mine naturally).

That's when I began to see alternative approaches with a fresh eye.

I must have ignored or rejected this one twenty times. It's a shot that's softly blurred not by panning but by using a moderate shutter speed of 1/60 second. I did this deliberately. Now I like it. It conveys the intense bouncing and pounding a jet skier endures. Struggling to hold onto his craft, the rider skips across the surface only to be jolted to the joints when he smashes his machine through the wakes of other water craft. He teeters and twists precariously on turns and struggles to stay upright.

The lesson for me was not to become trapped in your own channels of likes and dislikes, but to remain open to new paths be they your own or somebody else's.

Exposure at 1/60 second, f/25.

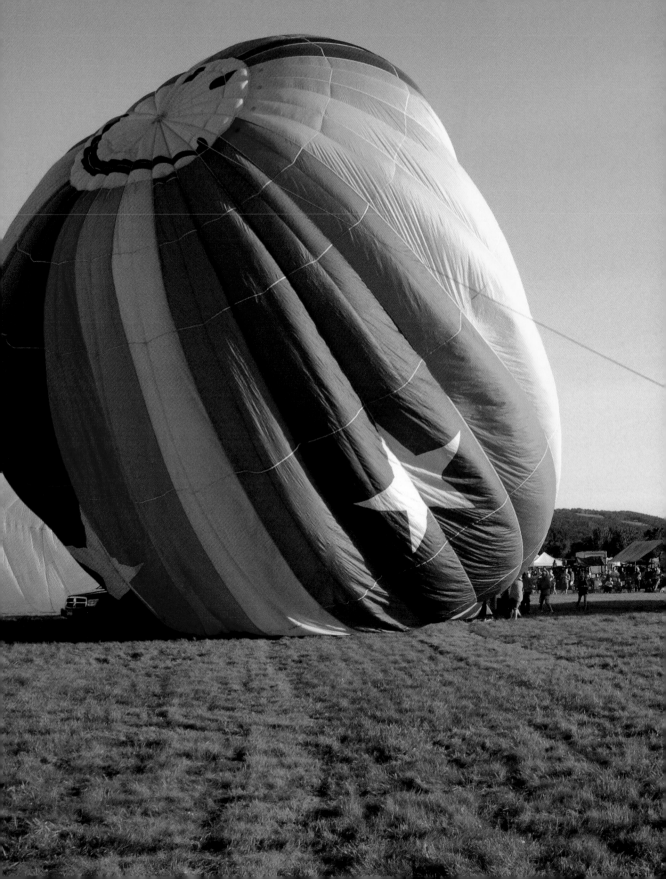

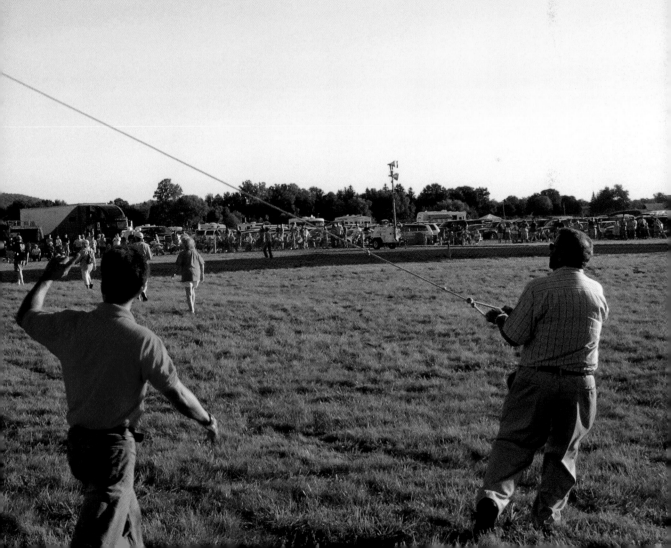

Chapter 4

Tools and Controls
to Exploit Shutter Speed

Whether your passion is golf, woodworking, gardening, sewing, or bicycling, there's one piece of advice that stands above all others. Get a good set of tools. For you, that means a good camera. Yes, it's a bit like telling a jockey to get a good mount or a NASCAR driver to get a good car, but without a camera capable of providing you high quality, well-exposed photos, your time and effort could be wasted.

When you're shopping for a digital camera, it's easy to bury yourself in hundreds of specs without really understanding what's relevant. Most people start off the selection process with a camera's resolution in megapixels. That's not a bad place to begin, but if photographing a variety of active subjects with a variety of techniques intrigues you, then you'll likely want to consider some of the features and accessories discussed in the next few pages.

As you know, equipment can make a big difference in results and it's tough to evaluate a camera model on your own. Before buying, I urge you to visit camera review websites, such as www.dcviews.com, www.dpreview.com, www.stevesdigicams.com, and other sites to get expert, in-depth analysis of the newest digital cameras.

The camera you need is a dSLR

To maximize your ability to capture light and motion, you need a dSLR (digital single-lens-reflex) camera as opposed to a snapshot camera.

Because I'm a value seeker (okay, cheapskate) and want to stretch my hard-earned money, I tend to get a high-end prosumer dSLR camera. Typically it costs about half or less of the comparable professional model from which it is descended while offering most of the same features. One of the main differences is that the amateur and prosumer versions are often housed in a less rugged body. Another difference is that these lower-end models typically come to market six months to a year after the introduction of the pricier parent professional models.

A digital single-lens-reflex (dSLR) camera offers superior image quality even at high ISOs and fast responsiveness that makes it ideal for action photography.

As a motion shooter, you need a camera with a top shutter speed of at least 1/2000 second, preferably 1/4000 second, and ideally 1/8000 second. But 1/4000 second can meet 99% of your needs. The longest shutter speed setting you'll likely need is about thirty seconds. Although nearly all cameras offer a "Bulb" setting that keeps the shutter open as long as you want it to stay open, make sure the model you choose includes it. A top flash synch speed of 1/250 second adds a bit of versatility, but 1/160 or 1/125 second suffices.

For creative effects—so you can achieve fast shutter speeds even in dim light and ultra-fast shutter speeds in bright light—look for a camera that delivers high quality (low noise) images at high ISOs like 800 and 1200. Most cameras made since 2007 offer good high ISO image quality, so this shouldn't be a problem.

What else should you look for from the perspective of photographing motion? Highly desirable is a very responsive camera. Fast response comes from quick and reliable focusing, a good burst rate (six or more images per second at full resolution), and ergonomics that let you interact quickly with the camera. Good ergonomics are somewhat subjective but with them you can easily and quickly make the camera settings you need without constantly resorting to the camera manual. A poorly-

For fast-moving subjects you need a dSLR for its responsiveness. It can focus quickly and accurately, and take a large number of pictures rapidly. Exposure at 1/500 second, f/11.

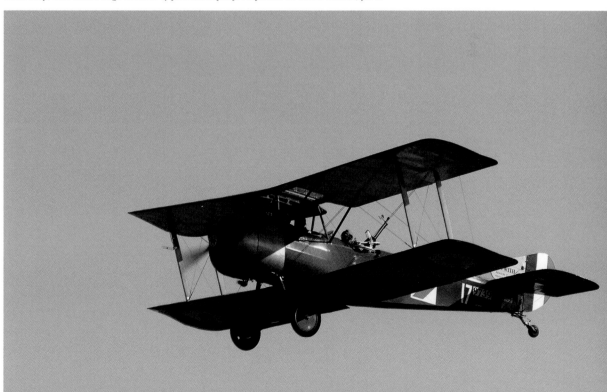

designed camera will not only frustrate the heck out of you but cause you to miss many good photo opportunities.

Is there a particular brand or model you should consider? It's hard to go wrong with the longtime leaders—Canon and Nikon. Olympus and Pentax have also been around for quite a while. Sony is the new guy on the block (taking over what was once the Minolta brand but sufficiently changing things—except lens mounts—to be considered a brand unto their own). Most of the newest dSLR cameras—regardless of brand—offer exceptional quality and capability. Perhaps the biggest advantage of going with a Canon or Nikon is the number of accessories available for them. In summary, before you choose a camera, research the camera review websites and then go to a store and handle the one or two models you prefer before buying the camera.

But let a snapshot camera tag along

Compared to a good dSLR, even the best digital snapshot camera falls short in many areas. This is especially true when photographing action, when you especially need fast response. To begin with, most snapshot cameras have motorized zoom lenses and these are woefully slow to change focal lengths. Most have modest minimum-to-maximum aperture settings that significantly reduce available shutter speed range for creative effects. Most focus much slower than dSLRs and, relatively speaking, can't keep up as well with high-speed subjects. Most give poor image quality above ISO 400 (too much noise). And many cannot match the rapid-fire shooting of a dSLR.

Having just listed the many disadvantages of a snapshot camera you may wonder why I use one as a backup. Simple—it can take excellent photos and offers much versatility, starting with extreme portability that lets you slip it into a roomy pocket so it's handy and available wherever you go. Although mine has a modest 5X zoom lens, the lens is sharp and produces superb photos. Other prosumer snapshot cameras offer zoom ranges up to 24X—that's a lot of telephoto power. Most also feature image stabilization, easy-to-use controls, and a video mode (now becoming more common on dSLRs).

So while a snapshot camera may not match the capability of my dSLR, it can produce excellent photos. And its compactness and convenience makes it the ideal traveling companion.

High-end snapshot cameras excel for casual photography and serve well as a backup camera for serious photographers.

My snapshot camera couldn't react fast enough to catch this motorcycle before it disappeared from view.

Controls that put you in the right mode

Like a door swinging open and shut, the camera shutter seems to operate independently. But that's not so. Few camera functions work in isolation. Just as the shin bone is connected to the knee bone and the knee bone is connected to the… Well, you get the idea—the same principle applies to your camera. And unlike your body which only has 206 bones, your camera is crammed with a multitude of external controls and software-driven menus that connect hundreds of selections, giving you a head-spinning and brain-numbing number of choices and combinations that impact how you use shutter speed.

There will be many times when you can simply set the shutter speed and be about your business. But when photography moves to the fringes of light and speed, your choices become critical.

Before I drag you into the swamp of functions here's a preview of what awaits you. The functions most important to creative motion capture include exposure modes, ISO settings, exposure compensation, bracketing mode, focus controls, rapid picture-taking controls, file format, mirror lockup and exposure delay.

By the way, different camera models implement these controls differently. They may even give them different names. So read your manual to make sure you know how to use them with your camera.

A variety of controls, such as ISO and quality settings (file size and format) impact how you photograph moving subjects.

Exposure modes

By setting the exposure-mode control you can tell the camera how to prioritize the shutter speed-aperture combination. There are four basic exposure modes: Manual, Aperture-Priority, Shutter-Priority, and Program. Some cameras also offer scene modes, sometimes a dozen or more that are supposed to simplify picture taking. Typical scene modes are named after the situations they're designed for: portrait, party, scenic, action, night, beach, snow, backlight, and so forth. Although handy for casual photography, scene modes don't let you choose specific aperture or shutter speed settings.

A single dial lets you quickly choose the exposure mode (marked in letters) or scene mode (indicated by icons) you want for the subject before you.

The Shutter-Priority mode (sometimes called Tv for "time value") stands out because it lets you choose the shutter speed you deem appropriate and it then sets the aperture for a correct exposure. This gives you the power and discretion to execute whatever creative vision you intend. Do you want to pan? Choose a shutter speed of 1/30 second. Do you want to freeze your kid jumping into the pool? Choose a shutter speed of 1/500 second.

Of course, there's one caveat. You still need to monitor the aperture chosen by the camera to make sure it fits your needs. Sometimes you may select a shutter speed that is beyond the camera's capability to give a correct exposure (meaning there's no aperture that can work with the shutter speed selected to give a correct exposure).

The Program mode excels for casual photography where the subject demands neither a specific aperture or shutter speed. I drove by the fields of my farmers' market friend, Ron, and saw he was weeding his snap peas. So I grabbed a few quick snapshots of him at work. The exposure was 1/125 second, f/5.6.

If the aperture doesn't meet your creative or correct exposure needs, your primary option is to change the ISO setting, increasing it if you want a smaller aperture (larger f-number), decreasing it if you want a larger aperture (smaller f-number). Alternatively, you may need to change the shutter speed to obtain a correct exposure. For example, you may set a shutter speed of 1/8 second on a sunny day only to find there's not an aperture small enough to give correct exposure. Then you would need to set a higher shutter speed, such as 1/30 second, to achieve correct exposure.

The Aperture-Priority (Av) mode lets you set the aperture you want, the camera then sets the shutter speed. Choose the Aperture-Priority mode when setting the correct aperture is critical to a successful picture. One common situation would be

Use the Aperture-Priority mode when you want to set a specific aperture to either show the entire image sharply or just a very limited area. I set the aperture to f/18 (shutter speed 1/125 second) so I could show both the foreground boats and the background buildings sharp.

Choose the Shutter-Priority mode when you need a specific shutter speed to achieve the effect you want. Both the geese and the tour boat were moving. I didn't need a fast shutter speed, but I did want to show them sharp, so I set the shutter speed to 1/500 second (aperture f/8).

when you want to use a large aperture (such as f/2.8) to create shallow depth of field so the subject appears sharp against a very out-of-focus background. (This technique is called selective focus.) Another time when aperture selection would be critical is when you need a small aperture (f/16 or f/22) to achieve the great depth of field needed to show a scene sharp from the foreground to the background.

The Program mode sets both the aperture and the shutter speed, usually trying for intermediate (or middle of the road) choices on both. It tries to set a shutter speed fast enough to stop moderate action and an aperture small enough to give you a moderate amount of depth of field so most of the picture is sharp. Typically, you would use the Program mode when you are taking snapshots and aren't overly concerned about getting the perfect picture (that's not to say you won't still get some great shots).

With the Manual mode, you set both the shutter speed and the aperture. You also have to check the exposure meter readout to make sure the settings you choose will yield a correct exposure. Use the Manual mode when you face tricky lighting that can easily fool the meter into giving you a bad exposure.

ISO control

This simple and perhaps most fundamental control determines the light sensitivity
of the camera's sensor. Settings typically range from ISO 100 all the way to 12,000.
A few cameras even offer ISO 25,000 but such a high setting is virtually unusable
because of the excessive noise it creates. Each doubling of the ISO number
represents a doubling of light sensitivity. Looked at another way, every time you
double the ISO, you can double your shutter speed. Good to know when you're
shooting fast moving subjects in dim light.

In general, for a given camera, the lower the ISO setting, the better the image
quality. However, in the past few years camera manufacturers have worked hard to
improve the image quality offered by higher ISOs. The result is that newer dSLRs
give excellent results at ISOs up to 1200. The reason higher ISOs reduce image
quality is because at each higher ISO setting the camera increasingly amplifies the
signal from the sensor, which also amplifies the noise (stray colored pixels) that's
part of the signal.

When image quality comes first, use a lower ISO. But for stop-action photography
where freezing subject motion is imperative, expect to regularly use ISOs of 400 and
800 and occasionally higher.

*On most dSLR cameras, setting the ISO
requires you to work two controls—an ISO
button and a change dial.*

ISO 200

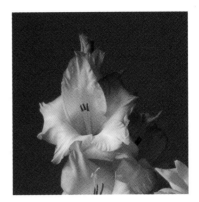

ISO 400

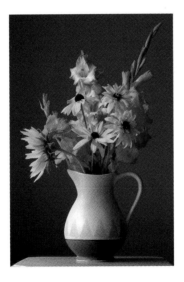

ISO 800

ISO 1600

Notice how electronic noise (groups of colored pixels that form splotches) increases at higher ISOs. Test your camera at different ISOs to find the highest ISO you can use without noise becoming a problem.

Exposure Compensation

This is a control you may use often. How do you know when to use it? Use the Exposure Compensation control when the histogram for a picture indicates the exposure is slightly off.

Once set, the Exposure Compensation control automatically adjusts exposure when you are shooting in automatic exposure modes, such as Shutter-Priority or Aperture-Priority mode. If you're in the Shutter-Priority mode, it will most likely shift the aperture setting and maintain the shutter speed you chose.

The amount this control changes exposure depends on how you set it. You set the incremental change you prefer using the camera menus. Available exposure increments are typically 1/3, 1/2, or even a full stop. I normally use a 1/2 stop exposure change. To increase exposure, you choose a value with a plus (+) sign in front of it. To decrease exposure, choose a value with a minus (-) sign in front of it. For example, +1 increases exposure by one stop and -1 decreases it by one stop.

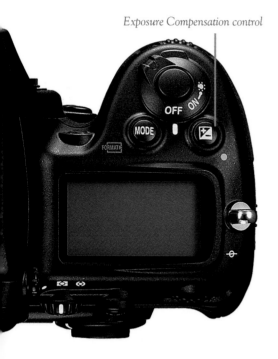

Exposure Compensation control

Why do you need this control? Because your camera's exposure system isn't perfect. There are thousands, indeed millions, of different scenes out there in the world. Each consists of a different mix of colors, shadows, and light areas. Sooner or later (trust me, sooner), one of these scenes will trick your camera into giving a poor exposure (too bright or too dark). So when the histogram indicates the exposure is incorrect, you need to step in and alter the settings. If the exposure is too dark (much of the histogram is on the left side of the graph), set the exposure compensation control to +1/2 or to +1 and retake the picture—again checking the histogram. If the histogram indicates the picture is too bright (much of the histogram is jammed up against the far right side of the graph), set the exposure compensation control to -1/2 or to -1 and retake the picture (again checking the histogram).

Use the Exposure Compensation control to vary the brightness of your pictures so you can obtain a good exposure as indicated by the histogram.

When the scene lighting fools the camera meter into giving exposures that are too dark or too bright, use the Exposure Compensation control to change the exposure. Here I set it to +1/2 stop to brighten the picture on the right.

Bracketing mode

Most dSLR cameras offer two forms of bracketing—one for optimizing exposure, the other for optimizing creative results.

With the Exposure Bracketing mode you can automatically create a series of three to seven photos (you decide how many) in which you both increase and decrease the exposure at pre-determined values. You end up with pictures ranging from overexposed to underexposed; from the series you choose the image you prefer. The term "bracketing" is used because the best exposure typically falls inside of the extreme exposures—in other words, it's bracketed by them.

The Exposure Bracketing mode lets you automate the process of taking a variety of exposures of the same scene.

1/30 second, f/11 *1/50 second, f/11*

To activate the exposure-bracketing function, you usually need to press a button or two on the camera. However, to set the increments used in bracketing (typically 1/3 or 1/2 stop), you may need to dig into the camera's menu system just as you do for exposure compensation. Normally a three-picture (three-exposure) bracket will suffice, but your system likely offers you up to a seven-picture exposure series.

You can also set the camera to create a bracketed series of shutter speeds for creative purposes. Say you're panning a cross country runner and want to try using 1/10, 1/20, and 1/30 second shutter speeds to see which gives the best results. You can do that with a shutter-speed bracket series. The difference here is that an equivalent exposure is used so all the pictures will have the same brightness. The advantage is that you can quickly take several pictures at different shutter speeds without having to fumble with controls.

1/100 second, f/11

Focus controls

Focus controls may seem to have little to do with exposure. They certainly don't influence how bright or dark a picture is. But—in the spirit of the knee bone connected to the thigh bone—consider focus to be connected to the exposure bone. Put simply, the act of focusing needs to be coordinated with (and accomplished before) the opening of the shutter. I think there's little question that you want your

Focus-mode selector

Learn the location and settings of your camera's focus controls so you can quickly set them to match the situation you are photographing.

picture to be in focus by the time the shutter opens. Admittedly, it's an expectation you probably take for granted. But as we all have learned the hard way, taking things for granted can leave you shaking your head at your own (well, mine anyhow) stupidity. So especially when dealing with the hyper-speed processes involved in photographing action, don't take focusing for granted.

Achieving fast, accurate focus is one of the biggest challenges facing a camera. Camera manufacturers know this and have provided you a variety of choices, probably too many, to accommodate the full range of situations you'll encounter. Some options your camera likely offers include where it prioritizes focus in the viewfinder (allowing you to move the focus brackets to almost any position in the viewfinder), how it focuses, how it predicts focus based on the path of a moving subject, and when it decides to stop focusing as you take the picture. This all sounds very complicated. Fortunately, it isn't. Most of the time you simply set one or two controls and you're ready for focusing on fast-action subjects.

The focus mode is the most important of the focusing controls. It typically offers you three settings: Single Servo focus, Continuous Servo Focus, and Manual focus.

Single Servo focus mode

Single Servo and Continuous Servo focus modes are the opposite ends of the same function. With Single Servo focus you press the shutter button and the camera locks focus on the subject beneath the viewfinder's focus target (or on the camera LCD) and won't refocus unless you release the shutter button. If the subject was moving at the time you pressed the shutter release, the camera may also engage predictive focus that would again adjust focus—this time to where it thought the subject was headed. You might see a problem. If your dog is dashing after a Frisbee, predictive

focus might work because the Frisbee's path is fairly predictable. However if the dog is chasing a cat, and the cat swerves and doubles back, predictive focus won't work. This is because it makes its focus decision when you first press the shutter button and doesn't change it even if the subject keeps moving.

Continuous Servo focus mode

Unpredictability is why the continuous servo focus mode is best for action photography. Once you lightly press and hold down the shutter button, the camera continuously focuses on the moving subject until you take the picture. If the subject was still when you first touched the shutter button but starts moving before you fully press the shutter button, continuous servo focus detects that movement and

Why a box of baking soda? It's the target I use to test my camera's focusing accuracy.
Its bright colors, big type, and well-defined shape make it easy for cameras to focus on.

readjusts the focus. As long as you lightly depress the shutter button, continuous servo focus keeps adjusting focus on the subject. Once in this mode, most cameras predict the direction of movement and slightly alter the focus to account for the subject's slight movement between the time you press the shutter button and the shutter opens.

Manual focus mode

What is the manual focus mode and why would you use it? Manual focus is when you turn a focusing ring on the lens to change where the lens focuses. Obviously it's a somewhat slower process than automatic focusing, so why use it? Well sometimes the camera has trouble focusing on a scene, particularly low-contrast scenes, such as a foggy seacoast or in very dim light. In such situations, you can often hear the focus motor repeatedly turning on and off as it tries to find the correct focus point—and if you're looking through the viewfinder (or at the LCD if yours offers a live view) you may see the scene going in and out of focus. Other times (particularly in close-up photos) you may want to be sure the focus is very precise, so it may be easier to take over the focus from the camera.

I don't manually focus a lot, but I do like to have it as an option.

Trap focus mode

Trap focus is aptly named. When a subject enters the trap—in this case a focus area you have chosen—trap focus tells the camera to take the picture. You turn on the trap focus mode, prefocus on the area where you expect the action to take place, and await the arrival of the subject. When the subject enters the predetermined focus area, it "trips" the camera, which takes a picture. It works best when you know where a specific action will take place—say a high jumper leaping over a bar, a sprinter stretching out to cross the finish line, or a bird landing on a feeder perch.

You can get some great action shots using this special focus mode, but since it fires the moment the subject hits the "trap" location, it prevents you from timing a picture for a specific pose or posture.

As with all these functions, carefully read your manual for any nuances (and new advances) that your camera model may offer.

Rapid picture-taking

When the action flies faster than the cards zipping out of the hands of a Vegas dealer, your reaction time has to be dead on. You also need to set your camera to machine gun picture-taking that can keep up with the action.

With your camera set up properly, you can easily take a series of pictures to show a sequence of action. I picked this sequence of pictures from a series of ten photos that I took in about two seconds as the bird landed, grabbed a seed, and flew away.

Fortunately, there's just such a mode: the Continuous Shooting mode (sometimes referred to as rapid or high speed mode). When you set the camera's shooting mode to continuous, you can hold down the shutter button and it will keep taking pictures until it fills the camera's buffer. How fast and how many pictures can you take? That depends on your camera model, the settings you're using, and the speed of your memory card. However, a typical dSLR could take five pictures per second (technically called frames per second—fps) for ten seconds for a total of fifty pictures. One of the limitations is the camera's built-in memory buffer used for storing and processing pictures before the camera transfers them to the memory card. With some high-end cameras, you can keep taking pictures until the memory card is filled—in other words you could hold down the shutter button, start your breakfast, and take hundreds, possibly thousands, of pictures without stopping.

In the normal picture-taking (single-shot) mode, you press the shutter button and the camera

takes a picture. To take another picture, you need to fully press the shutter button again. In the continuous or rapid mode, you just hold down the shutter button and it keeps firing until you either release the button or the camera fills the memory buffer. When the buffer fills up, the camera stops taking pictures until it can transfer the pictures to the memory card.

The main factor affecting the rate and quantity of pictures you can take continuously is file size. Large file sizes, such as those created when you use the RAW file format, slow down the rate of rapid picture-taking and reduce the total number you can take during a continuous shooting sequence. Medium and lower quality JPEG settings create relatively small files, enabling you to take more pictures faster.

By using both the continuous focus and continuous shooting modes, you can keep up with almost any moving subject.

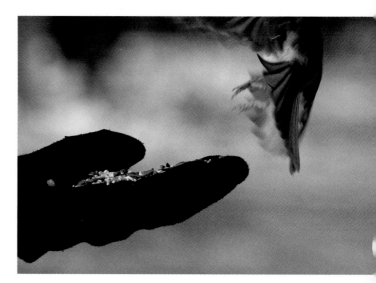

File format

At first glance you may think file format is unrelated to shutter speed. And largely it is. But (there's always a "but" in photography), there are a few subtle and a few not so subtle advantages to choosing certain file formats and file format settings. One file format, set up correctly, can be a bit like pouring an energy drink into your camera. The other file format offers you the ability to use a magician's wand to transform your picture after you take it.

Before I tell you which is which (and I'll pretend you don't already know), let me back up a second. Most cameras offer two file formats for storing your pictures: JPEG and RAW. JPEG, short for Joint Photographic Experts Group, compresses files so they don't take up much room on your memory card. If you've been setting it on your camera you probably already know that the amount of compression is variable, which gives you a pretty good clue of the advantages of the JPEG format. That variable compression is typically expressed in terms of photo quality: fine (only a little compression), normal (moderate compression), and basic (a lot of compression). In short, the more you compress an image the more you reduce its file size and its quality. If you think in terms of baking, then taking a picture using the JPEG file format is like taking a baked chocolate chip cookie out of the oven—it's done and whether it's just right, a bit underdone, or a bit burnt, there's nothing you can do about it (okay, you can mess around with it in Photoshop, but if it was poorly exposed, you'll not realize its full potential). Fortunately, most of the time your pictures turn out fine.

When you think you may want to remix and "rebake" your picture is when you choose the RAW file format. It preserves the original image data in the final picture file (think of the cookie's dry ingredients not yet mixed or baked) so that you can later (in Photoshop or other image-editing software) change the recipe somewhat. Since the RAW file format preserves most of the ingredients, its compression is limited, and it creates a fairly large file, one that can be ten times bigger than a JPEG file of the same picture.

Still with me? JPEG files are small, which means the camera can process and store them quickly (like filling a glass versus a gallon milk jug). RAW file formats preserve the ingredients so you can later change the picture recipe but they're large and it takes longer for the camera to process them.

So if you want to take a lot of pictures quickly, you choose the JPEG format. And if you really want to take a lot of pictures quickly, you choose a JPEG compression

level of normal or basic. Conversely, if your top priority is to take a lot of pictures quickly, you would not choose the RAW file format, because its large file size slows down the camera, which has to store each picture you take.

I've left one question unanswered: When would you choose the RAW file format for action photography? The answer is when your top priority is to get a high quality picture under somewhat tricky lighting conditions. The RAW format accommodates those tricky exposure situations where the camera may under- or overexpose the picture or give poor color quality because of mixed light sources, such as mercury vapor lamps in the ceiling combined with window lighting. With the RAW file format, you can adjust

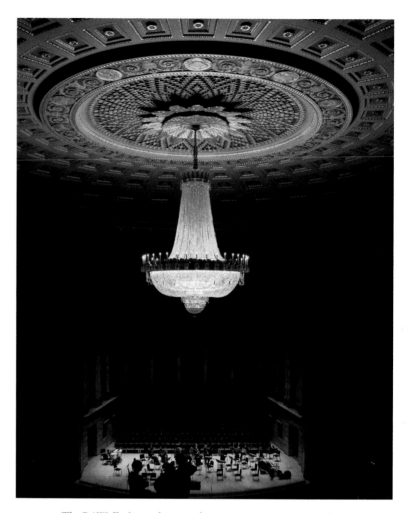

The RAW file format lets you alter apparent exposure a couple of stops but its large file size limits how many pictures you can take in a rapid sequence. Here the picture on the right was opened up almost two stops by adjusting the Exposure slider in Photoshop RAW.

the color balance in Photoshop (or other software) to your liking by changing the original "ingredients" (image data) without reducing quality. Similarly you can brighten or darken the picture and change the contrast without reducing quality. This ability to change a picture's brightness and contrast and maintain quality after taking the picture lets you underexpose the picture when taking it.

Why underexpose? Usually you shouldn't, but if poor lighting prevents you from setting a fast shutter speed, you can underexpose up to about two stops and use a

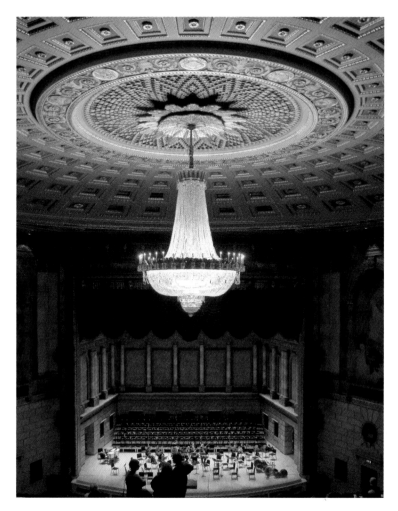

shutter speed four times as fast. The camera histogram will show the picture as too dark, but because you used the RAW file format, you can adjust it to the proper brightness in your image-editing software.

Let me repeat this. You can underexpose up to two stops when shooting RAW images, which means you can, in effect, trade those two stops of underexposure for a shutter speed two stops faster. For example, if you're shooting at 1/250 second, and you want a faster shutter speed, if you underexpose by two stops your new shutter speed will be 1/1000 second. It's not a good idea, however, to habitually underexpose while shooting RAW because you may go too far and lose image quality.

In summary: when you are trying to take as many pictures as quickly as possible, use a JPEG file format. When you are trying to boost the shutter speed, use the RAW file format and underexpose the picture a stop or two. When you are faced with tricky lighting conditions and need an excellent quality photo, use the RAW file format, and later adjust the color balance of the picture in image-editing software.

Mirror lockup and exposure delay

Why lock up the mirror? Why delay exposure? Vibration, that's why. If vibration can knock down bridges and loosen bolts on cars, then it certainly can shake up a picture now and then. Here's what can happen. When you greatly magnify an image by using a big telephoto or a strong macro lens with the camera mounted on a tripod and use a shutter speed between 1 second and 1/15 second, you risk picture blur from camera shake caused by vibration.

Where does this vibration come from? From a mirror that springs up and hits its housing when you take a picture. When you press the shutter button, the mirror (roughly the size of a postage stamp) that's built into a dSLR flips up to let light from the lens reach the sensor. When it flips up, it hits the top of its housing and lightly vibrates the camera. At moderate and fast shutter speeds (anything above 1/30 second), the vibration has minimal to no impact on picture quality. At slower shutter speeds, the vibration can lightly shake the camera and slightly blur the picture. The vibration is most noticeable when you're using a telephoto or close-up lens at longer shutter speeds. The vibration effect is somewhat dependent on camera model and your tripod setup.

To reduce (and hopefully eliminate) picture blur from this vibration, you have two choices. You can compose the picture and then lock up the mirror so it can't bounce and vibrate the camera when you take the picture. Or you can (on most cameras) set the camera to delay the shutter from opening until a second or two after the mirror flips up (so vibrations die down). Or, your third choice, you can do both. Of course, you should not take the picture by pressing the shutter button with your finger. Instead you should use the self timer or a remote release.

Mirror not locked up

Mirror locked up

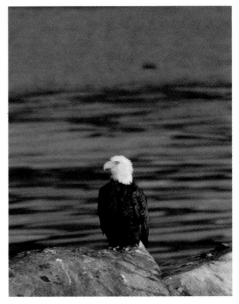

Here the difference is subtle, but locking up the mirror to eliminate blur caused by camera vibration can be a useful technique when using a long telephoto lens at a moderate or slow shutter speed (1/30 second and slower). I used a 600mm telephoto lens to photograph an eagle sitting on a breakwall in Maine.

Accessories for motion techniques

Trying to take pictures at either very slow shutter speeds or extremely fast shutter speeds with your camera and normal lens can become difficult. That's where accessories can help. With the right accessories—lenses, filters, and supports—you can greatly extend your range of shutter speeds and the variety of techniques you use to create even better photos.

Lenses

Here's your most important accessory: a good lens. Make that two good lenses so you can cover a full range of focal lengths from wide angle to telephoto. With two good lenses and a good camera, how else could you take anything but good pictures? Admittedly, I've proven it's still possible, but—once you're well-equipped—your path to success depends only on you. Like choosing a camera, choosing a good lens requires some help via websites that review lenses: www.dpreview.com, www.popphoto.com, and www.slrgear.com are three that offer solid technical reviews.

A lens with a large maximum aperture lets in more light so you can use a faster shutter speed in any situation. This 200mm lens has a maximum aperture of f/2.8. Notice the large diameter of the front glass element.

So what's a good lens? The first requirement of a good lens is to deliver a sharp image with minimal distortion. Let's assume you have a fairly sharp lens. What else is important, especially for motion photography? Four things come to mind: a large maximum aperture, fast focusing, image stabilization, and a zoom with a focal length range appropriate for your type of photography.

A large maximum aperture lens has a maximum f-stop from f/2.8 to f/4. The advantage of a large maximum aperture is that it lets in more light so you can use faster shutter speeds in both bright and dim light. A large maximum aperture also lets you throw the background far out of focus so you can emphasize the subject. Be aware that because depth of field is significantly reduced with selective focus, accurate focusing becomes critical.

The two disadvantages of a large maximum aperture lens are cost and weight. To achieve a large maximum aperture, all of the glass in the lens must have a bigger diameter which can only be achieved by making the glass bigger. All that extra glass makes the lens a lot heavier to haul around. For example, a Nikon 300mm, f/2.8 lens weighs nearly six and a half pounds, while a 70-300mm, f/4.5-f/5.6 zoom lens weighs just under a pound. Quite a difference. All that extra glass also costs more, sometimes ten times more than a conventional lens. And since a large diameter lens requires extra-large filters you'll pay more for those, too.

Sport lenses

A fast-focusing lens can greatly improve your yield of sharply-focused action shots. Most of the so-called sport lenses offer a superior focusing mechanism that focuses both faster and more accurately. Compared to a normal lens, the sport lens can easily keep up with rapidly moving action.

If you specialize in one or two sports, consider using a single-focal-length telephoto lens with a magnification appropriate for the subject distances you will encounter. I'll assume (and suggest) you need a telephoto lens for a variety of subjects. Therefore, we're going to assume you want a telephoto zoom lens. The most popular zoom focal lengths include 70-200mm and 70-300mm. But there are longer zooms, such as 80-400mm, 100-500mm, and 400-600mm.

Choose the lens with a range that best fits your photography. I feel the need to confess that despite often writing against this practice, I find myself using an 18-200mm zoom lens for amateur field sports, such as lacrosse and soccer. Its versatility to cover action at near and mid distances lets me get more action shots

because I don't have to change lenses very often. Its shortcomings include a fairly small maximum aperture and reduced image sharpness compared to lenses with a shorter focal length range. One note: you will find that top-notch, long-focal-length lenses can cost as much as a six-year-old used car.

Image-stabilized lenses

Whether your camera manual calls it image or optical stabilization or vibration reduction (the terminology varies among manufacturers), this technology lets you use slower shutter speeds for handheld photography and still get sharp pictures. With image stabilization, you may be able to use a shutter speed two, three, or even four times slower than what is recommended for handholding. While this is of benefit for any lens, the effect is particularly enhancing for telephoto shooting. Keep in mind, however, while image-stabilized lenses let you handhold at slower shutter speeds, you still need to use a shutter speed fast enough to stop the action before you.

Without image-stabilized lens

With image-stabilized lens

Image-stabilized lenses let you take sharp pictures by reducing the blur from camera shake that occurs while handholding the camera at slower shutter speeds.

An image-stabilized lens typically requires you turn on a switch on the lens to activate its stabilization feature.

Image stabilization works by incorporating a movable glass element that optically offsets camera movement. When you're handholding the camera and you zig (a very slight zig I might add), the lens element zags, so the net effect of camera movement is near zero.

Although no substitute for a tripod, image stabilization is a highly worthwhile technology. Camera giants Nikon and Canon and third party lens manufacturers such as Sigma and Tamron build image stabilization into select lenses. But it's not exclusive to lenses: some cameras, mainly from Sony, use an image-stabilized sensor. The advantage there, of course, is that you don't have to buy an image-stabilized lens, since sensor stabilization works with any lens you attach to the camera.

To activate image-stabilized lenses, you need to turn on a switch on the lens. With the early models you may also need to turn off the feature when using a tripod or when panning. But many of the latest image-stabilized lenses recognize when you're panning or have your camera attached to a tripod and adjust themselves accordingly. Read the lens manual to see if you to have change image stabilization settings to accommodate different shooting situations.

Neutral density filters

I love sunny days. But as a devotee of the slow shutter speed, I find it nearly impossible to obtain slow shutter speeds on sunny days, when too much of a good thing prevents getting good exposures using slow shutter speeds—at least without a little assistance. No matter how low an ISO and small an aperture I set, I still need a fairly fast shutter speed (1/60 second, f/22 at ISO 100) to create an exposure of the proper brightness.

So the same sunny days that bring out the wind surfers, cyclists, and other action sports you love to photograph also make it difficult to achieve the slow shutter speeds that create motion blur so appropriate to these fast-moving subjects. There's just too much brightness to get a correct exposure with a slow shutter speed like 1/8 second. Thwarted and frustrated, you could take your camera and go home and mow the grass.

A graduated neutral density filter gets increasingly darker from the filter's midpoint to its top. It's most often used for blocking the bright light of a sunset or sunrise so you can let more light in from the foreground.

A neutral density filter blocks light letting you use a slower shutter speed—especially useful on sunny days for photographing parades and other activities. Exposure at 1/6 second, f/16.

Or you could grab a couple of *neutral density filters* and start shooting away at 1/15, 1/8, 1/4, even 1/2 second. Like sunglasses, neutral density filters have extra density that blocks some of the light passing through them. The trick is to block enough light with a filter or filters to obtain a slower shutter speed that gives you a correct exposure and meets your creative goals.

Neutral density (also known as ND) filters are gray in appearance, come in a series of different densities, and they don't change the colors of your picture. The most practical neutral density filters are those made as 2 1/4-inch plastic squares as part of a filter system. Cokin, the major manufacturer of filter systems, has a complete range of ND filters. They can easily adapt to lenses with front accessory diameters of different sizes: a filter slides into a holder which has a circular opening that accepts a threaded adapter. The adapter, available in different diameters, screws onto the front of your lens.

You probably want to get two ND filters: one that blocks light equivalent to three stops and another that blocks it equivalent to about seven stops. Two systems that indicate light-blocking ability are used—one is based on logarithms, the other on a simple multiplier indicating the amount by which the light is reduced. Thus, a three-stop light-blocking ND filter could be designated by either the number 0.9 or 8x; a nearly seven-stop filter is indicated by either the number 2.0 or 100x.

ND filters also come in graduated versions: density is full on the top of the filter, and then gradually diminishes until it disappears at the mid point of the filter. Can you figure out why? Graduated neutral density filters are mainly used for reducing the brightness of the sky, particularly at sunsets and sunrises, so you can let in more light from the land to reveal detail in the foreground.

Polarizing filters

The primary purpose of a *polarizing filter* is to darken blue skies and intensify colors in the scene you are photographing. Light bouncing off shiny leaves and other reflective surfaces, even non-shiny ones, can be like a veil masking color. Eliminating the sheen reveals deeper, richer colors. The polarizing filter is the original super saturator for colors, called upon for its capabilities long before Photoshop hit the scene.

A polarizing filter can also reduce reflections from water. Lakes, ponds, and rain-drenched surfaces all exhibit mirror-like qualities that reflect light and surroundings—often distractingly so. With the polarizing filter you can reduce the reflections, often darkening them and minimizing distractions reflected from within.

Most polarizing filters screw onto the front of the lens and let you darken blue skies and reduce distracting reflections from a variety of subjects.

You likely know that once you attach a polarizing filter, you have to rotate it while looking through the viewfinder to determine its effect. You may want the maximum effect but sometimes a midway effect works well, too.

Since the polarizing filter reduces the brightness of the incoming light by almost 2 stops (1 2/3 to be precise), you can use it like a neutral density filter. Two stops isn't much.

But when you're outdoors on a sunny day photographing a race and you want to pan the athletes, that two-stop reduction may be

enough to get you down to a shutter speed of 1/30 or even 1/15 second. Either of these is a good shutter speed for panning most human and animal subjects.

Should you need to buy a polarizing filter, be sure to ask for a *circular polarizing filter*. That's almost the only kind sold nowadays, but just to be safe ask for it. It's the type that won't cause your exposure system to give false readings.

Here you can see how the polarizing filter lets you make the white clouds seem to pop out more in the picture on the right.

Memory cards

When the action flies you need a memory card that can fly, too. A high-speed memory card boosts how fast and how many pictures you can take in a series. As the memory card manufacturers like to remind you, high-speed memory cards—because of their superior transmission rates—can also save time later when you transfer pictures to the computer.

Memory cards are rated against an old data transfer standard so that's why even low-level ones now have "speeds" expressed in the hundreds. To boost burst performance in high-speed action photography, you probably should use a card with a rating of 200x or higher. Needless to say, such a card will cost more. On the other hand, using a cheaper, lower-rated card won't be disastrous and, when you are photographing slow to moderate action and everyday scenes, it will serve you well.

Read your camera manual to determine if your camera is compatible with the latest ultra-fast cards. If not, you won't be able to utilize the card's fastest speeds.

High-speed memory cards can speed up your fast picture-taking ability.

Monopods and tripods

Let's not spend a lot of time here. You know what they are. Many photographers use a monopod as much as a relief from carrying a heavy lens around their neck as they do for sharper pictures. Most monopods (one leg support device) let you reduce shutter speed a couple of stops from what you'd use when handholding and still avoid blur from camera shake. A monopod is lightweight and easy to carry around; if one meets your needs, by all means use it.

But when you're shooting at slow shutter speeds (1/15 second and lower), a tripod is the answer. My advice here is simple. Buy a sturdy, medium-sized tripod whose

Think of a monopod as a primitive image-stabilizer. It typically lets you take sharp pictures at shutter speeds a couple of stops slower than you could while handholding the camera—just like an image stabilization system.

weight and size is such that you will frequently use it. Don't buy a heavy-weight tripod you're not willing to lug around. At the other extreme, don't buy a super lightweight tripod that's flimsy and results in blurry pictures because the camera's unstable on it.

Shutter release devices

The main purpose for remote shutter controls and electronic shutter cables is to avoid the camera shake that occurs when you press the camera's shutter button with your finger. But these devices (especially the remote) also let you stand back from the camera, a feature of particular importance to wildlife photographers who want to remain concealed—or even indoors—while operating their camera setup outdoors. As discussed earlier, you can also use the camera's self timer to take a picture without pressing the shutter button—but it's impractical if the few seconds it takes for the self timer to count down may mean missing the picture.

Remote and electronic (shown here) shutter releases let you release the shutter without jarring the camera, thereby minimizing blur caused by camera movement.

This photographer at Zabriskie Point in Death Valley clearly knows the principles of getting sharp pictures. He's using both a sturdy tripod and an electronic shutter release cable.

Electronic flash

Although digital cameras come with a built-in flash, the more versatile flash units are portable accessory flash units—the kind you attach to the hot shoe, either directly or via a cord or even a wireless connection. Not only are accessory flash units more powerful than your built-in flash, they can be positioned away from the camera, and several can be used simultaneously for creative lighting effects.

For motion photography, the greatest value of accessory flash is simple: its short duration of light acts like an ultra-fast shutter speed—faster than any shutter speed offered by the camera. By firing an accessory flash unit within a couple of feet of your subject in a dark environment, you can in effect achieve a "shutter speed" as fast as 1/50,000 second, sometimes even faster. To achieve such a short duration of light, you would need either a very powerful unit or one placed quite close to the subject so it needs only a minimum amount of light for a correct exposure.

The flash may not completely overwhelm bright sunlight. So if you're using high speed flash outdoors, a moving subject may show a slight ghosting because part of it records during the flash sync shutter speed (typically 1/250 second) while the rest may be razor sharp as it's stopped by the short duration of the flash. On cloudy days or with exceptionally powerful

An accessory flash packs a powerful punch of light compared to a camera's built-in flash. When used in dim lighting close to a subject, you can achieve shutter speed like effects of 1/15,000 second or faster.

flash units positioned very close to the subject, you may be able to overwhelm the daylight to achieve an exposure taken almost solely by the light of the flash, which stops the moving subject without a ghosting effect.

Many creative photographers combine action-stopping flash with slow-shutter speed blur techniques to create compelling sharp-blur photo combinations. Most cameras offer a feature called *rear-curtain sync* that fires the flash at the end of the exposure (instead of the beginning) so that the subject appears logically sharp at the end of its motion trail.

Image-adjustment software

I should just say "Photoshop" and end the discussion right there. Although there are a variety of other software programs that let you adjust your photos, the widespread adoption of Photoshop means there are many books, classes, online tips, and advice available from fellow photographers to assist you in adjusting your photos. That's not to say you shouldn't use other less-complicated software, or software specialized for your purposes. But choosing Photoshop as your main image-editing program means help will always be available.

Photoshop comes in two flavors. The high-end, quite expensive, and extremely complex but extremely capable version is Photoshop CS. The latest version as of this writing is CS4, but a new version tends to come out every two or three years. If you're a professional photographer, very advanced amateur, or someone who gets great enjoyment digging into the software trenches, this is your program.

However, take a look at the much more reasonably-priced Photoshop Elements 7 (Elements 7 is the latest version as of this writing). Photoshop Elements can do all

This screen capture of menus from Photoshop Elements shows just a few of the hundreds of menus offering you seemingly unlimited potential to alter your image.

the important things that Photoshop CS can do when it comes to adjusting your photos and making inkjet prints. But it lacks the advanced features required by professional designers and photographers whose livelihoods involve large sums of money to provide photos customized to the special needs of newspapers and magazines.

By carefully selecting the area around the wagon and using the Photoshop motion filter to blur those surroundings, I was able to instill a sense of movement in this photo.

Before

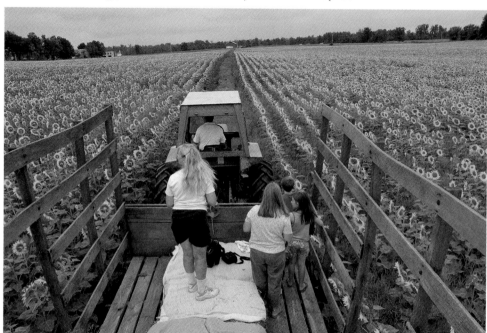

After

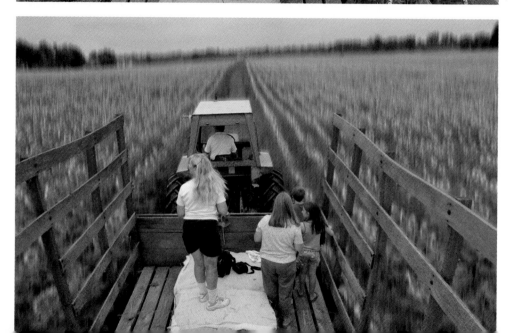

*What's the most important camera handling tip? That's easy: Carry
your camera with you wherever you go. Exposure 1/500 second, f/8.*

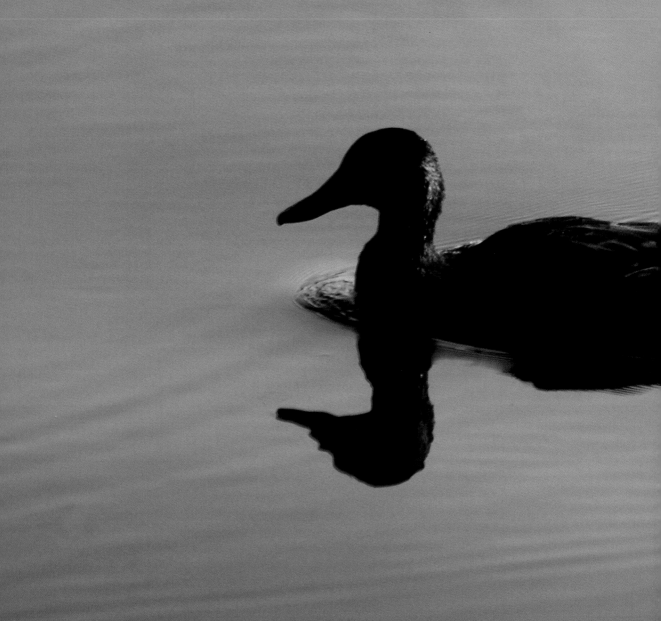

Chapter 5

Stopping the Action

Now that you're thoroughly grounded in the functions and controls used to manipulate shutter speed, you're ready for the techniques that will let you exploit them. In this chapter, you'll learn a variety of action-stopping shooting techniques that will enable you to stop action in a variety of situations.

What you've learned about the many camera controls that affect exposure, ISO settings, exposure compensation and exposure modes, focus controls, and file formats will help you choose the shutter speed you need to freeze even the fastest of subjects.

In this chapter you will discover not only how to maximize the action-stopping power of fast shutter speeds, but also how to effectively stop action with a shutter speed commonly deemed too slow to freeze a fast moving subject.

You may think that stopping action can be boiled down to simply choosing a fast shutter speed. Just set 1/4000 second on your camera and fire away. And while that may often work, you'll find that a variety of other factors can force you to use a slower shutter speed.

But before we explore the glory of fast shutter shutter speeds, let's take a look at shutter speeds appropriate for stopping the action in your everyday life.

For documenting family life, shutter speeds in the range of 1/60 to 1/250 second nicely balance the needs of stopping action and achieving overall sharpness. Exposure at 1/60 second, f/8.

Everyday shutter speeds

Shutter speeds ranging from 1/60 second to 1/250 second are like your everyday work clothes. They're serviceable but nothing fancy. Quite simply, they get the job done. And, because you'll use these shutter speeds frequently for everyday photography, you'll likely become as comfortable with this range as you are with your favorite T-shirt and jeans.

Of course, just as your everyday clothes aren't appropriate for every occasion, these everyday shutter speeds won't be suitable for every photograph you take. You dress up for special times, and you'll also occasionally want to stretch your shutter speed range up, too, so it includes a setting of 1/500 second. That little bump in speed might be just enough to stop most of the everyday events that are just a bit too fast for the relaxed attitude of 1/60 to 1/250.

These shutter speeds seem custom-made for everyday events and activities. They are the shutter speeds to use for snapshots at summer camp, on vacations, and for impromptu portraits. They're the speeds to choose for backyard soccer games and swingsets in the park. And these are the shutter speeds that fit right in when families and friends gather for holidays, reunions, graduations, and birthday parties.

This is not to say you can't take exciting and superb photos with these mid-range shutter speeds. You can. Especially when you visit racetracks and outdoor athletic events, these speeds stand out for their ability to pan fast subjects and give you some great results. But the majority of the time you'll use 1/60 second through 1/250 for family gatherings and informal activities.

As the shutter speeds most closely associated with casual, everyday photography, you'll use this range often—*but you won't often select them*. At least not consciously. More likely they'll be chosen for you by the camera, because you've set it to Program mode. I think of this mode as the snapshot or the "set it and forget it" choice: it lets you take pictures without thinking anymore about it. And it's the "compromise" mode, as well. It works to give you a middling combination of shutter speed and aperture that will cover the variety of features often present in everyday photo subjects.

The versatility of these everyday shutter speeds breaks down under more challenging picture situations. Whenever you find yourself wading through a field of pumpkins that stretches to the horizon or dodging a Flamenco dancer as she fires up her feet, everyday shutter speeds won't cut it. For extraordinary subjects like these, you need to wrest control from the Program mode. To show that field of pumpkins sharply from your feet to the horizon, switch to the Aperture-Priority exposure mode and choose a small aperture (a large f-stop number like f/16 or f/22). To freeze the flashing feet of the Flamenco dancer, switch to Shutter-Priority mode and select a hyper shutter speed, a very fast setting such as 1/2000 second.

Fast shutter speeds

With fast shutter speeds like 1/1000, 1/2000, 1/4000, and 1/8000 second, you can freeze almost any action, be it a water skier slaloming behind your boat or a speed skater hugging the inside curve as he comes into the bell lap.

Don't casually choose a super-fast shutter speed just because it's as simple as turning a dial until 8000 shows up on your camera-top LCD. There are risks involved. As we've mentioned before when shutter speeds rise so do the complications. Those super-fast shutter speeds require near ideal scene conditions and equipment: bright

When the action picks up, so should the shutter speed. A shutter speed of 1/500 second was fast enough to stop this slow-moving sleigh. Exposure at 1/500 second, f/8.

light, a high ISO (800 or 1200), a lens with a large maximum aperture, and a camera-lens combination capable of focusing quickly and accurately on a subject that moves so fast it can only be stopped by a super shutter speed.

And perhaps most importantly, a fast shutter speed tends to mean a large aperture that yields shallow depth of field. With a 300mm telephoto lens set to f/4 and focused on a subject twenty feet away, the depth of field is a mere four inches —about the width of your palm. That's not much room for error. Not only must the camera focus accurately, you must choose the most important subject area to focus on because there's a good chance other parts of the subject will be slightly soft because they're out of the depth-of-field area.

So go ahead and use that super-fast shutter speed. But first consult the action-stopping table that appears in a few pages to determine if maybe you can use a slightly slower shutter speed and possibly a smaller aperture to gain a bit more depth of field.

A re-enactor late for battle is running to get there in time. It seems like a simple picture but I purposefully tried to get him in front of one of the tents and hoped that I'd catch his legs pumping. Exposure at 1/1250 second, f/8.

In lacrosse, you always face getting whacked with a stick but timing the picture to show the whack requires a bit of luck. Exposure at 1/2000 second, f/7.1

Timing your shots

If you're a stock market player, then you know that timing (trying to buy low and sell high) is considered amateurish because it's highly unlikely to succeed. (Trust me, the experts are right for once.) But let's face it, timing is important. Who wouldn't like to have put $5,000 down on Dell in 1990 and have sold it ten years later for a 4000% gain?

Much like when playing the stock market, timing is critical when you want to photograph moving subjects. So let's find the techniques that put you on the path of success. You may not be able to predict if Peyton Manning is going to throw a deep post rout or when Sidney Crosby is going to steal the puck and make a breakaway goal, but many sports and action activities do offer you some predictability.

If you want to photograph a bowl of peaches, before they go bad you have at least a week to arrange them, monkey with various lighting schemes, and try out several angles, exposures, and backgrounds. When your subject is a still life like a bowl of peaches or perhaps a posed portrait of Uncle Ned sitting by the fireplace, you have the twin luxuries of predictability and plenty of time. These are not high-pressure situations.

But, if your goal is to get a picture of Uncle Ned as he juggles those peaches, both your preparation and execution need to be ramped up. The right timing is critical when you are photographing subjects in motion.

Some subjects are easier to time than others. You don't know how long a bronco buster can stay atop an angry bull or when a cat will stop teasing and finally pounce on its prey, but many actions and activities do offer predictability. Knowing where and when a high jumper will make his next leap or a golfer his next swing is, of course, a bit more predictable than deciding which direction a midfielder will try to head the soccer ball.

Setting up for a fast action shot

- Choose a shooting location based on high odds of climactic action and closeness to the action.

- Prefocus the lens where you expect the action to occur.

- Use your camera's rapid fire and continuous focusing (auto servo) modes so you can take several shots in rapid succession.

How well you can predict and prepare for climactic action depends on the nature of the activity. Before an event, can you walk a steeplechase or motocross course to find the locations for the best action shots? Yes, you can. You should arrive an hour ahead of the scheduled start to do just that.

Especially for the most active subjects and more unpredictable sports, the best technique to use to achieve superbly-timed photographs is to build an in-depth knowledge of the activity. Having a background for an event allows you to better anticipate what's going to happen. You should, of course, check up on a schedule of events—this insures that you won't do stupid things like arrive in Pamplona *three days after* the bulls ran the streets.

Before photographing a major race like a Boston Marathon or Daytona 500, first take your camera and scout out a local, scaled-down version of a similar event. And why not just wait for the big one? Well, under the low-pressure conditions of a smaller event, you can become familiar with timing strategies that will get you better results at the "real thing." A great advantage of small events and venues is that you can get close to the action—no press credentials required.

With good timing, you can instill story-telling tension into your pictures. Exposure at 1/800 second, f/5.6.

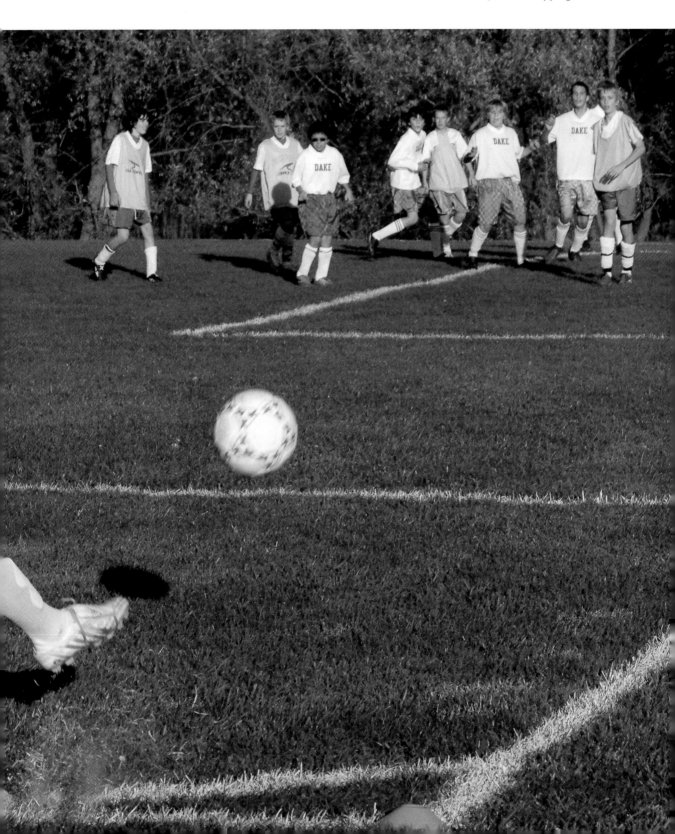

From the perspective of a former "silent spectator," I can tell you that one of the best tactics for acquiring substantial background knowledge at an event is to overcome your reserve and make an effort to engage staff, participants, enthusiastic fans, and fellow photographers in conversation. Most people I talk to are happy to answer questions. When I ask for more details (which I often do), it's not unusual to have some great photo opportunities, highly entertaining anecdotes—even invitations to go behind the ropes—come my way.

Determining a stop-action shutter speed

What shutter speed is fast enough to freeze your six-year-old as she wobbles away on her roller blades? Your skateboarding teen perfecting a One-footed Ollie? A horse leaping over a timber jump or a waverunner, throttle open full, slashing toward the finish line?

Several motion and photographic variables—not just subject speed—impact this decision. We'll cover them. But to help you stop most action most of the time, let's use a chart based on miles per hour to guide you. We're going to assume you're using a focal length of about 200mm and that the subject fills about one-third or less of the viewfinder or the picture area of your LCD. With those assumptions, the shutter speeds given in Table 5-1 will prevent blur from both subject movement and camera shake inherent in using a medium telephoto lens.

Table 5-1 Action-stopping shutter speeds

Subject speed	Minimum shutter speed based on direction of motion		
	↔	↕	↘
<10 mph	1/250	1/90*	1/160*
10-20 mph	1/500	1/125*	1/250
20-30 mph	1/1000	1/250	1/500
30-50 mph	1/2000	1/500	1/1000
50-75 mph	1/4000	1/1000	1/2000
>75 mph	1/8000	1/2000	1/4000

*With these shutter speeds, avoid blur from camera shake by using image stabilization or a tripod.

With subjects like windsurfers you can easily anticipate their course and be ready to take good pictures. Exposure at 1/640 second, f/5.6.

Other variables important to stopping motion

If one train leaves Chicago at midnight heading toward New York City at 55 mph and another leaves New York City heading toward Chicago at 77 mph, where will they meet? If you can solve this kind of math problem, choosing a shutter speed will never stymie you.

I think it's obvious speed is a major factor in choosing an action-stopping shutter speed but two other factors include the direction of the motion and image size.

When the action heads right for you, you can use a slower shutter speed to stop it and also give yourself the choice of using a smaller aperture to increase depth of field for greater overall picture sharpness. Exposure at 1/350 second, f/11.

Action cutting directly across the scene requires faster shutter speeds to freeze it. Exposure at 1/1500 second, f/8.

Objects moving directly across your field of vision cover a lot more retinal—and camera sensor—territory than those moving at the same speed directly towards you. As the shutter speed table shown earlier demonstrates, you may need a shutter speed four times as fast to stop motion moving across the scene than to stop motion moving towards you.

Another important factor is image size. Consider that sometimes you can visually track an airliner going 600 mph easier than a bicycle going 15 mph. How is that possible? When the airliner is passing overhead at 30,000 feet—or even 3,000 feet—you have no trouble following it because it's so far away that it seems quite small and moves slowly across your visual field. Compare that to a bicycle ten feet in front of you. Because it's so close, the bike fills much more of your visual field, and moves rapidly across it. So image size is a critical factor in determining which shutter speed you need to stop action. A shutter speed of 1/60 second that would quite easily stop the motion of that distant 600 mph airliner, would reveal the nearby 15 mph bike as blurred.

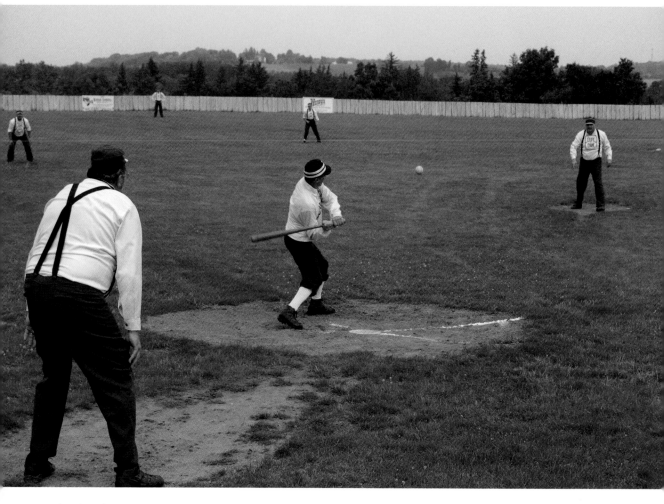

*When the subjects are moving a bit slower and not filling the frame, you can often
stop the action with a moderate shutter speed. Exposure at 1/500 second, f/8.*

In summary then, when choosing a shutter speed to stop action, consider the
direction the subject is moving, its speed, and how large it appears in the viewfinder.
A fast subject filling the viewfinder and moving directly across the field of view is the
most challenging of all subjects for the stop-action photographer. For our purposes,
those three things—subject speed, subject image size (how much of the picture area
it fills), and subject direction—determine the shutter speed you need to freeze the
action of your subject.

Getting the fastest shutter speed possible

There are times when speed is everything. Whether you're at the NASCAR track or the local motocross (where you can often get within a few steps of the action), when you're able to fill the viewfinder with a subject roaring close by, you'll need as fast a shutter speed as you can get.

For a few dSLRs, the fastest shutter speed is 1/2000 second, for most it's 1/4000 second, but for the high-end cameras, it's 1/8000 second. Shutter speeds of 1/4000 and 1/8000 second can stop some pretty fast action, but achieving a shutter speed that fast requires optimal conditions.

So how do you achieve the fastest shutter speed on your camera? As always, exposure is a set formula for delivering the amount of light required by the sensor based on the ISO you set. The higher the ISO you set, the less light the sensor requires, and the faster the shutter speed you can set. The tradeoff from high ISOs is an increase in sensor noise that reduces image quality, so you may want to take a series of test pictures of the same detailed subject at different ISOs to see at what ISO noise becomes a problem with your particular camera.

Next up is a large lens aperture, let's say f/2.8 or f/4. A large lens aperture lets in a lot more light. Going from f/5.6 to f/4, in fact, lets in twice as much light, allowing you to double the shutter speed. To get a lens with a very large aperture, you may need to spend a bit more money or buy a fixed-focal-length lens instead of a zoom. Moderately-priced telephoto zoom lenses typically have a largest aperture of f/5.6 or f/4 which is not ideal for high-speed action photography. To get a f/2.8 telephoto lens, you may have to spend a thousand dollars or more.

Finally, if you can, hold out for a sunny day. Then position the camera to use front lighting (sidelighting and backlighting typically require a 1/2- to 1-stop exposure increase). That extra light will let you max out your shutter speed. On a sunny day with the ISO set to 500, you can shoot at 1/4000 second at f/5.6 or 1/8000 second at f/4.

If you're shooting in RAW format, you can try this trick to boost your shutter speed. When your meter indicates you've reached the fastest shutter speed that will give a good exposure, double or quadruple that shutter speed (1/1000 second to 1/2000 or 1/4000 second) to underexpose the photo on purpose. When you return home, open the image in Adobe Camera RAW (or whatever imaging software you're using) and boost the exposure back to normal by moving the Exposure slider until the histogram indicates a good exposure. There may be a slight quality loss, but you'll have achieved the faster shutter speed you needed.

In summary, to maximize shutter speed:

- Set the camera to ISO 400 or 800 or even 1200 if the illumination is low and your camera performs well here.

- Set the exposure mode to Shutter Priority (sometimes designated Tv).

- Set the lens to its largest maximum aperture.

- If you still aren't at the fast shutter speed you need, use the RAW file format, and set the shutter speed two to four times faster than the fastest speed that gives a good exposure. Later, correct the exposure in Adobe Camera RAW software.

Action sequences—
the art of static action

I've waited almost the entire book to work in a phrase like "static action." Action sequences show motion using a series of still pictures. But more importantly static action is an oxymoron, a class of words I love and hardly ever get to use. You probably know it means a self-contradictory phrase—two words that seem to oppose each other, such as "cold toast," "government intelligence," or "serious fun."

Action sequences fall into two categories. The conventional approach is movie frame style. Here, each subsequent picture is a continuation of the one before it and the result is a series of pictures from that sequence that are intended to be displayed together. The more artistic approach embraces psychological surprise and uses fancy names: the diptych (two pictures) or triptych (three pictures).

Let's first focus on the continuous action sequence in which you use several pictures in chronological order to convey a subject's motion. How many pictures should your sequence hold? That's a creative decision. Typically three to five pictures can convey the motion. The ultimate criterion for deciding on how many pictures to use is the entertainment factor. A picture sequence of your wife taking a Sunday bike ride with no apparent change from picture to picture will bore viewers whether it's two photos or twenty. However, the liquid, undulating form and flapping ears of Bob the

It's fairly easy to create action sequences of subjects moving in straight lines or other predictable paths. Exposures at 1/1250 second, f/5.6.

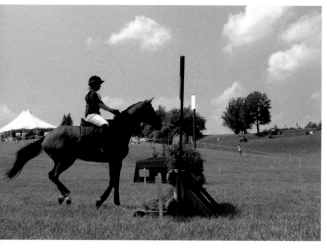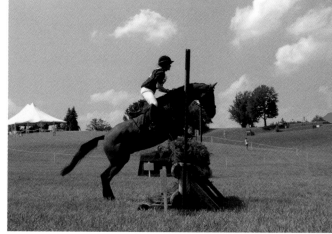

basset bounding after a Frisbee could easily run up to ten pictures. (Sorry, but Bob refused to sign a model release so you can't see him in action.)

The first set of sequence action photos is usually credited to the Englishman Eadweard Muybridge, whose early photographs of Yosemite Valley had been published in 1867. Using tripwires and an electrically-controlled shutter release apparatus, in 1878 he set up a series of twenty cameras and photographed a galloping horse. As legend has it, former California governor Leland Stanford hired Muybridge's services to prove a bet: that when a horse gallops, at some point all four feet are simultaneously off the ground. His series of twenty pictures of a single gallop showed that they are; this doesn't happen, however, at the moment when the legs of the horse are fully extended. It happens when the horse's legs are tucked underneath. Muybridge's achievement unleashed an unending fascination with freezing movement and photographing action at ever shorter exposures.

Muybridge became obsessed with his success and for years created action series of everything and anything in motion. By today's standards some seem quite quaint and amusing, especially the series of naked people doing things like pole vaulting, wrestling, carrying and pouring a pitcher of water, walking up stairs, and all sorts of mundane human activities. Muybridge and others photographed not only humans but hundreds of animate and inanimate objects in motion, and turned their efforts into the successful publication of reference books for artists on the human form in motion.

If you find straightforward action sequences artistically tame, the triptych may intrigue you. It's a series of three pictures, not necessarily of action subjects, but

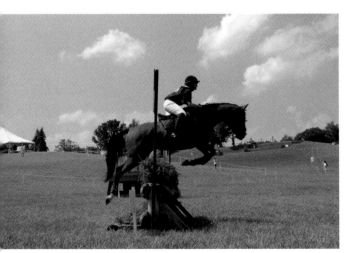 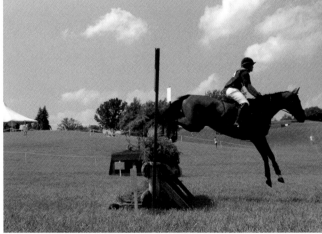

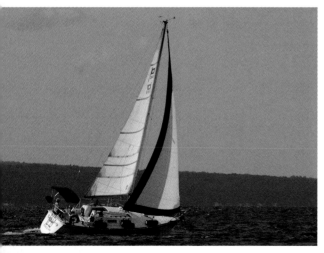

since that's our topic here, we'll hold true to it. The success of the form comes from entertaining the viewer. Somehow, your three pictures need to engage and hopefully surprise your viewer. Many triptych artists throw into the middle of the sequence a picture that visually seems out of place but perhaps is logically, artistically, or psychologically appropriate. (All I can say is that when it comes to art, be bold, be baffling, be mysterious, and be original.)

Here are a few tips to help you take action pictures in a rapid sequence.

- Review your camera manual on this topic to understand how to set your camera to maximize the number of rapid fire pictures you can take.

- Set the camera to JPEG file format. RAW files are large and slow down the camera, reducing the number of pictures you can take in a sequence.

- Choose the second highest JPEG quality to speed up transfer rate.

- Use a memory card with a high-speed transfer rate.

- Choose your camera's rapid fire or sequence settings for focus and shutter release. Your camera may have a specific setting for taking a large number of rapid sequence pictures that makes most of the settings mentioned above.

Give a twist to one of the three photos in a triptych. Here, the theme of different types of boats includes two floating in water and one that sails over ice.

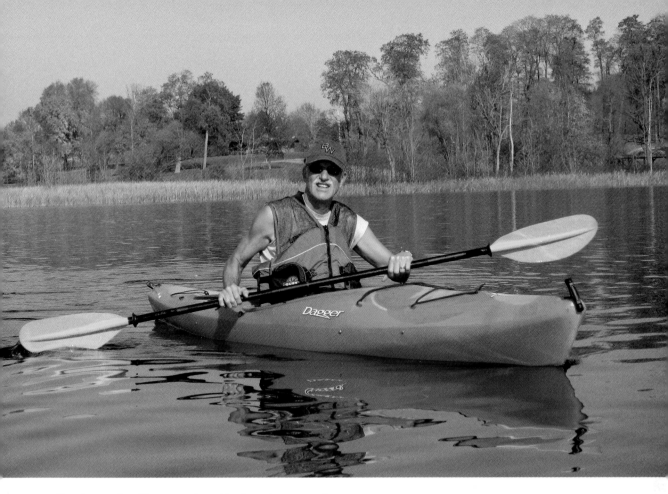

Surprise your kayaking companion with a framed memento of the outing. Exposure at 1/1250 second, f/4.

Taking pictures from moving vehicles

Planes do it. Cars do it. Even kayaks and canoes do it. What they all do is carry us past some fascinating sights that we'd like to photograph. Fortunately we can photograph while we're on the go. Planes in particular offer sights unusual for their aerial perspective. I'm especially intrigued by the unusual geometric patterns formed by farmlands and highway cloverleafs mixed in with housing developments, not to mention the textures raised by the sidelighting of a low sun.

Here's how to take sharp pictures of the sights passing by you. Planes, buses, cars, and trains all share two things: windows and high speed. (Lots of luck, but try to sit next to a clean window.) When taking a picture, hold the camera near—but not touching—the window glass and place your hand above the lens to block window reflections. (If you're photographing from a car, you can open the window.) Use Manual focus and set the lens to infinity (far distance). Don't touch the window

Air travel affords you many wondrous sights—if you have a window seat and a clean window. Exposure at 1/1000 second, f/5.6.

with the camera because vehicle and plane vibrations can add blur. For fast-moving ground transportation, use a shutter speed of 1/1000 to 1/4000 second and try to avoid foreground objects (especially telephone poles) as their nearness may render them strongly blurred. For airplanes, a shutter speed of 1/500 second will usually work.

You can also take pictures while on the water. Different water craft—kayaks, canoes, motor boats, cruise ships and ferries—present different challenges. Personal craft are close to the water but bob quite a bit. Large boats are high up and more stable.

When in a small boat, keep your camera in a waterproof bag until you're ready to take a picture. When you remove it for picture taking, be careful not to dunk the camera (which I have done—bye-bye camera) or splash it (which I have also done, but saved it with a quick drying). If you're in a kayak or canoe, use a shutter speed of 1/1000 to 1/2000 second and try to steady the craft as you take pictures. For motor boats flying across the water, use the fastest shutter speed you can—but don't hesitate to go creative with slower shutter speeds. The stability usually common to cruise ships and ferries lets you slow down to shutter speeds like 1/250 and 1/500 second.

The tinted windows of buses may block light and lower your shutter speed. For this scene in rural Peru, the bus slowed down. Exposure at 1/1000 second, f/8.

When you use a marginal shutter speed while handholding the camera, you risk incurring the subtle blur from camera shake that can ruin an otherwise good picture. Here a shutter speed of 1/125 second used with a 200mm telephoto lens wasn't fast enough to eliminate the blur caused by camera shake from handholding the camera. Exposure at 1/125 second, f/11.

Shutter speeds for sharp pictures while handholding the camera

One of the greatest quality issues in taking pictures is the blur that can occur from the subtle shake of a person handholding the camera. That slight blur is magnified when you use a longer focal length that magnifies the image size. For instance, if you zoom from a 50mm focal length to a 200mm focal length, you've magnified not only the image 4X but also the movement that results from handholding the camera.

You can counteract the blur from camera shake by using a fast shutter speed. How fast? That depends on your steadiness, your quality stringency, and the type of lens you're using. A longstanding rule of thumb guides you to use a shutter speed equal to the inverse of the focal length of the lens. For example, with a 50mm lens, you would use a shutter speed of 1/50 second (or faster).

But thanks to the recent innovation of image stabilization technology, that old rule of thumb needs to be updated for image-stabilized lenses.

Give these three rules a try:

1. For traditional, non-stabilized lenses, use a shutter speed approximating the focal length of the lens: 1/50 second for a 50mm lens, 1/200 second for a 200mm lens.

2. For a lens with image-stabilization technology, use a shutter speed of 1/4 the focal length of the lens: 1/15 second for a 50mm lens, 1/50 second for a 200mm lens, and so forth.

3. To truly prevent blur from camera shake, use a shutter speed twice as fast as recommended in the first two rules.

Number 3, my own rule of thumb, doesn't take chances—that's because I want you to be able to make sharp enlargements. And given the exceptional quality of images shot at ISOs 400 to 1200 in dSLRs made since 2007, you should be able to use fast shutter speeds in most circumstances.

How to find your personal steadiness shutter speed

Finally, test your personal steadiness quotient by taking a series of pictures at increasingly faster shutter speeds and then review them to see what shutter speed you require to get sharp pictures.

Here's how. Do your test on a sunny day. Find a fairly flat, detailed subject that's at least twenty feet away. A brick wall or a large sign with sharp lettering would work well. You want a flat subject so the changes in depth of field from varying the aperture don't influence your perception of blur. Set the ISO to 200. Set your camera to Shutter-Priority. If you're using a zoom lens, set it to 100mm as a nice mid-range setting. Focus carefully. Because you're doing the test on a sunny day, you may have trouble achieving the slowest shutter speed needed for the test. If that's the case, attach a polarizing filter when you need to use a slower shutter speed.

For convenience, either take notes or put a small sign in the picture denoting the shutter speed you are using. Alternatively, you probably know that picture-taking settings are contained in the file *metadata* that you can find by right clicking (PC users)

Personal shutter speed test while handholding a non-image-stabilized lens. Take a series of pictures at different shutter speeds as described in the text to determine the slowest shutter speed you can use to get a sharp picture.

1/25 second

1/50 second

1/100 second

1/200 second

1/400 second

on the file when in Explorer, choosing Properties and looking in the EXIF area. On a Mac, click on a photo, hold Cmd, and press I. Inside the new window, click on the "More Info" section that opens. In Photoshop, go to File>File Info and a window will open up with the shutter speed setting.

Before you start the test series, put the camera on a tripod and take the first picture at 1/500 second. This tripod shot will be your reference for your ultimate standard of sharpness.

Testing handheld, non-image-stabilized lenses

With the lens set at 200mm, handhold the camera and take a series of pictures at the following shutter speeds: 1/50, 1/100, 1/200, and 1/400 second. I want you to use a slow shutter speed so you can clearly see the blur effect from camera shake.

Testing stabilized lenses

If you're testing a stabilized 200mm lens, turn on the stabilization and give it a moment to kick in before you take the first picture. Then take a series of pictures at these shutter speeds: 1/25, 1/50, 1/100, 1/200, and 1/400 second.

Personal shutter speed test while handholding an image-stabilized lens. Take a series of pictures at different shutter speeds as described in the text to determine the slowest shutter speed you can use to get a sharp picture.

1/125 second

1/25 second

1/200 second

1/50 second

Use the test picture taken on a tripod (taken at 1/500 second) as your standard of sharpness.

View the images in Photoshop

Now transfer the images to your computer and using your notes add the shutter speed to the file name. For example, "Handheld200mmLens-125sec" is a typical file name. Open the images in Photoshop and look at them at 100% magnification by double-clicking on the magnifying glass icon. Be sure to also open the photo taken on a tripod and compare your other test images to it. Decide what level of blur from camera shake is acceptable to you and use that to create your own personal rule of thumb. For instance, if you find the image shot at 1/100 second is fine, then your rule of thumb becomes: Shutter speed = 1/2 times the focal length of lens.

Finally, to be extra sure, you may want to make three 8 x 10 prints: one each of the shutter speed photo you prefer, the one on the tripod, and maybe one at double the shutter speed you prefer. Look at the prints and see if you're still happy.

f/5.6 *f/11*

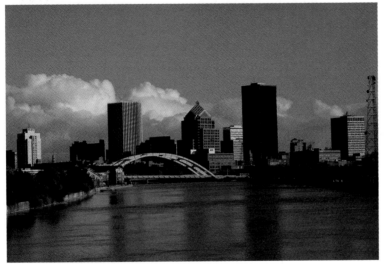

In addition to a fast shutter speed, lens quality and aperture setting also contribute to image sharpness. With many lenses, a medium aperture such as f/11 gives the sharpest optical results.

Taking sharp pictures at questionable shutter speeds

Eventually it happens to all of us. Daylight falls as the action rises. Or we find ourselves inside a dark cave of a wedding chapel and (because of our designation as the family photographer) we're expected to deliver some exciting photos—without using obtrusive flash. Or the invasion of very photogenic migrating butterflies is accompanied by thick clouds sliding a lid across the sky and forcing us to struggle to get a shutter speed fast enough for sharp close-up photography. Or speedy subjects are escaping the grasp of shutter speeds a step too slow. Of course, you could use flash for nearby subjects, but what about subjects beyond the reach of flash?

When photo opportunities soar as photo conditions sink, the temptation is to despair. Don't. You're about to discover that your resourcefulness will save the day. You can turn to one or several of the techniques below.

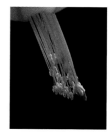

Fairly sharp

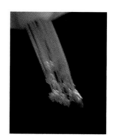

blurred

Handholding? Take lots of pictures. Fast.

Over the years, several articles have shown that if you take a rapid series of pictures while handholding the camera at a slow shutter speed, one or two (out of say, eight pictures taken) will be acceptably sharp. The theory is that even when you're handholding the camera, you are not constantly moving it so if you take several pictures quickly, you may get one where you barely moved the camera.

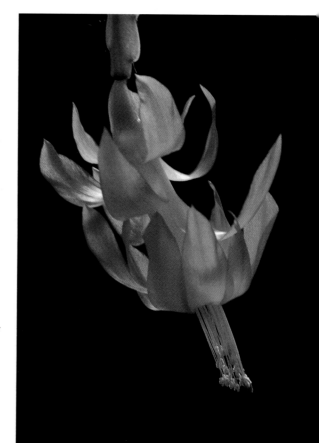

These close-up pictures were taken while handholding the camera at 1/15 second using a 100mm lens. That's too slow a shutter speed for sharp results, even with a stabilized lens—which this wasn't. As a last resort you can often get a fairly sharp picture by taking a rapid burst of pictures. From such a series of photos, at least one will often be fairly sharp, because your movements while handholding a camera usually are not constant and continuous. Exposure at 1/15 second, f/13.

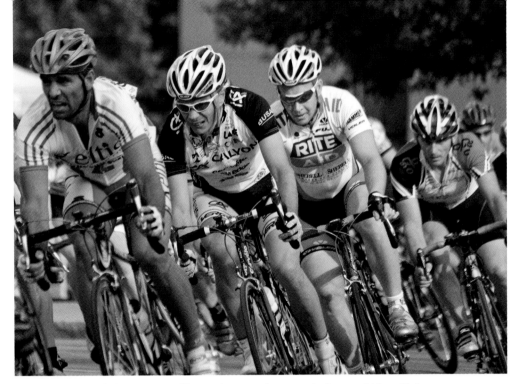

By using the RAW file format, I was able to underexpose this picture by 1 stop, which enabled me to use a shutter speed twice as fast as I'd normally use in this lighting. Exposure at 1/2000 second, f/5.6.

Use the RAW file format and underexpose

Before you shoot, boost the ISO to 1200. Still not getting a fast enough shutter speed? Then underexpose by two stops so you can use a shutter speed twice as fast. By using the RAW file format, you can better address any noise issues that may arise with a high ISO. And when you underexpose, the RAW file format allows you to restore good exposure with minimal loss of quality. Of course, all these corrections happen when you're later using imaging editing software to adjust the RAW file format image. And a word of caution: underexposing, even with the RAW file format, does pose a risk of reducing image quality.

Conversely, you can also overexpose a stop or two to get a slower shutter speed for panning or other slow motion techniques. Again, open the RAW file and in combination use the controls to reduce the exposure and recover the highlights until you get the results you want.

Pull out the stabilized lens

What could be more obvious? If you have an image-stabilized system, now is the time to use it and to try and stretch it beyond its limitations. Most stabilization systems let you get pretty good results at shutter speeds two or three times slower than what you would normally try. So what the heck, try an even slower shutter speed—you might get lucky.

Find a perch to support your camera

My perch for that wedding was the balcony railing. Railings are often round and most cameras have squared flat bottoms, so it can be hard to get a steady, firm support on a railing. I bunched my coat on the railing and then nested my camera in it. Now I had a good support. When using an impromptu support, the key is to very carefully press the shutter button—no jabbing—to avoid moving the camera as you press downward.

A wedding may not be filled with fast action but the dim light of a chapel and the subsequent slow shutter speed (1/6 second here) means even a nod of the head can blur a picture. The camera was placed on a jacket on a balcony railing for extra steadiness. Exposure at 1/6 second, f/3.5.

Direction of action

Okay, so the subject you are photographing is moving. Then position yourself so it is moving toward you. With the subject moving toward you, you can choose a shutter speed at least one-third slower than you'd use when the subject is crossing in front of you. The picture may not be as dramatic, but your chances of getting a sharp shot rise dramatically.

Wait for the action to pause

This seems obvious. But when I was in the balcony at a wedding and focused on the couple and the preacher below I couldn't believe how much everybody fidgeted. With a shutter speed of 1/6 second, each fidget caused a frustrating blur—and time was running out. But patience and taking extra pictures paid off as I got several good photos of the couple exchanging vows.

Wait for peak motion

Many moving subjects include a motion in which there is a short-lived momentary pause before they reverse direction. This usually includes a leaping motion that slows and then stops before gravity takes effect and they accelerate back to earth. Gymnastics, basketball, springboard diving, and figure skating all bring obvious examples to mind. But peak motion can also include a reversal of direction, such as a water skier swinging out to the far side before coming back, or a halfback, faced with a wall of tacklers, deciding to turn and go the other way. Just time your picture for when the action is slowest and you may get that sharp shot even with a fairly slow shutter speed.

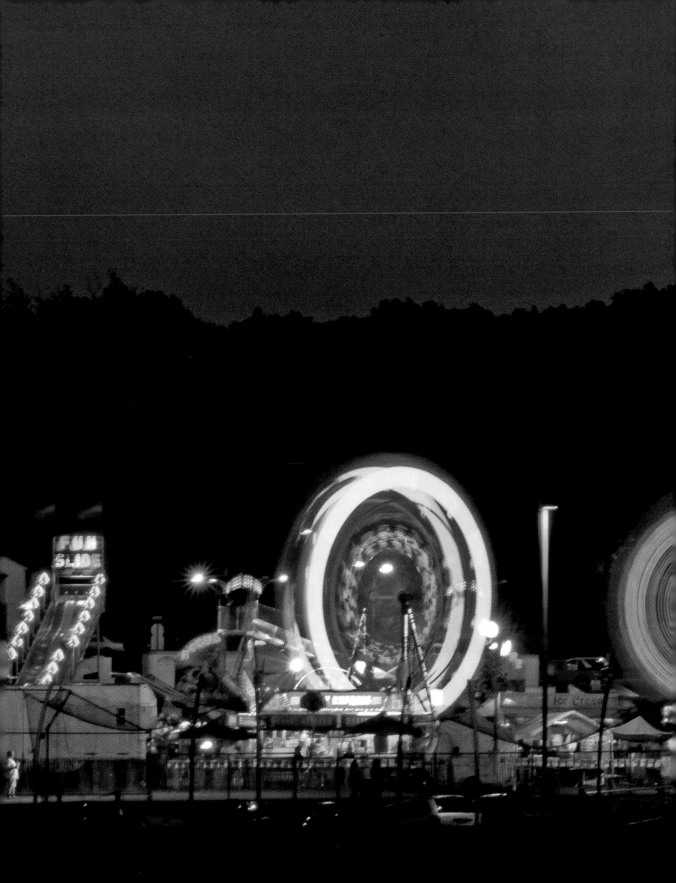

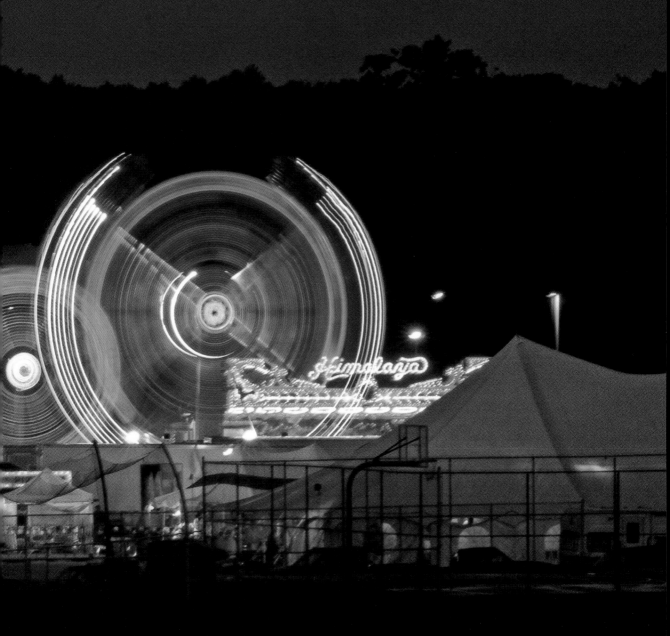

Chapter 6

Shake, Rattle, and Roll
Your Camera

You're about to undo the most sacred of all camera rules: "Thou shalt hold your camera as steady as humanly possible." You're not only going to undo it, you're going to smash that rule to smithereens. You're going to do things with your camera that seem not only zany, but crazy. Guess what? They are. And so are the results, too.

With a relatively fast shutter speed such as 1/60 or 1/125 second, you can predictably count on fairly sharp results but with less of the motion-conveying blur that results from using a slower shutter speed, such as 1/8 or 1/15 second. Exposure at 1/60 second, f/18.

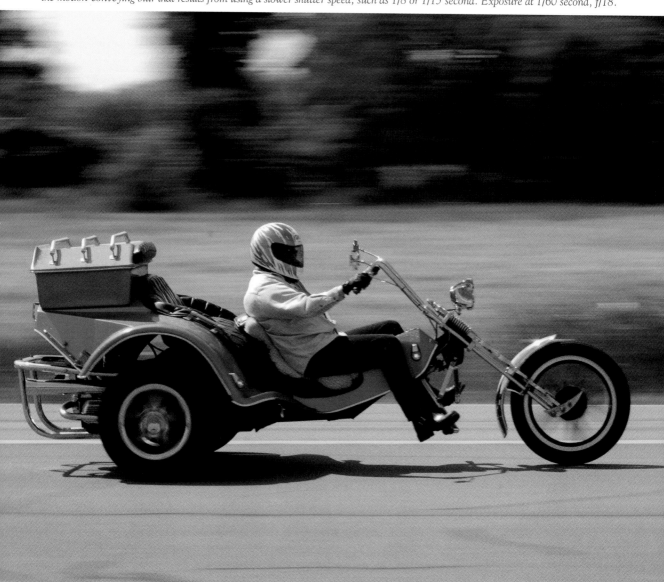

But they'll also be amazing results. Pictures that are amazingly bad, amazingly good, and, best of all, amazingly fun, especially for those of you with a creative rebel clamoring to break out. Now you'll get to play with your camera as if it were a ping pong paddle instead of a fragile electronic device. For a brief time you will no longer pursue that perfect sharp picture because you'll be after the far more elusive perfect blurred picture. Best of all—you get to decide what's perfect.

To enter the photographic world of shake, rattle, and roll, prepare to pan, zoom, jiggle, wiggle, spin, jump, and swing— usually with your camera. Although the destination— and your pictures—will be totally unpredictable, getting there will be a blast.

So remember, as you read through this section, there are no rules. I'll give you ideas, I'll spell out techniques, and at times I'll even give you specific settings. And if I happen to forget myself and speak in a serious tone, feel free to disregard what I say and uncork your own creativity as we turn the camera into a bouncing pogo stick. (Hey, now that's one I haven't tried yet.) Maybe you'll even become a reverse Philippe Halsman. His photographs of famous people jumping became famous themselves—as did he. Maybe you can become famous for creating a portfolio of pictures taken while you do the jumping.

Pantastic panning

If you're one of those people who slinks away moments before the start of the office's annual Secret Santa party, then panning may not be your bag. After all, panning is also full of surprises. But mostly pleasant ones. That's why I love to pan.

Panning is the primary technique photographers use to instill a strong sense of motion in photos through blur. Because it's so important and pretty easy to perform, we're going to give it in-depth coverage.

Here's a refresher. Panning creates a picture in which the moving subject appears nearly sharp and the still areas very blurred. That contrast between sharpness and blur imparts a terrific sense of movement. By now you've seen in this book a lot of pictures taken using the panning technique.

How does it work? By breaking that time-honored tradition of holding your camera still while taking a picture. Instead of holding your camera steady, you sweep it in synchronization with a moving subject such as a bicyclist. The motion mimics that of a birder looking through binoculars while tracking a seagull flying in front of him. While sweeping the camera across the scene, you take the picture. For example, by moving the camera in sync with a bicyclist, you keep the image of the bicyclist in the same position on the sensor, so the bicyclist appears sharp. Of course, everything else that wasn't moving is blurred by the motion of the camera.

Depending on your approach to panning, the results can be either predictable or unpredictable. If you want your panning to be predictable, you'll need to consistently create sharp subjects with blurred backgrounds. Here's how. First, choose a subject that's passing directly across your field of view. An example would be when you're standing on a sidewalk looking across the street and you intend to photograph a bicyclist coming down the road just as he passes in front of you. Use a shutter speed that's two to three times as fast as your subject (for example, 1/30 second for a bicyclist going 10 mph). Synchronize the camera motion to the subject motion and try to pan the camera as smoothly as possible.

Be sure to keep moving the camera after you press the shutter button. Just as follow-through is important in swinging a golf club, shooting a basketball, and throwing a football, so it is in panning. The follow-through motion is critical, especially for beginners, because if you briefly stop, pause, or even slow down your panning movement as you press the shutter release, you'll interrupt the blur created by the moving camera and produce an unattractive picture. The indication of success is that the numbers, words, and logos on uniforms and equipment in your photo are clearly legible.

If you want to emphasize the motion-conveying blur that panning can create, avoid a plain and uniform background like a blue sky. Exposure at 1/20 second, f/16.

The background of blur

Purposely achieving blur for creating artistic effect rests not solely on moving the camera while using a slow shutter speed. Sure, that's important. But it also depends on the scene's background or foreground (or both) being structured to facilitate showing blur. For example, if you pan a seagull or eagle soaring against a cloudless blue sky, you'll not see any blur because a clear blue sky lacks detail to become blurred. You can easily find this out at motocross events in which you try to pan a cyclist soaring off a jump and the background is blue sky. But if the background is a leafy canopy, then your panning will create huge amounts of blur.

The advice here is to avoid excessively plain, colorless backgrounds and foregrounds and find vantage points that offer surroundings resplendent with colorful and richly detailed objects. When I found a field of sunflowers with a path running through it, I knew immediately it would excel for panning because colorful sunflowers grew both in front of and behind the path the bicyclist would ride. Of course, there was no bicyclist when I first saw the sunflower field. The bicyclist appeared only when I went home and conscripted her for photographic duty.

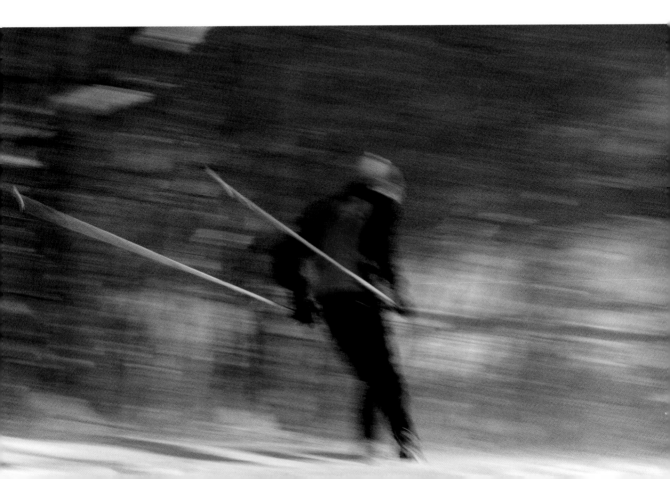

Rev up the blur for expressionistic panning

You now know the conventional way to pan. Now here's the fun way. You can become another Jackson Pollock. But instead of hurling gobs of paint across your canvas, let's use gobs of light. With this slight change to technique, your results become unpredictable, abstract, often unusable, but occasionally supremely expressionistic. I often pan a couple of pictures with a fairly fast shutter speed, just to be sure I've got a couple good shots, then switch to this technique.

Let's start off by changing just one variable: use a slower shutter speed (one that is 1/6 to 1/2 the speed of the subject—for example 1/2 to 1/5 second for a bike going 10 mph). That slower shutter speed revs up the blur. Take several shots on the rapid fire mode and work extra hard to synchronize the motion of the camera with the subject. If you achieve good subject-camera synchronization, the background will be dizzyingly blurred.

If you have an external flash (you can use the built-in flash if the subject is within ten feet of your camera), use it and set the flash mode to rear-curtain sync. The short duration of the flash will give you a very sharp image of a portion of the subject that's embedded within the subject that was successfully blurred by panning.

Now let's start improvising. Choose your shutter speed (slow or fast) but try one or several of these additional techniques:

- Pan with an occasional (or frequent) bump in the motion.

- Use a different perspective, and don't just pan subjects crossing directly in front of you.

- Choose an angle so the subject moves diagonally to you.

- Pan and zoom simultaneously; for this you'll need a fairly slow shutter speed, say less than 1/5 second.

How do you know when you're successful? When you like the results.

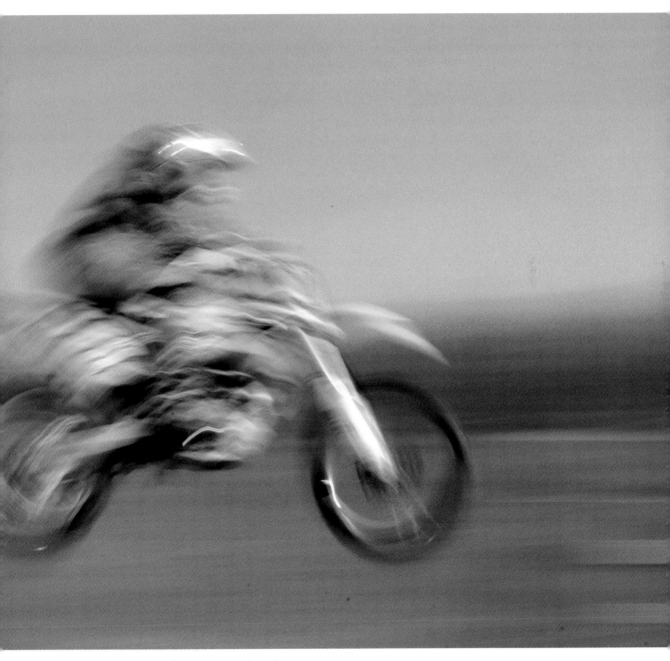

At 1/4 second, fast-moving subjects begin to warp themselves. Exposure at 1/4 second, f/29.

A gallery of panning

Since panning is one of the easiest, most effective, and powerful techniques for conveying motion, I thought I'd show a small gallery of images to encourage you to pan even more of your shots at a variety of shutter speeds. The captions will provide the details.

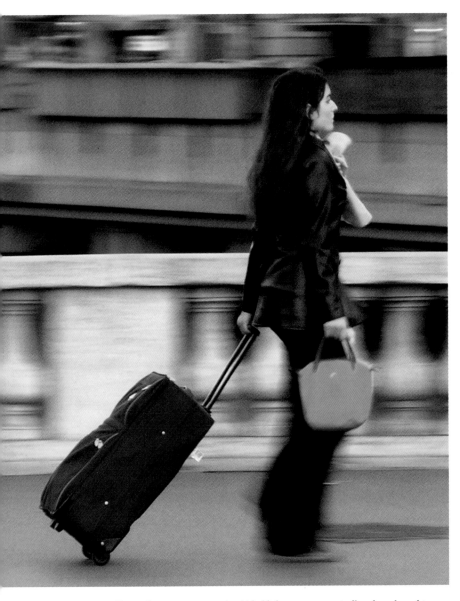

Even when panning you should hold the camera vertically when the subject seems to better fit a vertical format. Exposure at 1/10 second, f/8.

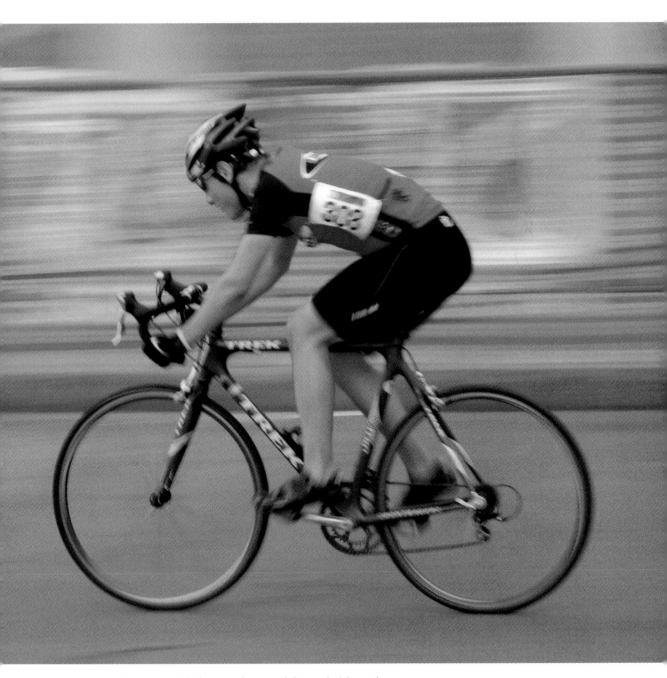

A shutter speed of 1/30 second conveyed the speed of this cyclist racing down a straightaway. Exposure at 1/30 second, f/16.

In the small villages of Peru, the main method of transporting things is by carrying them. All day long people lumber by under large loads. Exposure at 1/5 second, f/4.5.

Every motion photographer loves a parade. What better place to practice your motion techniques? Exposure at 1/6 second, f/32.

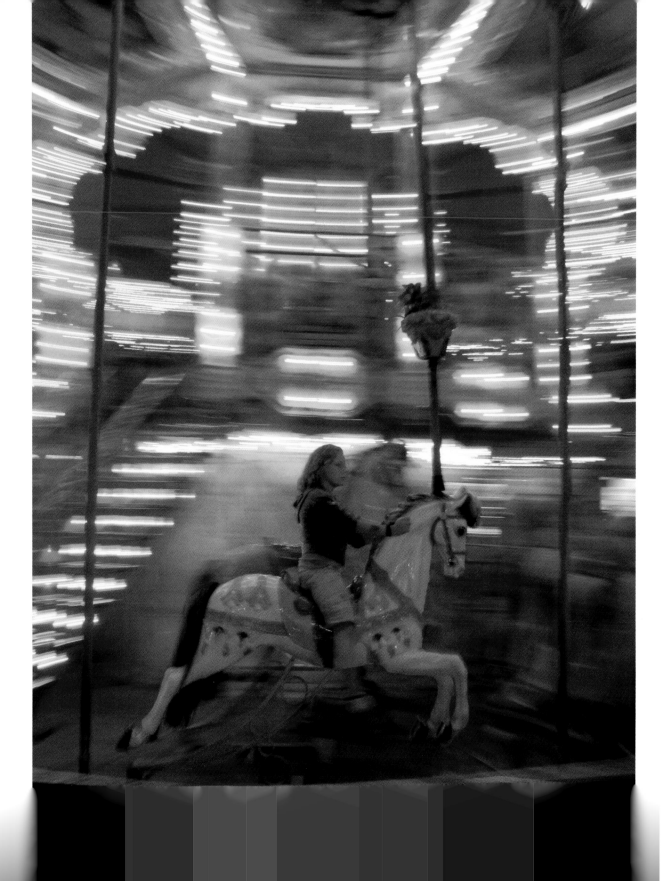

What technique could better capture the carnival atmosphere of a merry-go-round at night? Exposure at 1/6 second, f/9.

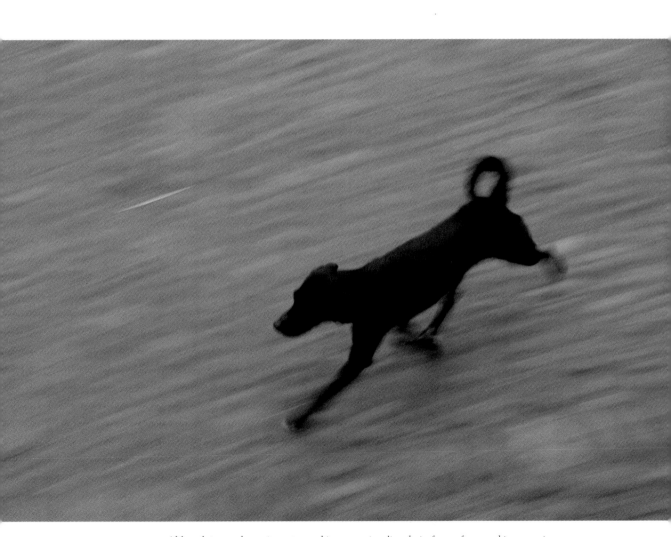

Although it may be easier to pan subjects crossing directly in front of you, subjects moving on a diagonal can exaggerate the sense of movement .Exposure at 1/20 second, f/11.

Zooming

This time-honored technique makes your subject look like it's exploding in a radiating pattern. Like a fingerprint, the unmistakable pattern of radiating lines identifies a shot as having been zoomed.

It's pretty easy to create a zoom photo. You need a zoom lens, a fairly slow shutter speed—typically from 1 second to 1/15 second, and, optionally, a tripod. Because you vigorously rack the zoom through a range of focal lengths, if you handhold the camera, the picture stands little chance of being sharp.

By fixing the camera to a tripod, you minimize the jerk of the camera motion from abruptly twisting or pulling the zoom control. The tripod gives you well-defined zoom shots with the signature radiating lines.

But there's no reason not to handhold the camera while zooming. I encourage trying it, and you may find that you prefer less predictability and more variation in your photos. Just expect to see some color streaks swirling across your photo, particularly if you're using a lens with a rotating zoom control. Unlike the push-pull zoom collars that when moved direct the force on the same axis as the subject, a rotating zoom collar almost always torques the camera sideways, forcing you to jerk the camera to the left or right.

There are several variables you can play with. These include the duration of the shutter speed, the range of the zoom, the speed of the zoom motion, and whether you choose to pause for a fraction of a second at the end of the shot or to zoom continuously during the whole exposure.

I like to use a 70-300mm lens for zooming. I choose a focal length and distance from the subject that lets me nearly fill the viewfinder area with the subject—typically around 200mm. Then I set the aperture so that I can get a shutter speed of 1/6 second or longer, using a neutral density or polarizing filter as required to get the longer shutter speed. If it's an intriguing subject, I'll try it with and without a tripod, but more often with a tripod.

Finally, just zoom away. I take umpteen variations, adjusting how fast I zoom, changing the focal-length range of the zoom (try for at least double, such as 200mm to 100mm), zooming both inwards (200m to 100mm) and outwards (100mm to 200mm), varying the shutter speed and also how long I pause at the start or end of the zoom. This pause at the beginning or end of the zoom adds just an extra dash of subject sharpness for greater recognition of what's buried in that zoomed shot.

Not all subjects work well for the zooming technique, but it seems appropriate for this jack-o-lantern. Shutter speed 1 second with the camera mounted on a tripod. Exposure at 1 second, f/14.

The Boardwalk
RESTAURANT
ON THE LAKE
COCKTAIL LOUNGE
ENTERTAINMENT
Open All Year

Nature often lends itself to slow shutter speed techniques. A shutter speed of 1/8 second revealed the water fanning around this rock. Exposure at 1/8 second, f/14.

Camera and subject are still— everything else moves

Coming to a dead stop in the middle of the sidewalk at Times Square can be a rush (and a risk) as the crowds suddenly part and flow around you like you're a rock in a stream. I love photographs that convey this sense of stillness, of solidness amidst change, of immobility in a relentless swirl of movement.

Neon signs at night also lend themselves to the zooming technique. I used a shutter speed of 3/4 second for this photo. Exposure at 3/4 second, f/20.

You can do this quite easily with a variety of subjects. The rock in a stream analogy nicely conveys the scene requirements: a large area of movement containing a smaller immobile subject. But this analogy need not just be an analogy. In many streams you'll find not only water but an abundance of rocks. If the water level is at the right height, the stream will fan gracefully over the rock; if it's running low, the flow simply parts to flow around the rock and then rejoins, usually forming an attractive pattern.

This streaming effect excels when the subject offers a surprise or delight or tension of some kind; for instance, a golden retriever napping in the sun as clouds of orange and yellow autumn leaves whirl past him; a person standing still, alone on a traffic island as cars whiz by; a sandpiper standing tall as a wavelet laps around its feet; or a field of wheat undulating around a rusty, abandoned pickup truck.

Although the concept is fairly simple, coming across the right combination of movement and still subject can pose a challenge. When you find your potential subject combination, use a tripod and a fairly slow shutter speed such as 1/4 or 1/2 second. (For pictures of fast-moving vehicles, start out with a shutter speed of about 1/15 second.)

A slower shutter speed than the 1/4 second used here would have worked even better to blur the people into a blurry stream of motion. I took a separate picture of the sign at a fast shutter speed and used Photoshop to replace the somewhat blurred sign in the original scene. Exposure at 1/4 second, f/22.

The blurred hands and feet combined with a whirling log show the precarious nature of these log rollers. Exposure at 1/45 second, f/22.

Camera held still— subject in motion

Sometimes the best way to convey a sense of motion is to let the moving subject blur itself in a scene that is otherwise sharp.

You have to balance subject blur with attractiveness and recognition. If the subject is so blurred that you don't recognize it or that it loses appeal, then the picture may fail. The trick is to manage the amount of blur to keep it attractive and appropriate, but not let blur obliterate the subject's identity and impact within the context you've chosen.

For instance, you could create a very appealing blur of a pirouetting ballerina or a spinning figure skater. You may find people engaged in an activity in which they move only a part of their body; this gives you the opportunity to use a shutter speed that reveals overall body sharpness but blurs their moving hands or feet. The result is a telling depiction of the action critical to their activity. You can, for example, animate fiddlers, pianists, dancers, drummers, sculptors, painters, jugglers, barbers, bakers, basketballers—and any others who create a flurry of motion with their hands or feet.

The approach is fairly simple. You hold the camera still (mount it on a tripod for slow shutter speeds) so that non-moving picture parts appear sharp, then use a shutter speed slow enough to moderately blur the subject. Since choosing the shutter speed is critical—as it is with nearly all motion techniques—you'll have to experiment to find the appropriate shutter speed that yields the results you want.

For a musician or artist, 1/8 to 1/30 second might work. For a BMX biker performing mid-air stunts, you could try 1/30 to 1/125 second.

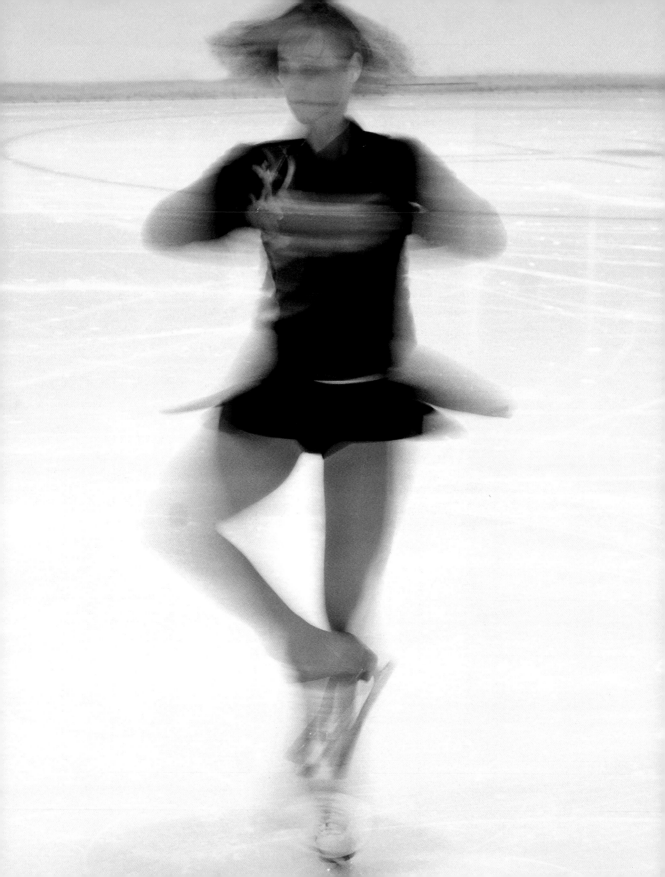

I added a brief burst of electronic flash to give a slight element of sharpness and recognition to this spinning ice skater. Exposure at 1/10 second, f/10.

Running, jumping, spinning, and twisting with the camera

Are you beginning to get the idea that maybe all these crazy motion techniques are good for people who get bored easily? Could that be you? Let's now put our whole body into the effort and turn our pictures into a whirlwind of motion and blur.

Take a look at the picture below to see how my running with the camera in a lighted tunnel created a rather unusual result. For the picture on the next page, I was walking with the camera at the state fair. If you have young children you might want to try running alongside them while aiming the camera their way and snapping a few shots. This technique is a rough version of what you see in the movies quite frequently, where an actor in motion is photographed—smoothly—by a camera on a track, or (more commonly done nowadays) by a handheld camera so the actor's movement is made intentionally jerky.

This is what a picture looks like when you run in a lamp-lit pedestrian tunnel while pointing the camera ahead of you. Exposure at 3 seconds, f/18.

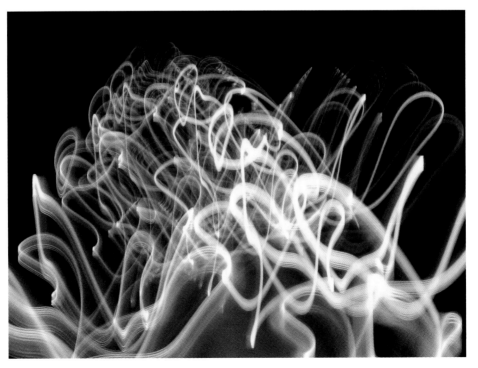

You can even spin the camera—and yourself—while aiming down at a flower or pointing overhead at a canopy of tree tops. There's no end to the acrobatics you can put yourself and your camera through until (sooner or later) you get dizzy and fall down.

Under a canopy of autumn leaves, I set a slow shutter speed, pointed my camera overhead, and spun in a circle. Exposure at 1/13 second, f/16.

As I strolled along the midway at the New York State Fair, I took several shots at a slow shutter speed as I walked. Exposure is 1/8 second, f/11.

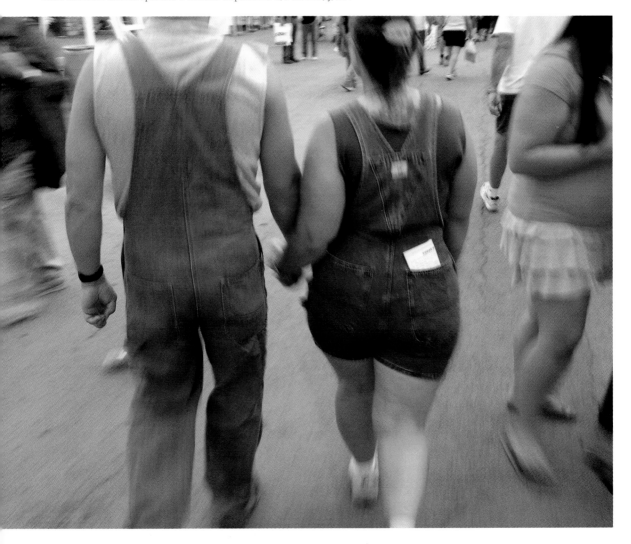

Shooting blur shots from the car

While taking pictures for some books on upstate New York, I spent so much time driving back roads that I got bored and started taking pictures from the car. I was just fooling around but I liked some of the shots.

First of all, I want to say that there's only one safe way to shoot from a moving vehicle: let somebody else drive. I'd also advise doing this on a road with low traffic volume. Not that I'm developing a mothering complex, but never take any actions that could put others at risk.

Yes, I know, it looks like I tripped and took a picture accidentally. But I'll be remembered for this artful picture one day. When shooting drive-by blur photos, find unobscured buildings with distinct shapes. Shutter speed 1/4 second, f/11. Car speed approximately 30 mph. Brain speed quite high.

Country roads lined with trees lend themselves well to creative blur. Shutter speed 1/4 second, f/22. Car speed unknown.

So, with your spouse or friend or your chauffeur at the wheel, open the window and catch some scenes flying by. It's hard to suggest what subject matter will work well, or even what shutter speed to try. Just play the numbers game by taking lots of pictures at different shutter speeds, ranging from about 1/4 second to 1/125 second to vary the blur. Use a wide-angle lens and set the camera on Manual Focus mode and the focus to the infinity (far distance) mark. (You can try auto focus, but it may not react well—mine doesn't—to this shooting situation).

The combination of blur and the somewhat tilted camera angle can create some very disorienting pictures. If you point the camera straight ahead of the car—while moving down a road surrounded by houses or trees—you can create a sort of vortex funnel effect that zooms with motion.

Camera tossers—only centerfielders need apply

So let's move on and wrap up this warped series of techniques with the ultimate—camera tossing. If you're keeping abreast of the extreme photo trends (I'm not, but fellow photographer Jeff Wignall told me about this), then you may know about the new trend of camera tossing. Many practitioners actually do this in front of a monitor for which they create a graphic design and produce elegant and intricate light patterns reminiscent of the Spirograph designs of our youth.

But that's the sophisticated approach. Let's go rough-and-ready and undertake the athletic method. Here's how it works. Set your camera's self timer to a second or two, activate it, and then toss the camera skyward and let it take a picture while tumbling through its ascent or descent. The kicker in all this is whether you can catch the camera before it hits the ground. (No, this is not a ploy by camera stores to boost camera sales.)

Although it sounds risky, to qualify as a certified tosser you need only have your hands off the camera body when the shutter opens up. So you don't have to toss it twenty, ten, or even five feet into the sky. You can just gently toss it from hand to hand as if you were fidgeting with an apple.

Regardless of the distance you toss your camera, the technique risks both limb and lens. And pearly-whites. For the safety of you and those nearby, as well as my peace of mind, follow these few guidelines, whose helpfulness is admittedly dubious (as well it may be, but the technique sounds like a hoot).

- Use a camera whose destruction won't leave you weeping.

- Clear all loved ones from the launch area.

- Invite a local politician to catch the camera (throw it extra high).

- Choose an environment with some interesting features on the ground and up in the air.

- Start out with a shutter speed of 1/500 or 1/1000 second in Shutter-Priority mode to try and stop the blur from the spinning camera. Then try some incrementally slower shutter speeds for that creative blur.

Some key elements in taking successful pictures with everyday camera tossing is choosing an appropriate subject, taking lots of pictures, and getting lucky. Exposure at 1/60 second, f/11.

- Practice catching a can of tomato soup for a few days or maybe your old film SLR.

- Wear a mouth guard, helmet, and steel-toed safety shoes.

- Yell "Fore!" when you release the camera.

And good luck—you'll need it.

Composition on the fly

Powerful pictures derive from powerful composition. But it's one thing to leisurely compose a sunset scene with a sailboat drifting in front of the sun and another to snatch an attractive composition from a writhing web of stick-whacking lacrosse players weaving down the field.

As the action picks up on the field, so does the level of your panic as you begin to realize you may not get any good shots, so thoughts of composition fall to the side and photo survival pushes to the front. After only a few sessions of fast action photography, you realize you're in a different ball game. No longer can you compose pictures in a leisurely manner. It's not like landscape photography where you're driving along the coast and find a beautiful vista at which you can linger and consider the possibilities. Should you get low to emphasize that driftwood stump, or stand taller to capture the surf lapping the shore?

When the ball is kicked off or the hockey puck dropped, mayhem ensues and your reactions sometimes have to be faster than the athletes or you miss the shot. In other words, all hell breaks loose and you don't get to call "Time-out!" to sort your options. Where you point the camera, what focal length and shutter speed you use, and possibly where you position yourself—these are the primary decisions you must make.

Conventional subjects usually give you enough time to leisurely compose your picture in any way you see fit. Exposure at 1/60 second, f/13.

This salt miner in Peru repeatedly carried his fifty-pound bag of salt along the same route, giving me a chance to take the shot I wanted. My daughter later spoke to him in Spanish and he surprised us by telling her he likes his job. Exposure at 1/250 second, f/11.

Being able to act fast enough to compose a picture almost instantaneously is like trying to write a love note as a tornado roars toward the house while you're crouching under the kitchen sink.

But when you live in tornado country, you're always prepared and you know just what to do when the siren sounds. The same is true for experienced action photographers. When the buzzer bleats, they respond instinctively because they've thoroughly rehearsed their options until they become second nature.

Improving composition when the action picks up

Shooting high-speed activities can be a rush. But it's also a bit like trying to catch a jumping frog. If you're experienced at frog catching, you just might be able to sneak up from behind and snatch it on the first try.

But most of us aren't experienced, so we'd be better off rounding up our friends and surrounding it. And if we still failed to capture it, well, at least the frog had some fun.

The photographic equivalent of a having a lot of friends is taking a lot of pictures. So in just a few pages we'll show you how to set up your camera to take a lot of pictures quickly and increase your odds of snatching several good pictures from the pandemonium in front of you.

When you're photographing team sports like soccer and football, you can try to isolate an action that occurs in the open field. That way you can single out one or two individuals and not have to deal with a confusing tangle of players.

You might also compose a bit more loosely than normal to accommodate unexpected action, and then crop the picture later in Photoshop. Instead of zooming all the way out to 300mm, settle for 200mm or maybe even 135mm. This runs counter to capturing the flying spit, bloody noses, and clawing fingers that you might better reveal with an in-tight, frame-filling composition; but it gives you more leeway. Simply put, by casting a wider net you'll catch more of the action. With your zoom lens at a midway setting, you'll also find it easier to zoom out to a wider setting when the action comes pounding toward you, or zoom to a telephoto setting when the action retreats. It's sort of like a tennis player who after each shot returns to the middle of the court so she can better cover the total court.

This loose composition technique works best with a camera offering a resolution of 12 megapixels or more. With such a high resolution camera, even if you need to crop the picture later in Photoshop, you will still have sufficient resolution to make a good-sized print.

Another piece of advice that runs counter to general composition practices is that you may be better off (especially if you're inexperienced) shooting fast action with the camera constantly in the horizontal position—even for vertical subjects—for two reasons. One is that horizontal is the more natural position for holding the camera, so you'll be able to compose and adjust controls easily and quickly. The second is that this orientation reinforces the loose composition technique in that it includes more of the action. You can crop to vertical later.

If you're already comfortable photographing fast action, then by all means hold the camera vertically and fill the frame to strengthen the composition of your photos.

When the action picks up it often pays to compose a little more loosely by shooting at a slightly wider angle than you think you should. By casting a wider photo net, you'll probably catch more when you crop in closer in Photoshop. Exposure at 1/500 second, f/11.

Loose shot

Tight shot

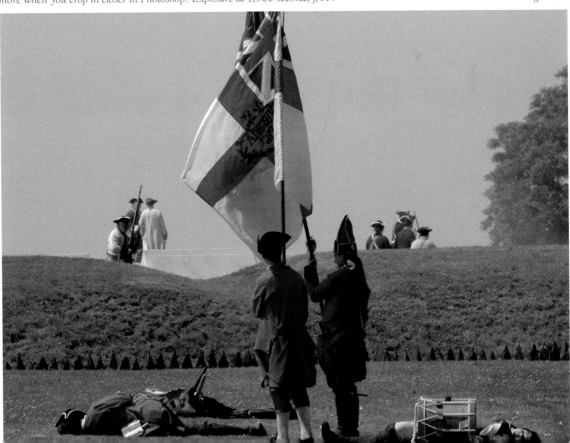

Low angle versus high angle

The height at which you position the camera dramatically impacts how powerful a subject appears.

If for some reason you are shooting from a high angle down at a subject, the subject will appear flat and one dimensional. That high angle sucks the dominance right out of it. Shooting from above, might, however, instill a sense of originality or abstractness, because most of us—except for the times we might be spectators at professional sports stadiums—seldom see subjects from a high angle.

From a low angle you instill athletes with the strength and power you'd expect of them: a soccer goalie, entire body stretched out above you as she leaps, stretches, and deflects a goal attempt, or a hitter's swing exploding as bat strikes ball. As you raise the camera, you lower the power of the subject. (Normal viewing angles tend to reveal normal strength and skill.)

Camera above subject. Exposure at 1/250 second, f/11.

Shooting from a low angle exaggerates power even in those who lack it. It turns the feeble and the fumblers into decisive subjects who could be the model of any "after" picture showing the advantages of sports drinks or exercise equipment. From a low angle, even toddlers tower and puppies predominate.

Whether you're crouched or prone on the ground, you'll find holding the camera straight more difficult. Strive to keep the camera square to its subject, unless of course, you want to try the technique of tilting it for a specific effect.

Picture dominance depends in part on the implied personal perspective. When the subject is lower than you, you seem in control. When it's higher, it's in charge.

Camera below subject. Exposure at 1/500 second, f/5.6.

Composition—positioning the subject in the frame

The camera's rectangle presents you a 3:2 ratio of width to height. Where you choose to place a moving subject within the picture area can dramatically affect interpretation of it. The picture area defines itself with very distinct borders—walls if you would. And who wants to bump into a wall? Well, you just might want your photo subject to, if you seek drama in the picture.

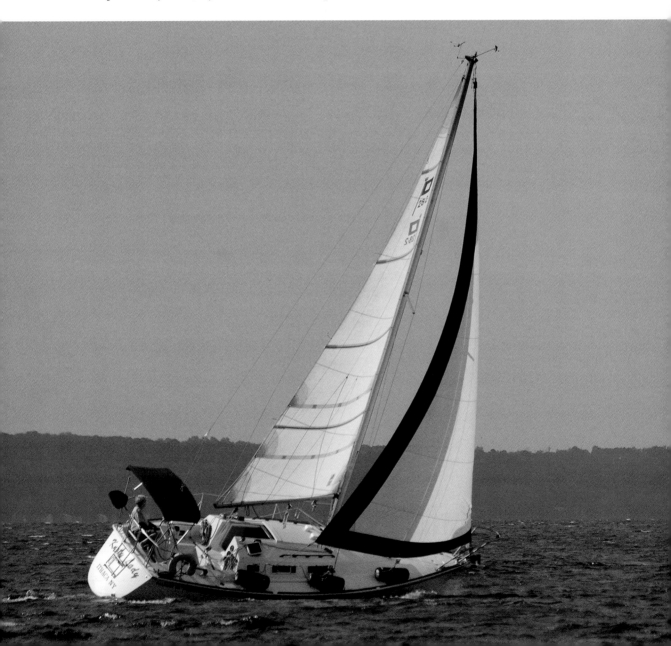

Back to the main question: Where should you place the subject within that rectangle? That all depends on your intent. If your intent is to present balance and harmony, follow the famous rule of thirds (itself derived from a golden rule created by Greek mathematicians and embodied in the design of the Parthenon). It dictates a specific placement to achieve visual balance. Imagine a tic-tac-toe grid imposed over your scene or the camera viewfinder. Any of the intersections of lines pinpoint a "thirds" area of the grid where you could place the subject or an important part of the subject.

Another general guideline for action shooting is to leave about one-third of the picture area in front of a moving subject so it has space to move into. Speed seems to demand an area to move into because the essence of fast-moving subjects is that they depart almost as soon as they arrive—so give them a place to go. That space ahead also implies a runway or track for building acceleration. For that reason, a cyclist racing across the photo will more likely seem to be gaining speed when there's space in front of him to move into.

By both western culture and photographic convention, the preferred direction of movement is left to right. That's largely because the alphabet of the western world is written left to right, which trains our eyes from early childhood to expect to move left to right when looking at paper (or a monitor). So it's a natural and expected eye movement for us to scan for subjects left to right, despite the fact that you'll often be photographing subjects moving in the opposite direction.

But what if you don't want to convey just speed? What if you want to depict recklessness or daring on the edge of disaster, or uncontrolled power? Then jam the front wheel of that motocross bike into the lower right corner as if it were about to splat into the ground. Or toss that leaping wave runner into the upper right quadrant so it seems to

For a relaxed and pleasing composition of a moving subject, provide some space in front of its path so the composition doesn't seem cramped and claustrophobic. Exposure at 1/640 second, f/9.

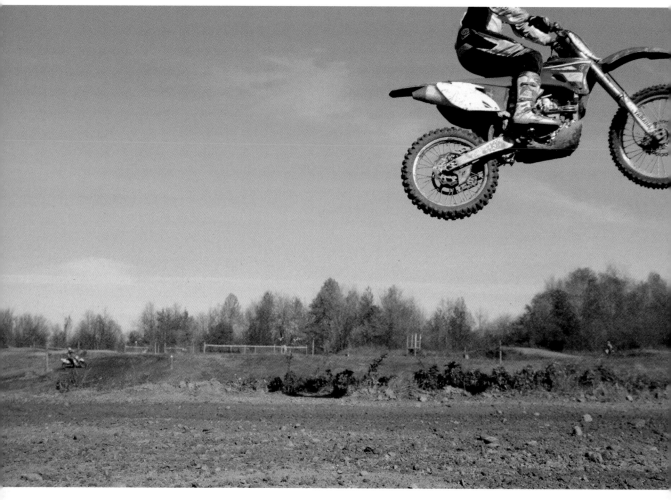

Want to convey a sense of recklessness and speed? Push your subject to the picture's
edge and maybe even cut part of it off. Exposure at 1/2500 second, f/8.

be rocketing out of control by putting part of it out of the picture. You don't even
have to do this on purpose: more times than you'd think possible, you'll find you've
taken a number of pictures in which your high-speed subject has already half fled
the scene.

When positioning your subject in the picture area, you can follow the guidelines
for placing subjects, or you can ignore them to achieve your own purposes. But
whatever you do, use that rectangular picture frame to amplify attitude and
modulate mood.

Composition—sizing the subject

How big should you show the subject? Should it fill the entire frame, half the frame, one quarter? Would there ever be a reason to show an action subject filling only a tenth of the frame—reducing it to an almost insignificant force? (Hmm, how tempting…) Although you usually decide these things almost automatically and subconsciously, taking pictures requires you to make hundreds of choices.

Should you show that beach volleyball player tightly-framed as she grimaces and dives to dig out a wayward ball; or should you show her smaller, with her teammates positioning themselves for her save; or pull back even farther to show the spectators rising to their feet in anticipation of a spectacular play? I think you're beginning to see how subject size impacts the picture.

Showing a subject from a distance adds atmosphere and context
while reducing intensity. Exposure at 1/90 second, f/5.6.

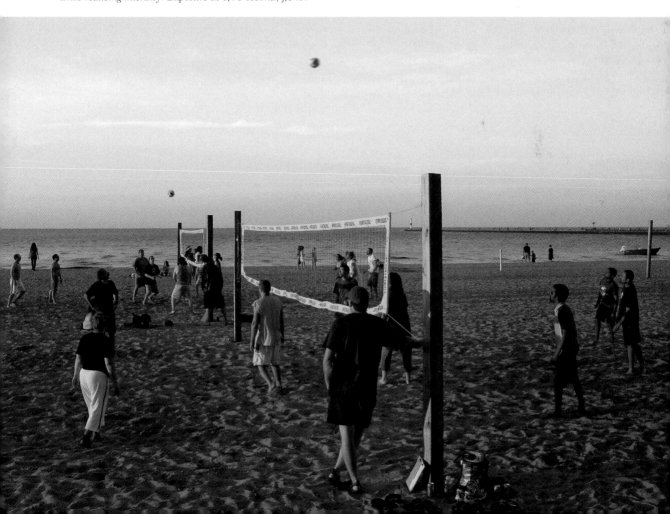

If you're still not with me, let's spell it out. How big you show a subject largely determines the mood or objective you're setting. Showing a subject small and its surroundings relatively large establishes context and interaction and dependency on others. Showing your subject big, almost frame-filling, can reveal an individual effort of grace, power, or skill (or even the opposite—clumsiness and blunder). You can add many nuances between those bookends, depending on any additional factors you want to consider.

Subject size affects not only mood. The bigger you show the subject, the greater the number of technical challenges you impose on yourself. Accurate focus, fast focus, sufficient depth of field, freezing the action, an appealing composition; all these and more becomes increasingly difficult as the subject starts to fill the picture area.

With the subject smaller, seen from a distance as it were, small and middle-sized details (hands, for example) draw less attention. Fingers awkwardly bent, a face turned away, and other minor "errors" present few problems because they aren't of a significant size. But up close, even small flaws are thrust before you for inspection. You can expect your yield of pictures to fall when you show a subject large, because a problem that might otherwise have been minor tends to be magnified and become a big deal.

Imagine that you want to take a sharply-focused shot of a frame-filling gymnast as she performs a twisting dismount from the balance beam. Not only must you catch her in a pleasing position from among the hundreds of rapidly evolving positions of the dismount, but you must freeze her movement with a very fast shutter speed; your camera's focus mechanism must keep up with her during all these gyrations; and your aperture and focus must work in concert, so that—if you freeze her motion—the depth of field is deep enough that nearly her whole body appears sharp.

That's a lot to keep track of, isn't it?

Intensity seems to grow as the subject grows in size. Exposure at 1/30 second, f/22.

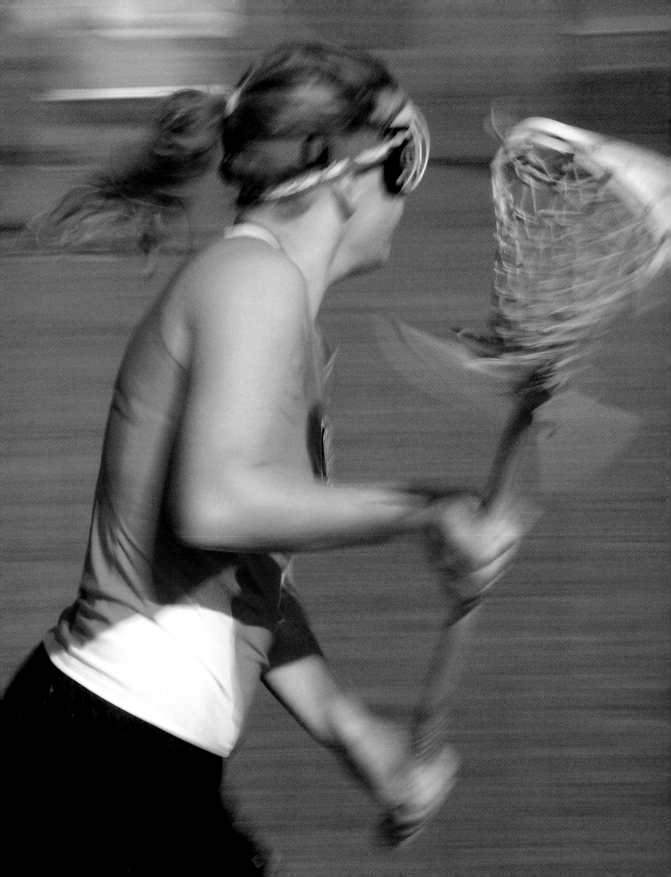

Composition and subject direction

Like subject size, subject direction influences the resulting mood of the picture.

Let's simplify this discussion by reducing the infinite possibilities of subject direction to three broad categories: subject movement directly toward or directly away from you (advancing or receding action that moves perpendicular to your outstretched arms); subject movement crossing in front of you ("crossways" action that moves parallel to your outstretched arms); and diagonal subject motion.

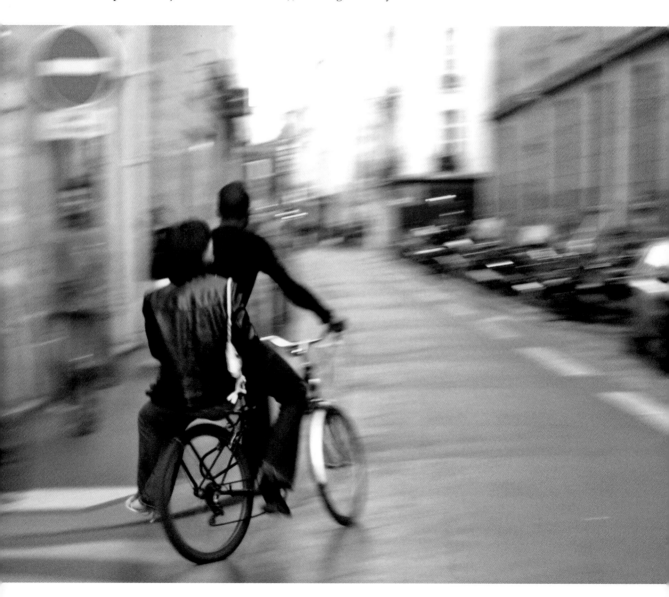

Moving toward you

Technically speaking, a subject moving directly toward you (or directly away from you) is the easiest to photograph.

Creatively, head-on movement offers you fewer choices. You can't really pan a subject that is moving directly at you, so the option of a motion-blur photograph falls to the wayside (although you could zoom it). A subject moving directly at you offers none of the dramatic profile of legs, arms, chest, head, and other body parts extended in action postures. So conveying the drama of action in a freeze shot also becomes more difficult. With the subject coming directly at you, you do, however, put the viewer in a direct line of action so it might seem as if a fullback or a racehorse is about to run right over you.

Crossing in front of you

Creatively, subjects moving across the scene in front of you offer a variety of opportunities to reveal action and portray excitement and emotion. Imagine a sprinter rising out of the starting blocks. From the side you are presented a profile that reveals all the action postures: arms cocked and stretching out, legs lunging, head tilted. It's when they're seen from the side that most subjects best show positions and movements that shout power and speed.

Taking the diagonal route

Not surprisingly, subjects moving diagonally to the camera offer a technical and aesthetic mix of the other two directions. Direct or implied diagonal lines are often considered both powerful and dynamic. They tend to lead the eye through most of the picture establishing the greatest range of dimension possible in a rectangular picture.

Unlike head-on and crossing subjects, diagonally moving subjects usually show two sides of themselves, making the picture seem more three-dimensional. In action shots the added dimensionality of showing another side can reveal muscles or postures that reinforce strength and agility.

Making a turn, a bicyclist and friend seem to be leaving you behind as they head down a Parisian street for an unknown destination. Exposure at 1/8 second, f/11.

Glossary

A

accessory flash A flash unit separate from the camera that has either a wireless connection or attaches directly to the camera's hot shoe. Also called *external flash*, it provides supplemental light to a scene.

Adobe Photoshop software The preeminent image-editing software used for adjusting photos. Photoshop comes in two versions: Photoshop Elements for amateur photographers and Photoshop CS for advanced and professional photographers.

ambient light The light, natural or artificial, that is found illuminating a subject or scene; the photographer adds no additional light to it. Also called *existing light* and *available light*.

aperture An adjustable, circular opening in a lens through which light passes to reach the camera's sensor. It works with shutter speed to deliver the proper amount of light for a correct exposure of a picture. The diameter of the aperture is expressed as an f-stop number; the smaller the f-stop, the larger the aperture.

Aperture-Priority mode An exposure mode that allows the photographer to choose the aperture (f-stop); the camera then sets the shutter speed to provide a correct exposure. Also called *Av*.

Auto exposure mode An exposure mode in the camera which sets both the shutter speed and the aperture. Depending on the camera model, it may also adjust the ISO and turn on the flash to achieve correct exposure.

auto focus A camera function that enables the lens to focus automatically on a specified area in the scene.

Averaging metering mode At this setting, the light metering gives equal emphasis to all light values reaching the sensor, and then averages them to determine the camera's exposure settings.

B

backlighting The subject is lit from behind—and the light shines directly at you.

bracketed exposure A series of exposures that varies the amount of light reaching the sensor. You create a sequence of pictures with different degrees of brightness with the expectation that one of the series will be correctly exposed. Bracket exposures when you think the scene lighting or subjects may fool the camera meter.

bracketing mode A camera function that automatically takes 3 to 7 pictures at different exposures when you press the shutter button.

brightness In a digital image, the lightness value of a pixel is expressed from black to white, with 0 (zero) for black and 255 for white.

buffer The computer memory in your camera that temporarily stores digital photos as you take them. Later, the pictures are written to a *memory card*.

bulb A shutter speed setting that keeps the shutter open as long as the shutter button is depressed. Normally used for time exposures of several minutes and longer.

burst mode See *Continuous Shooting mode*.

C

cable release An electronic or mechanical cable that attaches to the camera which you use to release the shutter without incurring the vibration or jarring that often occurs when you press the shutter release with your finger.

Center-weighted metering mode A metering mode that gives extra emphasis to the center of the picture area when measuring light in a scene.

circular polarizing filter A special polarizing filter for autofocusing cameras. See *polarizing filter*.

close-up lens Also known as a macro lens. It enables the camera to focus extra close to the subject by using a focusing mechanism that extends the lens further out than a conventional lens does; not to be confused with supplementary close-up lenses that screw on to the front of a lens like a filter.

color balance The overall color appearance of a picture. Normally, white subjects should look white and colors should appear natural and match the color in the scene. The color of light varies depending on the source and on the time of day for sunlight. White balance settings on the camera can be used to create neutral results.

color cast A color shift or tint that uniformly covers an image. It is often caused by a mismatch between light source and white balance setting. Can also be caused by light reflected from colored walls and other surfaces.

CompactFlash card A specific type of removable memory card used to store pictures in many dSLR cameras.

composition The arrangement of subjects in a photograph to create a pleasing and meaningful design. Composition is largely a matter of personal taste.

compression A reduction in the file size of a stored digital picture. This reduction is achieved by algorithms for file compression that evaluate picture data and eliminate redundant information. See also *JPEG*.

Continuous Servo focus A function that enables the lens to continuously adjust focus as the subject moves, so long as you continue to partially depress the shutter button.

Continuous Shooting mode A setting that enables the camera to keep taking multiple pictures once you press and hold down the shutter button. Continuous Shooting mode is also known as *Burst mode*.

contrast range See *dynamic range*.

correct exposure See *exposure*.

crop To eliminate unwanted portions of a picture with image-editing software.

D

Delayed Release mode A camera setting that delays the opening of the shutter by a few seconds, usually to reduce vibration that may occur when the mirror in a dSLR lifts up to admit image-forming light from the lens.

depth of field The near-to-far distance in a scene that appears sharp in a picture. Once the camera is ready to take a picture, depth of field is controlled by the aperture setting. Before the camera is set to take a picture, depth of field can be altered by the aperture, camera-to-subject distance, and the lens focal length.

depth of field scale A series of markings on a lens barrel, typically in both feet and meters, which indicates the depth of field for a given aperture setting and subject distance.

dSLR Digital single-lens-reflex camera. A digital camera design that uses a pentaprism to bounce the light image from the lens to a viewfinder via a 45-degree mirror.

directional light Backlighting, sidelighting, and front lighting are examples of light which strikes a subject from a particular (and usually obvious) direction.

display See *LCD*.

dynamic range From the lightest to the darkest, the range of tones in a digital photo. The greater the dynamic range, the more detail appears in both shadow and highlight areas. Also called *contrast or tonal range*.

E

electronic flash A device that creates a brief and bright burst of light to enable picture taking when the light is too dim. The light is created by using electricity from a battery to spark a gas (usually xenon) contained in a small tube.

electronic noise Random electrical signals from the camera's sensor that appear as stray and unwanted colored specks in a digital photo. Noise increases at higher ISOs, because cameras amplify the signal from the sensor, which in turns amplifies or increases the amount of noise. Also called *noise* and *random noise*.

electronic shutter release A cable that attaches to the camera and allows the photographer to open the shutter without jarring the camera by pressing a button on the cable that sends an electronic signal to the camera and opens the shutter.

equivalent exposure Different combinations of aperture and shutter speed settings that let in the same amount of light. For example, 1/125 second at f/16, 1/250 second at f/11, and 1/500 second at f/8 are equivalent exposures because they admit identical quantities of light when the scene illumination remains unchanged.

EXIF Acronym for EXchangeable Image File format. This standard describes how digital cameras can store a variety of picture-taking data in the picture file that can later be reviewed by looking at the Properties portion of the file using a Windows or Macintosh computer. Typical data stored includes a wide variety of camera settings such as shutter speed, f/stop, focus mode, focal length, scene illumination, white balance, file size, and so on.

existing light See *ambient light*.

exposure The amount of light that reaches the sensor; a *correct exposure* requires a specific measure of light to give a picture brightness and darkness values that closely resemble the scene. The amount of light reaching the sensor is controlled by shutter speed and aperture setting.

exposure bracketing See *bracketed exposure*.

exposure compensation The process of deviating from the meter recommendation to increase or decrease the amount of light reaching the sensor for artistic or technical exposure reasons; often done to accommodate for shortcomings of the metering system or to customize the setting to a specific subject in the scene.

Exposure Compensation mode A setting that automatically increases or decreases exposure.

exposure meter The camera meter that measures the amount of light when framing a photo and determines the best exposure. Averaging, center-weighted, matrix, and spot are the main metering types.

exposure modes A series of camera functions that automatically sets the shutter speed and aperture to give good exposure based on predetermined requirements for each mode.

external flash See *accessory flash*.

F

file format The structure of the photo file when it is saved on a camera memory card or a computer hard drive. Common file formats include JPEG, TIFF, and RAW.

fill flash The use of flash outdoors, usually in sunlight, to lighten deep shadows on faces; can also be used with other subjects. Also called *fill-in flash*.

filter Optical quality glass or plastic placed in front of the lens to modify the qualities of light.

fixed-focal-length lens A lens with only one focal length as opposed to a zoom lens which has a specific range of continuously variable focal lengths. Also called a *prime lens* or *single-focal-length lens*.

flash synch shutter speed Typically the fastest shutter speed in which the shutter fully opens so that the flash can be used. Slower shutter speeds can also be used, but at higher shutter speeds, the shutter forms a slit that travels above the sensor and would cut off part of the light from the flash.

focal length An optical measurement of the internal focusing distance of a lens expressed in millimetres. Commonly used to classify a lens as to whether it's a wide-angle, normal, or telephoto lens.

fps (frames per second) A measure of the rate at which pictures are taken.

front lighting The direction of light that strikes the surface of the subject facing the camera.

f-stop A numerical indicator of the size of the lens aperture. Also called *f-number*.

G

graduated neutral density filter A lens filter with its density decreasing from the greatest density at the top to no density from the middle to the bottom. Referred to as neutral because it doesn't alter color.

H

HDRI (high dynamic range imaging) A technique in which a series of pictures of an identical scene are taken in a range from underexposure to normal exposure to overexposure and then combined in special software to extend the dynamic range beyond what a single exposure could reveal.

histogram A graphic display of tonal values in an image. It is a feature on cameras and image-editing software commonly used to evaluate the quality of an image's exposure.

hot shoe A bracket on the camera used to hold an accessory flash unit.

I

image-editing software Computer software designed to enable uses to adjust and manipulate digital pictures. With image editing software, you can darken or lighten a photo, rotate it, adjust its contrast, crop out extraneous detail, remove red-eye and more.

image resolution The number of pixels in a digital photo. Often used as an indicator of how much a photo can be enlarged.

image stabilization Technology that counteracts slight movement of the camera when it is handheld to create sharp pictures taken at slower shutter speeds. Also known as *optical stabilization*.

image-stabilized lens A lens technology that employs a movable glass element to counteract slight movement of the camera when it is handheld so as to enable sharp pictures at slower shutter speeds.

infinity The distance setting on the lens at which light rays enter the lens effectively parallel to each other and everything beyond it appears in focus.

ISO speed Determines the sensitivity of the camera sensor and affects how much light is required to make a correct exposure. Based on the rules from the International Organization for Standardization. This sensitivity is expressed with ISO numbers: ISO 100 is a slow speed and indicates low light sensitivity; ISO 800 is a fast speed and indicates high sensitivity.

J

JPEG file format The most popular file format used in digital photography. JPEG is the standard method for compressing image data and was developed by the Joint Photographic Experts Group. Compression is used to make image files small enough to store greater quantities of them on memory cards. JPEGs image files are considered lossy in that they get rid of some of the image data when they are compressed.

L

lag time The time between when you press the shutter release button and the camera takes the picture.

LCD (liquid crystal display) The device on the back of a camera used to display digital pictures and menus.

lens speed Designated by the maximum aperture of a lens. A lens with a relatively large maximum aperture is considered fast. One with a medium or small maximum aperture is considered slow.

light meter An instrument that measures light so the camera can deliver the amount of light required by the sensor for a correct exposure of a specific scene. It's built into all modern cameras, but is also available as a separate unit.

M

macro lens See *close-up lens*.

Manual exposure mode A camera setting that requires the user to set both the shutter speed and aperture to achieve a correct exposure.

manual focus A focus adjustment made by hand-turning the focus ring on the lens.

Manual focus mode A setting that requires the user to turn a ring on the lens to adjust the focus.

Matrix metering mode A meter setting that determines the exposure settings required by variably weighting data through the use of a segmented pattern superimposed on a scene as seen through the viewfinder or LCD.

megapixel See also *pixel*. One million pixels. The measure often used to indicate a camera's resolution, although it should not be used as an indication of picture quality which also depends on a variety of other factors.

memory card A small and portable electronic storage device for recording and storing pictures from a digital camera.

metadata Data about data. At the time of picture taking, cameras capture a variety of information about camera settings and picture specifications that can be accessed through the camera, your computer's operating system, or your image-editing program.

metering modes Individual settings that determine the pattern the meter uses to measure light from a scene; modes include center-weighted, averaging, matrix, and spot metering.

mirror lockup setting A camera setting that lifts the mirror and locks it in position during picture taking so its movement does not vibrate the camera.

monopod A lightweight, one leg piece of tube about three feet long with a mount to support a camera to enable the use of slower shutter speeds.

N

neutral density filter A lens filter made of material that reduces the amount of light passing through it without altering the light's color quality. Also called *ND filter.*

noise The introduction of unwanted colored pixels into an image. Noise is increased by electronically boosting the signal by setting a higher ISO. Also called *electronic noise* and *random noise.*

normal lens A lens focal length believed to show a scene similar to how the human eye sees it. In 35mm equivalent focal lengths, this would be about a 50mm focal length lens.

O

opening up Increasing the size of the aperture to let in more light.

optical stabilization See *image stabilization.*

overexposed A picture that is too bright because too much light was allowed to reach the sensor. It lacks details in the highlights.

P

panning The technique of moving the camera to track the subject while using a medium to slow shutter speed. The purpose is to convey a sense of motion by showing the subject fairly sharp against a blurred background.

pixel Another name for picture element, the smallest light-sensitive component of a sensor used to form pictures. A digital photograph's resolution, or visual quality, is measured by the width and height of the image measured in pixels.

polarizing filter A rotating lens filter (also called a *polarizer*) that is capable of reducing reflections from nonmetallic surfaces (glass, water, etc.) by filtering out certain angles of light waves. Polarizing filters are also able to darken blue skies (by removing reflections from airborne moisture) and saturate colors. Auto-focus lenses require what is known as a *circular polarizing filter.*

Predictive focus mode A camera program that measures the path of a subject as it moves and adjusts focus of the lens after the shutter button is pressed to anticipate the location of the subject when the shutter opens.

prefocus To focus on the area of the scene you want to photograph before composing and taking the picture. Often used in action photography.

prime lens A lens with one fixed focal length.

Program mode The exposure mode that tries to give equal emphasis to shutter speed and f-stop during picture taking.

prosumer cameras An industry term used to describe cameras designed to fit the needs of consumers who demand some of the performance features of a professional camera but at a lower cost.

R

RAW file format A file format that saves a camera image as an unfinished file that preserves much of the original photo data in an unaltered form. This allows you to make many more broad adjustments in image-editing software than you could with a JPEG or TIFF file.

rear curtain synchronization Rear curtain synch is an electronic flash mode in which the flash fires at the end of the exposure, immediately before the camera's shutter closes.

remote shutter release An electronic device that allows you to press a button to send a signal to the camera to take a picture.

resolution See *image resolution.*

S

selective focus Intentionally limiting focus to a specific area of the subject for creative effect by restricting a photograph's depth of field.

self timer The camera device that when set and then activated by pressing the shutter button takes a picture at predetermined delay time typically from 2 to 20 seconds.

Sensitivity See *ISO speed.*

sensor The electronic, light-sensitive device in a camera that records a picture in a digital camera.

sensor stabilization An image-stabilization technology that moves the sensor to counteract movement of a handheld camera and thus enable sharp pictures at slower shutter speeds.

sharpness The clarity of detail in a photo.

shutter A mechanical device in the camera that opens to admit image-forming light from the lens onto the sensor to form a picture.

Shutter-Priority exposure mode An exposure mode that requires the user to set the shutter speed; the camera then selects the aperture to give a correct exposure. Also called *Tv.*

shutter release button A button usually on top of the camera that you press to take a picture.

shutter speed The length of time that the camera's shutter remains open to create an exposure; typically measured in full seconds, hundredths of a second, and thousandths of a second.

sidelighting Light that shines on a subject from either side and creates shadows that show a subject's dimensionality.

single-focal-length lens A lens with a fixed focal length that cannot be adjusted; as opposed to a zoom lens which offers a fixed range of focal lengths that the user can select from.

Single Servo focus mode a function that causes the lens to focus once when you partially depress the shutter button. See *Continuous Servo focus mode.*

Single Shot shooting mode A function that results in the camera taking only one picture each time you fully depress the shutter button.

soft light Gentle light that is created from a large, diffuse light source, such as found on a cloudy day or next to a window away from direct sunlight. Also called *diffuse light.*

snapshot camera A small, often inexpensive camera designed with automatic and often non-adjustable settings to simplify picture taking for casual photographers.

Spot metering mode A light meter function that measures only a tiny area of a scene—typically anywhere from a 1- to 5-degree angle of view.

stopping down Reducing the size of a lens aperture to decrease the amount of light admitted by the lens.

storage card See *memory card* and *CompactFlash card.*

Sunny 16 rule A rule for manually setting (or checking) exposure for taking pictures of subjects in bright sunlight. The rule states that the correct exposure for a subject in bright sunlight is to use an aperture of f/16 at a shutter speed of 1/ISO setting on the camera. Example: If the camera ISO is set to 200, the correct exposure would be 1/200 second at f/16 (or an equivalent exposure, such 1/800 second at f/8.

T

telephoto lens A lens using an optical design that magnifies the apparent size of distant subjects by narrowing the field of view. In 35mm equivalent measurements, a telephoto lens would include focal lengths upwards of 70mm.

telephoto zoom lens A lens with an optical design that both magnifies distant subjects and allows the focal length to be varied through a specified range. Common zoom lenses include 70 - 200mm and 70 - 300mm focal length ranges.

TIFF Tagged image file format. A standard photo file format. No longer common in cameras but still widely used for saving images in image-editing software because it maintains lossless quality and supports most advanced features, such as layers, embedded by the image-editing program.

tonal range See *dynamic range*.

track To look through the camera viewfinder and follow a moving subject with the intent to take its picture.

Trap focus mode A camera setting that automatically takes a picture when a subject moves into a preset focus distance within the camera's field of view.

tripod A three-legged camera support used to steady the camera during long exposures.

TTL Acronym. Through-the-lens light metering means that the light is measured at the sensor plane of the camera.

U

underexposed A picture that is too dark because too-little light reached the sensor. An underexposed photograph lacks details in the darker tones.

V

viewfinder An optical device built into the camera through which the photographer looks to determine the area to choose to make a picture.

W

white balance A method of neutralizing color shifts in the existing light source by matching the color response of the digital sensor to the color temperature of the light.

wide-angle lens A lens using an optical design that reduces the apparent size of distant subjects by increasing the field of view. In 35mm equivalent measurements, a wide-angle lens would include focal lengths downwards of 40mm.

Z

zoom lens A lens with an optical design that allows the photographer to continuously change the field of view through a specified focal length range to include more or less of a scene. Such lenses come in a wide variety of focal length ranges, some offering extended focal length ranges from wide-angle to telephoto, such as an 18-200mm lens. Typical ranges include 12-24mm (wide-angle only), 18-55mm, 18-70mm, 70-300mm (all telephoto settings).

zooming A technique using a zoom lens to instill a sense of motion in an inanimate object. The photographer sets a relatively slow shutter speed, such as 1/4 second and while the shutter remains open, quickly adjusts the zoom control to move through a wide range of focal lengths.

Index

Numbers

A

B

C